An Ecotourist's Guide to the Everglades and the Florida Keys

UNIVERSITY PRESS OF FLORIDA

Florida A&M University, Tallahassee
Florida Atlantic University, Boca Raton
Florida Gulf Coast University, Ft. Myers
Florida International University, Miami
Florida State University, Tallahassee
New College of Florida, Sarasota
University of Central Florida, Orlando
University of Florida, Gainesville
University of North Florida, Jacksonville
University of South Florida, Tampa
University of West Florida, Pensacola

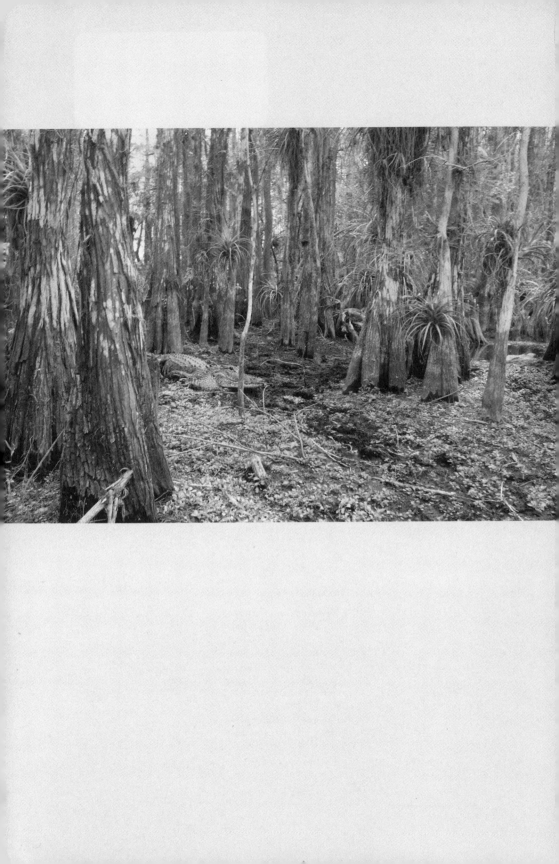

An Ecotourist's Guide
to the Everglades
and the Florida Keys

ROBERT SILK

Foreword by Clyde Butcher

University Press of Florida

Gainesville · Tallahassee · Tampa · Boca Raton

Pensacola · Orlando · Miami · Jacksonville · Ft. Myers · Sarasota

This book may be available in an electronic edition.

21 20 19 18 17 16 6 5 4 3 2 1

Library of Congress Control Number: 2015956438
ISBN 978-0-8130-6265-5

The University Press of Florida is the scholarly publishing agency for the
State University System of Florida, comprising Florida A&M University,
Florida Atlantic University, Florida Gulf Coast University, Florida
International University, Florida State University, New College of Florida,
University of Central Florida, University of Florida, University of North
Florida, University of South Florida, and University of West Florida.

University Press of Florida
15 Northwest 15th Street
Gainesville, FL 32611-2079
http://www.upf.com

For my beloved Nana, Ginger Lewis,
who introduced me to southern Florida.
She never much liked the Everglades,
but I know she would have been proud of this book.

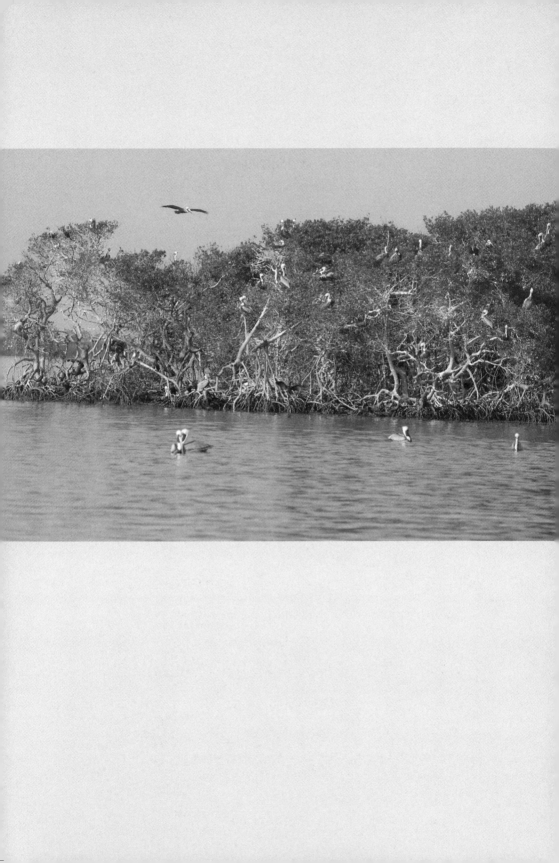

Contents

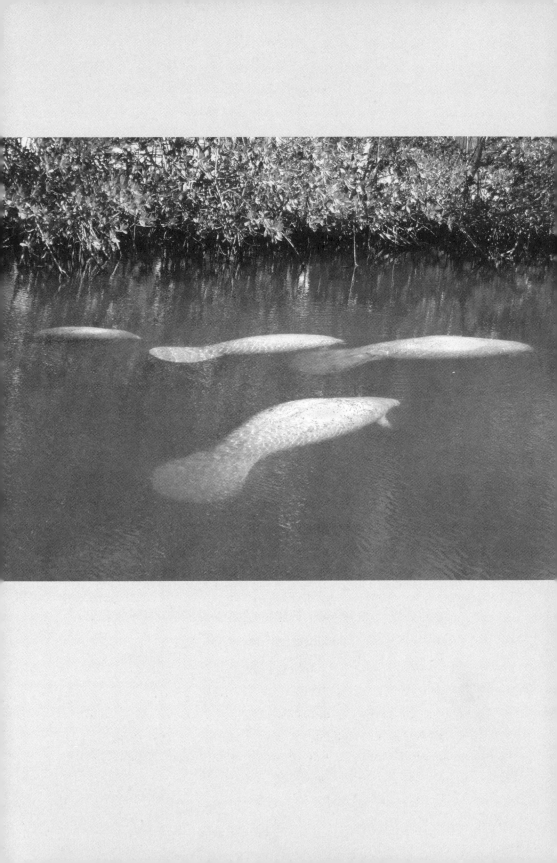

Foreword

As I stand hip deep in the swamp, an ancient part of me reconnects with the earth. The primeval mystery of the Everglades ecosystem soothes my soul, and I feel whole again.

I own a gallery, Big Cypress Gallery, and I lived in the Big Cypress National Preserve of the western Everglades for more than twenty years. Having now lived in the middle of more than a million acres of wilderness, I often wonder how it was that when I came to Florida I saw nothing but flat land, and then a friend took me out into the swamp and my world changed forever.

For those of you who have newly moved to Florida or are visiting and want to see and understand the beauty of southern Florida, this book is an excellent beginning to your adventure. Most of the United States has prominent geological features, such as the rugged uplift of the Grand Teton Mountains, the sculptural features of Monument Valley and the Grand Canyon, and the rocky coastline of Oregon. In contrast, southern Florida is flat and composed of subtropical flora and fauna. It is known for its biological diversity, which cannot be glanced at through a car window. Everglades National Park was the first in the federal park system to be created for biological reasons.

The beauty of Florida is subtle and unique. When I experienced the wilderness of southern Florida for the first time I felt a primeval presence I had never felt before. It was as though I was experiencing the beginning of time. The feeling captured my heart, and I began photographing the landscape of Florida. I felt a need to preserve this unique environment and share it with others through my photographs, with

the hopes that the images would inspire others to take care of this irreplaceable portion of our country. But I also want my images to inspire people to get out of their cars, touch the earth, and have an adventurous love affair with Florida. *An Ecotourist's Guide to the Everglades and the Florida Keys* is the beginning of your exciting journey of discovery.

The distance between my gallery in the swamp and the stunning coastlines of the Florida Keys is a short drive. As a result, I sometimes have the pleasure of being in two very different, yet intricately connected, ecosystems all within a day. And so, as I close this short piece of writing, I have traveled to an island in the Florida Keys. I close my eyes and feel the warm turquoise water of the Gulf Stream lapping over my feet. I'm sitting on the edge of a beach enjoying a moment of tranquility. My eyes and heart look to the horizon, and I feel a sense of freedom as the concerns of this earthly life are lifted from my shoulders and peace flows over me. I need this. We all need this.

May your journey of life be filled with wonderful adventures as you discover Florida . . .

Clyde Butcher
www.clydebutcher.com

Author's Note

Where applicable in this book, I have sought to include ecofriendly operations—especially lodging facilities. However, businesses come and go, and their practices can improve or get worse without notice.

The state of Florida maintains programs that recognize lodges and marinas that are run in an environmentally sensitive fashion. Similarly, the Florida Keys National Marine Sanctuary runs the Blue Star program, which recognizes responsible Florida Keys dive operators.

Because these lists are ever changing, I have not mentioned whether specific businesses have qualified for these recognitions. However, I encourage readers to look at the most up-to-date information as they plan and experience their journeys through the Everglades and the Florida Keys. Go to the following websites to learn more:

> http://www.dep.state.fl.us/greenlodging/lodges.htm
> http://sanctuaries.noaa.gov/bluestar/operators.html
> http://www.dep.state.fl.us/cleanmarina/

Throughout this book I use the term "southern Florida" to reference the entire vicinity covered in the guide, as well as the urban communities of Miami/Fort Lauderdale/Palm Beach and Naples/Fort Myers. I use the term "South Florida" when referencing only the Florida Keys, portions of the greater Everglades that sit to the east of the Big Cypress National Preserve, and the urban area of Miami/Fort Lauderdale/Palm Beach. The term "Southwest Florida" is used in specific reference to Collier and Lee Counties, including the Everglades City area that is the subject of the guide's chapter 5.

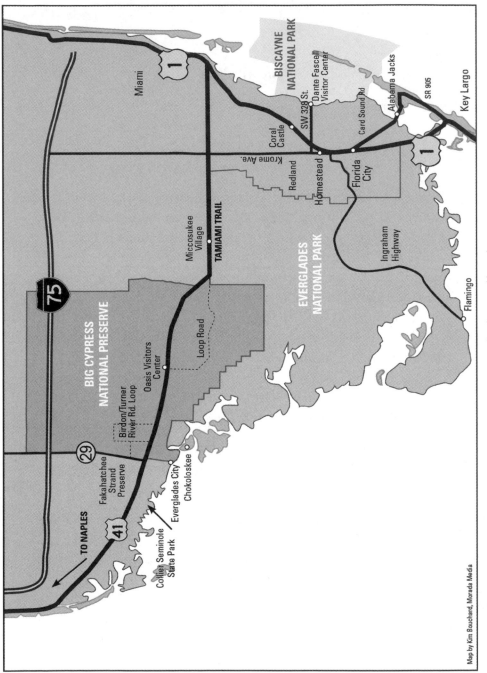

The southern Everglades and surrounds. Map by Kim Bouchard, Morada Media. All rights owned by author.

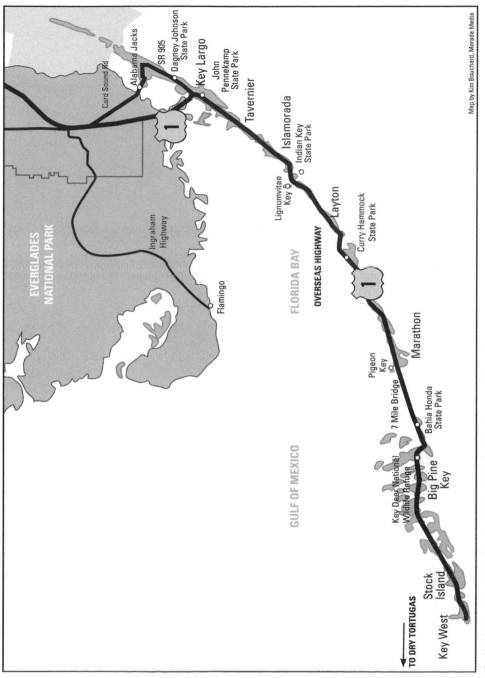

The Florida Keys. Map by Kim Bouchard, Morada Media. All rights owned by author.

An Ecotourist's Guide to the Everglades and the Florida Keys

1

Introduction

Southern Florida, with its seven million inhabitants and its well-earned reputation for sprawl, is viewed by many as little more than a concrete jungle with beaches. Fortunately for outdoors lovers, that impression is far from accurate.

The region is home to the largest national park east of the Mississippi. Its waters contain the third-largest barrier reef system in the world. And along many of its shorelines are miles of mostly untouched mangrove forest.

Take a drive east on the Tamiami Trail, between the suburban edges of Naples and Miami, and you'll pass some 75 miles of almost entirely undeveloped landscape.

Head south from there, down the Krome Avenue corridor, and you'll see the core of South Florida's little-publicized agricultural community.

Farther west again, beyond the rural belt, lies the main entrance to Everglades National Park. The park's 38-mile Ingraham Highway transports visitors past inland pine forests, strands of cypress trees, and sawgrass marshes before ending at the Flamingo visitor complex on the serene shores of Florida Bay.

Back to the east, outside the park, the 128-mile Overseas Highway through the Florida Keys crosses 42 bridges, offering breathtaking views of open seas, small islands, and mysterious shallow water estuaries.

All told, these approximately 275 miles of roadways serve as a gateway to three national parks, five national wildlife refuges, the sprawling

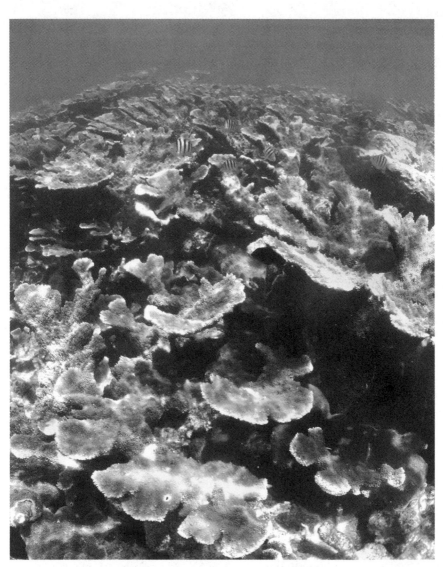

The elkhorn corals on Horseshoe Reef, off Key Largo, serve as alluring habitat for several sergeant major fish. Courtesy of Florida Keys National Marine Sanctuary.

Big Cypress National Preserve, the Florida Keys National Marine Sanctuary, and 12 state parks. Together they protect almost five million acres of land and water, making southern Florida far more than just a place of strip malls, swimming pools, and winter sunshine.

With so much public land, and with their diverse and spectacular assortment of marine habitats, the southern Everglades and Florida Keys are undeniably a premier destination for ecotourists. Diving and snorkeling the reefs, paddling through winding mangrove tunnels, hiking through pine forests, fishing the world-class shallows of Florida Bay, and hanging out on isolated sandy beaches are just some of the activities that are available.

More conventional roadside stop-offs also abound. The Keys, with its plethora of dockside restaurants, fish markets, and watering holes, is known for its laid-back charm. The Tamiami Trail harkens visitors back to the 1950s and earlier, when most of southern Florida's communities were rural outposts. In the agricultural Redland area, farm shops proudly display tropical fruits that won't grow anywhere else in the continental United States.

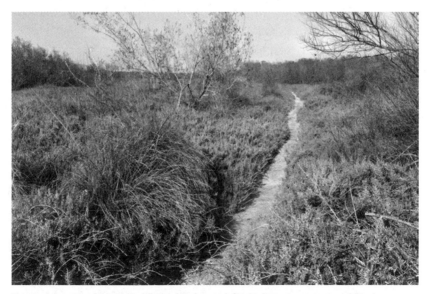

The coastal prairie of Everglades National Park is one of eight distinct ecosystems within the 1.5-million-acre preserve. Courtesy of the National Park Service.

Small mangrove islands dot the glassy water of Florida Bay in Everglades National Park. Courtesy of the National Park Service.

But sadly, even in their wildest, most isolated areas, the Everglades and the Florida Keys are a landscape altered. Canals, built in the last century to protect cities and farmlands from flooding, have diminished the traditional north-to-south flow of freshwater that has shaped the Everglades and nourished its plant and animal life for 5,000 years. Water pollution, destruction of hardwood forests, overfishing, and an inundation of exotic plant and animal species also continue to harm the area's habitat, both on land and beneath the sea. Meanwhile, rising seas, caused by climate change, have the potential to transform and even swallow vast swaths of low-lying southern Florida in the decades to come.

Fortunately, many efforts are underway to reverse the damage that poor management practices have wrought on the Everglades and the waters of the Keys. The biggest of those, a multidecade program called the Comprehensive Everglades Restoration Plan, was passed by Congress in 2000. Estimated to cost $13.5 billion as of 2015, it's the largest ecosystem restoration plan the world has ever seen.

Progress on the plan's more than 60 separate projects was slow but tangible through the first decade and a half of its incarnation. But other public and private initiatives to preserve the habitats of southern Florida are also afoot.

As a result, visitors to the Everglades and the Keys can choose among numerous attractions that are dedicated to the local environment. Museums, nonprofit foundations, and historic sites throughout the region provide opportunities to learn about the natural and human forces that have shaped this beautiful southeastern corner of North America.

2

~~~~~~~~~~~~~~

# When To Go

For the most part, the choice is obvious. Southern Florida is best experienced in winter. Few people need a guidebook to tell them that. Still, for ecotourists, there are at least a few reasons to consider visiting the Everglades, and especially the Florida Keys, during the summer.

First, though, the hard facts. Two seasons separate the calendar in southern Florida: wet and dry. During the wet season, from approximately late May to late October, temperatures consistently reach 90 degrees, while lows rarely drop below the upper 70s. Thunderstorms develop nearly every afternoon, especially on the southern Florida mainland, making the air thick with humidity. You can't actually cut the Everglades atmosphere with a knife. That's just a silly wives' tale. But on August afternoons it often feels as if you could.

Making matters worse are the biting insects, most notably mosquitoes and sand flies. If you plan on visiting a southern Florida natural area during the wet season, especially in the Everglades, prepare for the worst. Dawn and dusk can be brutal. And you should ready yourself for an onslaught if you venture into a hardwood tree hammock, mangrove creek, or low-lying coastal area before the first cold front of November rolls through. You'll usually be fine if you stick to the beaches and open water.

Summer is also hurricane season. Technically, the season runs from June through November. However, the large majority of tropical

storms and hurricanes materialize over the south Atlantic from late July through late October.

That's not to say you're likely to encounter a storm if you visit southern Florida during these months. In fact, you'd be quite unlucky if that were to happen. As of the start of the 2015 storm season, it had been 10 years since the last hurricane hit Florida. Still, it's important to be cognizant of hurricane season. Even the emergence of a tropical depression with the potential to track toward Florida can bring uncertainty to travel plans.

In contrast to summer, the dry season of November through May brings mild temperatures, cool breezes, drier air, and a refreshing dearth of bugs to the Keys and Everglades. During the most comfortable of those months, from November through the middle of April, daytime highs typically hover in the high 70s or low 80s, with lows, especially in the Everglades, dropping into the 60s. Slightly warmer evening temperatures can be expected in the Keys, where the surrounding waters keep the air more moist.

Southern Florida's seasonal cycles of wet and dry also have a profound impact on the Everglades landscape. Unlike points farther north, it is not the absence of leaves from the trees or the presence of snow on the ground that most distinguishes winter from summer. Rather, it is the absence of standing water.

Some 75 percent of the rain in southern Florida falls during the five-month wet season, turning prairies into swamps and shallow marshes into flowing rivers. Water levels in the greater Everglades region are often three to five feet higher during the peak of the wet season than they are in April or early May. That's a huge difference in a place where just a foot of elevation change can make the difference between a pine forest and a marsh.

For wildlife lovers, the wet/dry cycle offers another reason to visit southern Florida in the winter. During the summer, when freshwater is widespread, alligators, wading birds, and all sorts of other Everglades denizens disperse into the broader hunting grounds where they are difficult to view. During the winter, when the landscape dries, they

congregate in the remaining wet areas. Visit one of those areas and you're in for a show.

Still, there are definitely reasons to visit the Everglades and Keys during the hot weather months. One is the water, which is warmer and generally calmer in summer than in winter. Summer, in fact, is the peak season for diving and snorkeling along the Keys' reefs.

Another is the flowers. Plant life takes center stage in southern Florida during the wet season. It's when the most spider lilies bloom in the grassy rivers, known as sloughs. It's when the largest number of orchid species bloom in the Big Cypress and Fakahatchee swamps. It's when the cypress trees have their needles.

The bird migrations of September and October offer still another delight to nature lovers. Hundreds of thousands of birds, maybe millions, make their way through southern Florida in the fall, en route to the Caribbean from points farther north. Warblers, hawks, and many more species stop in the Everglades, or along the Keys, to ready themselves for the long crossing to places like Cuba and the Yucatan Peninsula. It's possible to see many of the same birds in March and April as they make their way back north, of course, but then you have to deal with the crowds.

Speaking of crowds, the absence of them is another reason to visit the natural areas of southern Florida, or at least the Keys, during the summer and fall. Only the hardy will enjoy the Everglades from June through mid-October, though you'll encounter the fewest people then. If you go, embrace the heat of the day to stay clear of bugs. Aside from open water, your best bet is often the higher ground of the pine forests, where shade is prevalent but the foliage is thin enough for breezes to pass through, dispersing bugs.

The Keys are much more tolerable. Mosquitoes can be avoided on or near the open water, as well as in developed areas, where the local government spends upward of $10 million annually on mosquito control. Meanwhile, ocean breezes make the heat more bearable, though not necessarily comfortable.

Things still get busy during the summer in the Keys, especially on weekends. Weekdays, though, are usually fairly calm. September

through November, meanwhile, are the slowest months of the year. Prices plummet as the highway clears out. Go to the Keys or the Everglades in November and you might just combine good weather with bargain prices and quiet waterways, beaches, and attractions.

## Birding Southern Florida

Southern Florida's subtropical climate, unique ecology, and strategic location within the North American/Caribbean migratory routes combine to make it a prime destination for birders, especially during the spring and fall migrations. In fact, publications routinely name Everglades National Park, where more than 350 species of birds have been spotted, as one of the top birding destinations in the United States.

Wading birds get the most attention throughout the greater Everglades and the Florida Keys, and for good reason. A century ago the beautiful plumage of species such as snowy egrets, great white herons, roseate spoonbills, and more were literally worth their weight in gold. Hunted no more, those species and others can now be seen on shallow water mudflats, on mangrove islands, in cypress swamps, along the shores of lakes and ponds, and in all kinds of other southern Florida locations. Even pink flamingos occasionally make a visit from Cuba and other Caribbean locales to the flats of Florida Bay.

Nevertheless, wading birds are far from the only feathered charm in southern Florida. Nesting osprey lurk on mangrove coastlines, swooping to the water to grab fish with their impressive talons. Magnificent frigatebirds, large tropical seabirds, soar majestically over the Keys year-round. Dry Tortugas National Park has the lone breeding colony of sooty terns in the United States. They show up 80,000 strong during a typical winter and spring. The Big Cypress swamp and the Everglades' Taylor Slough are home to the endangered Cape Sable seaside sparrow. The Middle Keys sees one of the largest falcon migrations on the eastern seaboard. Barred owls perch over the Fakahatchee Strand. The locally endangered snail kite, another bird of prey, flies over the

(continued)

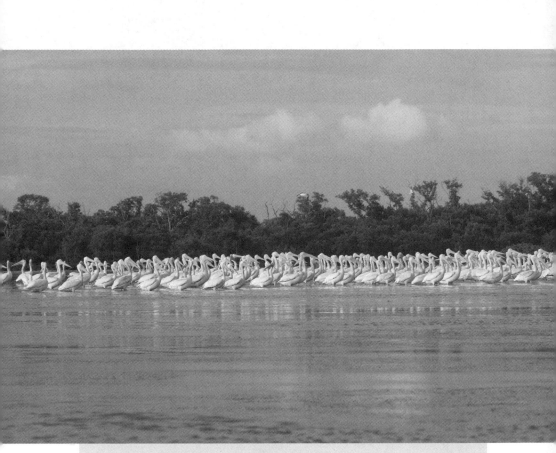

A white pelican flock gathers on the mud flats of Florida Bay, near Flamingo. By permission of Garl Harrold, www.garlscoastalkayaking.com.

Everglades. White-crowned pigeons, with their neck of distinctive iridescent green, reach the northern edge of their range in southern Florida and nest in the hammocks of the Lower and Middle Keys.

Those are just a few examples of why as long as you pay attention, you'll see plenty of interesting birds simply by being in southern Florida. But if you want the best viewing, or to see some of the less common species, it's advisable to venture into wild spaces.

In the Big Cypress/Tamiami Trail region, the Big Cypress Bend and Kirby Storter boardwalks offer excellent birding, as does Loop Road, where the habitat ranges between pineland, cypress swamp,

hammock, and prairie. Definitely stop and look for birds at Sweetwater Strand, and don't forget to look high in the trees for hawks.

Everglades National Park contains an almost unlimited selection of excellent birding sites. Look for purple gallinules, rainbow-colored birds of the freshwater marshes, at the Anhinga Trail; woodstorks and roseate spoonbills at Paurotis Pond; and the secretive mangrove cuckoo along the Snake Bight hiking trail.

The Keys, too, have numerous outstanding birding spots. Try Dagny Johnson Key Largo Hammock Botanical State Park for migrant song-birds, such as warblers. Fort Zachary Taylor Historic State Park in Key West is a nice place to check out some of Florida's beach-dwelling terns and to look above for magnificent frigatebirds. Mid-September to mid-November is an exciting time for birders to visit Marathon's Curry Hammock State Park, where the organization Hawk Watch International sets up a seasonal counting site. One of Curry Hammock's frequent migratory visitors is the peregrine falcon, a once-endangered species that has recovered to a population of 2,000 to 3,000, according to the U.S. Fish and Wildlife Service.

The best birding in the Everglades and Florida Keys comes during the migrations of September/October and March/April. Wading bird nesting season, typically coinciding with the January to April dry months, also presents excellent viewing opportunities.

An outstanding resource for more information on birding in southern Florida is the Tropical Audubon Society website: http://tropical audubon.org/birds.html.

# 3

~~~~~~~~~~~~~

A Diverse but Connected Ecosystem

For outdoor lovers, the Everglades and the Florida Keys form a natural itinerary. After all, within the space of a single day one can hike, paddle, or cruise though the world's most famous wetland, then dive or snorkel on North America's only living barrier reef.

Other than proximity, however, the connection between the very different worlds of an Everglades sawgrass prairie and a coral reef isn't so obvious. In fact, the two ecosystems could hardly look less alike.

Appearances, though, can be deceiving, as a blue-striped grunt might tell you if only it could talk. Golden-hued around those wavy light blue stripes, adults of the species are commonly seen schooling along the reefs of the Keys. But the grunts one encounters while wearing masks and fins would not have made it to adulthood if the shallow nearshore estuaries of southern Florida weren't home to the seagrass meadows that juvenile grunts call home. In turn, those seagrass beds, which cover more than 2,200 square miles around the Keys, can only flourish in water that is clear and clean enough to allow direct sunlight down to the seafloor. Since water coming out of the Everglades is a key ingredient in the coastal estuary mix, those adult blue-striped grunts, and the snorkelers smiling at them, are dependent on a healthy Everglades.

As the habitat needs of the blue-striped grunt demonstrate, water is the common ingredient throughout the ecological chain that connects southern Florida. But the freshwater that eventually enters the region's

coastal estuaries gets its start much farther north than the coasts of the peninsular mainland. In fact, the Kissimmee River basin, just south of Orlando, forms the headwaters of the Everglades.

Before the dawn of the twentieth century, when modern Floridians began efforts to drain what Governor Napoleon Bonaparte Broward called "that abominable, pestilence-ridden swamp," water that fell into the Kissimmee traveled unfettered through the twisting river for 100 miles to Lake Okeechobee. Next, the water would top the banks of the lake during the summer and fall wet season, then slowly work its way another 100 miles south into the estuaries of Florida Bay, Biscayne Bay, and the Ten Thousand Islands. Pushing south as a shallow, slow-moving sheet of water, the so-called River of Grass once shaped a 4,000-square-mile expanse of sawgrass and coastal prairies, hardwood tree islands, cypress swamps, pine forests, and mangrove shorelines. Even now, it can take as long as six months for a drop of rain that falls south of Orlando to make the journey through the Everglades to the southern edge of the Florida peninsula.

Nevertheless, the Everglades of today is a shadow of its former self. Governor Broward didn't succeed in draining the swamp. But in the years since his 1903 campaign promise to do so, the system has been sliced and diced by 2,000 miles of levees and canals, crisscrossed by the damaging Tamiami Trail, and diminished in size by half as the cities and farms of the Miami/Fort Lauderdale/West Palm Beach metroplex have grown ever larger.

Even the natural areas that remain are sick. Agricultural fields, most notably sugar plantations immediately south of Lake Okeechobee, pollute the Everglades with phosphorous. Flood protection leaves wetlands dry. And the water that managers do permit to go south is sometimes let out in large pulses at the end of canals, overwhelming marine populations in those immediate vicinities while leaving much broader areas with a freshwater thirst.

During an average year in modern times, Everglades National Park, in the southern third of the Everglades system, is the recipient of only about 40 percent of the water it received during the predrainage years

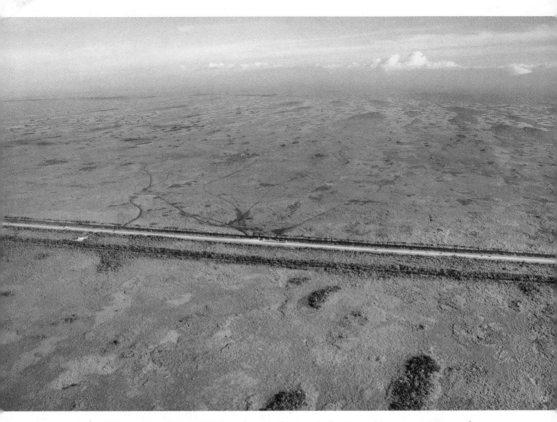

An aerial image from March 2008 shows how the Tamiami Trail acts as a dam, preventing water from flowing south into Everglades National Park. The road separates the dry park (*bottom*) from the wet South Florida Water Management District property (*top*). Courtesy of Lori Oberhofer, Everglades National Park.

of the nineteenth century. Taylor Slough, a shallow marshy river that winds though the park, delivers 75 percent less freshwater to Florida Bay than it did a bit more than a century ago.

Such drastic changes in water flows have had a strong effect on life in the Everglades. Sixty-seven species of plants and animals within the famed wetland are now listed as threatened or endangered. Meanwhile, Florida Bay nest counts for roseate spoonbills, pink and white wading birds that scientists view as a key indicator of the overall health of the Everglades, have dropped from more than 1,200 in the late 1970s to closer to 300 in recent years. Taxed by the increasingly less reliable

transition between the summer wet season and the winter dry season, the birds struggle to find consistently good fish-foraging grounds.

Some of the problems now faced by the Everglades and Florida Keys ecosystems won't be reversed. The seven million people who call southern Florida home aren't going away. But other issues can be tackled. Polluted water can be more efficiently cleaned. Canals and levees can be built and altered to more effectively send water south, mimicking the natural sheet flow they replaced.

The $13.5 billion federal and state Comprehensive Everglades Restoration Plan is a complicated patchwork of projects that seeks to accomplish those goals. In the 15 years that followed its inception in 2000, the plan was implemented tentatively—delayed by disputes between stakeholders within southern Florida, by funding difficulties, and by broader partisan bickering in Washington. Still, several restoration projects had been brought online. If, during your visit to southern Florida, you walk the Fakahatchee Strand, paddle in northern Florida Bay, or stop along the eastern Tamiami Trail for an airboat ride, you'll be venturing into a landscape that has begun to see the benefits of restoration.

Everglades restoration alone, however, won't ensure that the blue-striped grunt will continue to flourish in the southern Florida seagrass meadows and along this region's reefs. Nor will it guarantee that visitors to places like the Big Cypress National Preserve and John Pennekamp Coral Reef State Park will continue to be able to enjoy the area's one-of-a-kind ecosystem. Fortunately, other public efforts, including a $1 billion sewer project in the Florida Keys, government-led land acquisition programs, and myriad restrictions on growth, are also geared toward preserving this area's natural assets.

Numerous nonprofit groups have also gotten into the act. Among many other initiatives, they plant coral nurseries, remove exotic plants, chase after invasive lionfish, and exert pressure on politicians to write eco-friendly laws and to keep restoration funds flowing.

4

Rising Seas

There is a sense of timelessness as one hikes through an Everglades pineland or watches the sun set over the Gulf of Mexico. The reality, however, is that timelessness is merely an illusion in low-lying southern Florida.

The Everglades themselves are only 5,000 years old. Meanwhile, the Florida peninsula has expanded and contracted greatly over the millennia as ice ages and interglacial periods have variously led to rising and plummeting seas. Approximately 130,000 years ago, when sea level was 25 feet higher than today, all of southern Florida and the Keys lay beneath a shallow sea. Fifteen thousand years ago, in the midst of the last great North American ice age, sea level was more than 300 feet lower than it is today and the exposed Florida peninsula was more than double its present size.

Global warming now threatens to transform southern Florida again. In the past century alone, seas off the Everglades and Keys have risen nine inches, a lot for a region in which elevations of five feet or less are common.

The expanding seas have already had a demonstrable effect. Low-lying streets in the Keys and elsewhere are inundated more frequently than before by tidal floods. Saltwater intrusion in the Biscayne Aquifer, from which South Floridians draw their freshwater, has increased. The Lower Keys marsh rabbit, an endangered species, lost 48 percent of its habitat in less than 60 years as brackish and freshwater marshes turned saltier. And Florida's coastal mangrove forests have expanded inland,

A super high tide, known as a "King Tide," floods a Key West road on a sunny day. By permission of rights holder Alison Higgins, City of Key West.

filling a void that is created when rising seawater diminishes the prevalence of less salt-tolerant plants.

The situation is expected to get worse, not better. The Southeast Regional Climate Change Compact, composed of Palm Beach, Broward, Miami-Dade, and Monroe Counties, is projecting 9 to 24 more inches of sea-level rise by 2060. Under the 24-inch scenario, the Keys' second largest island, Big Pine Key, would be split in half; numerous Upper Keys neighborhoods could become unlivable; Key West's famed Mallory Square could be consumed by water; and 60 percent of the freshwater marshes in Everglades National Park would be inundated. Even with nine more inches of sea-level rise, park habitats will be significantly altered and the Florida Keys will see a projected 60-fold increase in the small-scale tidal floods known as nuisance floods.

Of course, fortifications to infrastructure could guard against some of the impacts of sea-level rise, especially in developed areas. But in relation to the Everglades, the forecasts of sea-level rise have led some to

wonder if the $13.5 billion Comprehensive Everglades Restoration Plan is even worth implementing. Why, the doubters ask, should we spend so much to preserve something that is likely to be lost in any case?

Advocates have a good answer to that question. At its essence, the restoration plan is a water management plan. Its goal is to allow for billions more gallons of water to flow south each year from Lake Okeechobee to Everglades National Park, instead of being dumped out to sea through South Florida's extensive canal and levee system, or through the Caloosahatchee River on the west coast and the St. Lucie River on the east coast.

The plan was conceived so that the park could be returned to something approximating its natural state, before levees, canals, and the Tamiami Trail dried its environs to the detriment of plants, fish, birds, and everything that feeds there.

That freshwater would also function as a bulwark against saltwater intrusion into the groundwater table. After all, if seas rise by a foot, the best way to keep saltwater from seeping into coastal areas is to raise freshwater levels just as much.

Meanwhile, in the Everglades, where the land is built up by partially decayed wet vegetation, called peat, a drying out can lead to soil collapse and a loss of land elevation. That, too, would accelerate the problems caused by rising seas.

Call it fighting water with water.

5

~~~~~~~~~~

# Everglades City and the Western Tamiami Trail

Gaze at a map and you'll see that the parks, public lands, and communities of the southwest Everglades reach almost all the way up to the burgeoning sprawl of Naples and the towering condo buildings of Marco Island. But you wouldn't know it by visiting the area.

Spanning a bit more than 30 miles, from Collier-Seminole State Park southeast to State Road 29 and Everglades City, the region still has the feel and look of the Florida of the 1950s. Small lodges dominate the hotel and motel scene in Everglades City. Restaurants serve sweet tea on screened-in porches. And unless they're escaping a cloud of mosquitoes, nobody is in a hurry to get anywhere.

The southwest Everglades is linked together by the Tamiami Trail, the 1920s triumph of industrialist Barron Collier that brought civilization to the swamp, connected Miami with Naples and Fort Myers, and fundamentally altered the natural water flow and environment of the Everglades ecosystem. Today, motorists traveling through this western portion of the Tamiami pass along a string of parks and preserves, including Collier-Seminole State Park, Fakahatchee Strand State Preserve, and Ten Thousand Islands National Wildlife Refuge. Just a few miles south of the highway sits Everglades National Park's Gulf Coast Visitor Center.

The parks protect southern Florida's healthiest cypress swamp, the southwestern fringe of North America's largest mangrove forest, sawgrass prairies, pine forests, and rivers—in which Everglades freshwater moves south to mingle with the saltwater of the Gulf of Mexico.

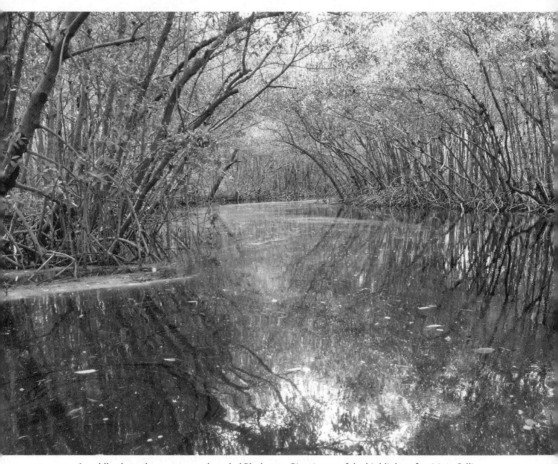

A paddle along the mangrove-shrouded Blackwater River is one of the highlights of a visit to Collier-Seminole State Park. Photo by author.

Panthers and black bear roam inland portions of the western Tamiami region, though you're not likely to see them. Gopher tortoises, listed as threatened by the state, are found in the uplands of places like Collier-Seminole State Park. More common are white-tailed deer, which like to prance through sawgrass prairies in the early morning hours. Endangered wood storks can often be seen alongside anhingas, herons, and other wading birds in the foliage that surrounds the Tamiami. Nearby, alligators sometimes congregate by the dozens.

Foliage, too, is a prize of the western Tamiami. Loggers in the middle of the twentieth century destroyed most of the old growth cypress

forests, but remnants still remain. Royal palms, tall and regal, are found by the thousands in the Fakahatchee swamp. Orchid lovers, meanwhile, can search for nearly four dozen species in the Fakahatchee alone.

South of the Tamiami Trail, the freshwater prairies and swamps give way to the mangrove labyrinth that is the Ten Thousand Islands. Extending approximately five miles offshore, the islands are protected within Everglades National Park as well as the national wildlife refuge that shares their name. The Ten Thousand Islands are home to endangered sea turtles and manatees, bottlenose dolphins, and a wide variety of wading birds. They are also a haven for game fish such as snook, redfish, and tarpon.

Lying on the edge of the Ten Thousand Islands is Everglades City, the former frontier town that Collier turned into the hub of his Tamiami Trail construction enterprise in the 1920s. It's a small place, with a population that fluctuates between approximately 500 in the summer and 5,000 in the winter. Still, Everglades City, including the neighboring island community of Chokoloskee, is unquestionably the commercial hub of the southwest Everglades.

A nostalgic remnant not just of Old Florida, but of the Old South, Everglades City retains much of the character it derived from its roots as a centrally planned company town. Near its central roundabout are several lodges, fish houses, and restaurants, some of which sit pleasantly along the edge of the Barron River.

The town caters most prominently to paddlers and fishermen but is also a central base for airboat excursions, swamp buggy rides, and hiking.

## Top Eco-destinations

### Collier-Seminole State Park

This 7,300-acre park offers paddling along a mangrove-shrouded tidal river, hiking through the swamp, and off-road bicycling amid pines, palms, and prairie. It also commemorates the modern history of Southwest Florida.

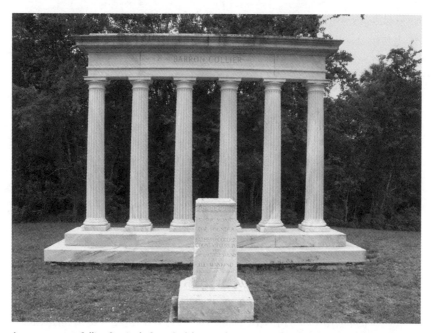

A monument at Collier-Seminole State Park honors the memory of park namesake Barron Collier, who built the Tamiami Trail, opening the southern Everglades to the world. Photo by author.

Located less than 20 miles southeast of downtown Naples on the Tamiami Trail, the park is named for its early benefactor, Barron Collier, and for the Seminole Indians, who between 1855 and 1858 fought many of the skirmishes of the Third Seminole War in what would become Collier County.

Unlike most of southern Florida's protected lands, Collier-Seminole State Park didn't result from a political showdown between conservationists and commercial interests. Instead, Collier, the developer who brought Southwest Florida into the modern age, set aside the original 150 acres of the park himself in the 1920s as he worked to construct the adjacent Tamiami Trail. He envisioned it as a national park called Lincoln-Lee, which in addition to preserving a stand of royal palms and a tropical hardwood hammock, was to be his attempt at healing old wounds of the Civil War. Alas, Congress rejected the idea of such a small national park in an area that was still quite remote, and Collier-Seminole didn't become a state park until 1947.

Today, park visitors can view a Greek-columned monument to Collier, who passed away in 1939, as well as outdoor exhibits about the lives of the Seminole Indians of the Everglades. Also of historical interest is the park's Bay City Walking Dredge, the last remaining machine of its kind, which was used for swamp excavation during construction of the Tamiami Trail.

Outdoor enthusiasts, though, mainly visit Collier-Seminole for its 120-site campground and for its paddling. The park's marina backs up to the Blackwater River, with its 13.5-mile twisting trail through red mangrove canopy and tidal bays. Most choose to do only a section of the route. But for the adventurous, a primitive campsite is available at Grocery Place, midway through the trail. Canoe and kayak rentals are available on-site.

Collier Seminole's 6.5-mile hiking trail lies just east of the main gate, and on the north side of the Tamiami. The trail circles a combination of cypress swamp, hammock, and pinelands and also has a primitive campsite. Portions of the path are likely to be underwater during the summer wet season, when bugs are often intense. Hikers must stop at park headquarters to get a gate code for trail access.

The park's 3.5-mile bicycle trail is accessed on the south side of the Tamiami, 0.7 miles west of the main Collier-Seminole gate. Though it is unpaved, it is still dry year-round. The trail is a remnant portion of the Old Marco Road, which in the early twentieth century was the first to take motorists to the Marco Island ferry launch.

Collier-Seminole is open daily from 8:00 a.m. until sunset. Information: (239) 394-3397.

## Fakahatchee Strand Preserve State Park

Located just west of the Big Cypress Preserve and northwest of Everglades National Park, this 75,000-acre wilderness might lack the renown of its larger neighbors, but it is arguably more spectacular. Featuring an astoundingly diverse combination of trees, plants, and wildlife, the Fakahatchee Strand is dense and mysterious, but also subtle and austere in its beauty.

Infesting more than 700,000 acres of central and south Florida, Brazilian pepper is arguably the most pernicious invasive plant in the Everglades. Photo by author.

## Invasive Species

Invasive animals, such as Burmese pythons and lionfish, get most of the headlines. But invasive plants are also an enormous problem throughout the southern Florida wilds.

In 2013 some 77 plant and tree species in Florida were listed as Category I invasives, a designation given to flora that is crowding out local plant species. Even scarier, it is estimated that non-natives now account for one-third of all plants in Florida.

The most successful invasive flora take over an area, killing off competitors that haven't evolved defenses to their new neighbors. In the worst cases, these invasives create monoculture communities that are unsuitable habitat for local wildlife. Southern Florida's warm climate, its diverse mix of habitats, and Miami's status as a major world port have combined to make the area such a fertile ground for exotic plants.

The most fearsome of southern Florida's invasive plants is Brazilian pepper, which is widespread in the Keys, through the Everglades, and practically anywhere else you look. A short-trunked shrub that produces red berries, it beats out native species by forming a dense canopy that blocks their access to light. Brazilian pepper infests more than 700,000 acres of central and southern Florida and can grow anywhere from mangrove forests to pinelands to hardwood hammocks.

Other especially common invasive plants in southern Florida include melaleuca trees, an Australian import that can grow on land and in shallow water, Australian pines, and hydrilla, an aquatic plant that clogs waterways and sucks up oxygen that its native neighbors need.

For the past 20 years, state and federal agencies, as well as nonprofits, have been fighting invasive plants in southern Florida through a combination of chemical and biological methods, as well as by physically removing them. Battling invasives is also an important goal of the Comprehensive Everglades Restoration Plan. In 2013, the South Florida Water Management District opened a $16.7 million research facility near Fort Lauderdale that is dedicated to the cause.

Invasives even impact relatively healthy southern Florida ecosystems. In early 2015 officials at the Fakahatchee Strand Preserve, for example, were preparing a plan to remove 4,000 acres of Brazilian pepper.

Thousands of years of rainfall and naturally occurring acids carved this swamp, shaping it as a two- to six-foot-deep depression in the earth that drains the Big Cypress into the Ten Thousand Islands and the Gulf of Mexico. That depression is formally known as a strand in Everglades parlance. But for those uninitiated to the unique language of the southern Florida environment, it's helpful to think of a strand swamp as a shallow, slow-moving stream of trees.

Panther, black bear, white-tailed deer, and, of course, alligators, are among the charismatic fauna that roam the Fakahatchee's 20-mile-long expanse. The strand's collection of flora, however, is even more

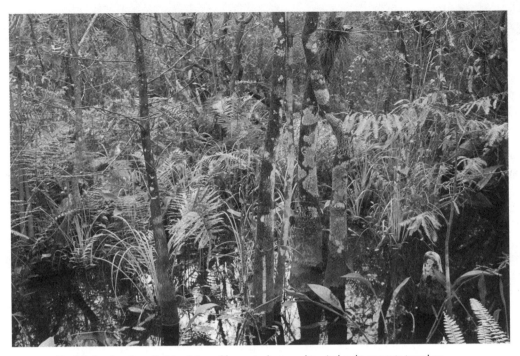

The Fakahatchee Strand's rich mixture of ferns, air plants, and tropical and temperate trees has earned it the nickname "Florida's Amazon." By permission of Dan Campbell, Key Largo, Florida.

impressive. In fact, longtime preserve biologist Mike Owen likes to refer to the Fakahatchee as Florida's Amazon.

The preserve might be best known for its rare ghost orchids, made famous in Susan Orlean's 1998 book *The Orchid Thief* and in the 2002 Meryl Streep and Nicholas Cage film *Adaptation*. But the ghost is just one of 47 orchid species known to thrive in the Fakahatchee, making it the richest orchid ecosystem in the United States.

The park, which is the largest in the Florida state system, also has this country's widest diversity of bromeliads. In addition, the Fakahatchee harbors one of southern Florida's best preserved bald cypress communities and is home to an estimated 5,000 to 7,000 royal palms, some 10 times more of the stately tree than is found in all of the far larger Everglades National Park.

The relatively healthy state of today's Fakahatchee is a triumph of the southern Florida conservation movement. Back in 1944, when com-

mercial logging of the strand's old growth cypress trees began, it would have been easy to imagine the death of the Fakahatchee. By the time the logging ended a decade later, some 192 miles of elevated rail routes, or tramways, had been built through the swamp and most of the cypresses were gone.

A second major threat to the Fakahatchee came in the 1960s when a development company called Gulf American began construction of the four broad canals immediately to the strand's west. The canals sucked massive volumes of water out of the swamp, and by 1974 had reduced its annual low water mark from three feet above sea level to just one foot above sea level.

By then, a decade-long fight to save the Fakahatchee was reaching fruition. The state of Florida purchased the first 24,500 acres for the preserve that year and has been expanding its holdings ever since. In 1999, at the strand headquarters just off State Road 29, the Florida Park Service erected a monument to the spearhead of the Fakahatchee preservation movement, a Miami lawyer and conservationist named Mel Finn. Another milestone for the Fakahatchee came in 2006, when the Prairie Canal along the preserve's western edge was plugged as part of the Comprehensive Everglades Restoration Plan, allowing much of the traditional north-to-south water sheet flow to resume.

Today, the large majority of park visitors get their taste of the Fakahatchee on its 2,000-foot-long Big Cypress Bend boardwalk, located along the Tamiami Trail about 7 miles west of the State Road 29 and Everglades City junction. Meandering through a 215-acre virgin old growth cypress grove, the boardwalk terminates at a small pond—more specifically a gator hole, dug through the years by alligators in need of water during the dry winter season.

Scenery along the boardwalk changes with the swamp's varying water levels, which are commonly as much as four feet deeper at the peak of the wet season in September than they are when the dry season ends sometime around May or June. During the fall and winter, baby alligators are often abundant in the gator hole. A pair of bald eagles also lives along the Big Cypress Bend. During successful nesting years their eaglets are best seen in March.

Those who want to get their feet wet can venture further into the Fakahatchee Strand via the unpaved Janes' Memorial Scenic Drive. Hiking trails, located on a few of the old logging tramways, lie behind gates along the roadway. Two of the best trails are accessed through gates 7 and 12. The West Main Tram (gate 7), located 4.5 miles from the ranger station and nearby fire tower, takes hikers along the swamp for 2.2 miles to a sawgrass prairie.

The East Main Tram (gate 12), located 6.5 miles from the fire tower, heads along the swamp for two miles to a small rustic cabin that is still privately owned. The approximately 1.5-acre lake next to the cabin is the easiest to access of the 94 swamp lakes in the Fakahatchee Strand. During the winter it teems with dozens of alligators. The trail continues for eight miles beyond the cabin but is not well maintained. Bicycles are also allowed on the tramways.

Mosquitoes are generally tame in the winter but can be prolific along the Fakahatchee trails during the wet season. Prepare accordingly.

Janes' Memorial Scenic Drive is accessed off SR 29, three-quarters of a mile north of the Tamiami Trail. Entry to the drive is $3 per vehicle, paid at an honor box. Big Cypress Bend is free, though a $3 donation is suggested. The nonprofit Friends of Fakahatchee Strand Preserve State Park offers periodic guided swamp walks and motorized tram tours through the preserve. Check their website orchidswamp.org for a schedule and for lots more information on the strand's natural history.

## Everglades National Park Gulf Coast Visitor Center and the Ten Thousand Islands

Located along the causeway that links Everglades City with nearby Chokoloskee Island, the Everglades National Park Gulf Coast Visitor Center is a launching pad into the isolated but alluring world of the Ten Thousand Islands.

The region is a mysterious one that stretches southeast from the tip of Marco Island for approximately 45 miles. Its name aside, the actual island count in the Ten Thousand Islands is closer to 1,000. They are mainly small patches of mangroves, unsuitable for human habitation,

which quickly begin to look the same for even many experienced boaters and paddlers. Dotted among the mangroves are islands with higher ground, some of which sit on a foundation of shells that the Calusa Indians, who dominated Southwest Florida when Europeans first arrived in the sixteenth century, built up over the course of a thousand years. Along the edge of the Ten Thousand Islands, where it abuts the Gulf of Mexico, some small islands have narrow tidal beaches.

This unique landscape is protected today by not only Everglades National Park, but the adjacent Ten Thousand Islands National Wildlife Refuge to the north, and beyond that, the Rookery Bay National Estuarine Research Reserve. Together they help preserve an exceptionally rich ecosystem. The submerged mangrove roots and shallow seagrass flats of the Ten Thousand Islands serve as nurseries for shrimp, stone crab, lobster, and many fish. Approximately 200 fish species are known to reside within the 35,000-acre Ten Thousand Islands National Wildlife Refuge alone. Nearly as many bird species also either reside or migrate through the region. Loggerhead, green, and Kemp's Ridley sea turtles, as well as manatees and bald eagles, are among the threatened and endangered species that call the Ten Thousand Islands home.

It was the region's unusually large bounty of wildlife that drew white settlers in the late nineteenth century. They were a mixture of hardscrabble frontiersmen and outlaws who were willing to endure the geographic isolation of what was then a roadless water world. Stifling heat and humidity and the often-extreme nuisance of mosquitoes, horse flies, and other biting insects made life harder still.

Under such circumstances, it should hardly be surprising that the Ten Thousand Islands of 120 years ago resembled America's Wild West. A contemporary account, detailed on a Florida Department of Environmental Protection website, says that the residents lived under seven unwritten laws: "suspect every man; ask no questions; settle your own quarrels; never steal from an islander; stick by him, even if you do not know him; shoot quick when your secret is in danger; cover your kill."

The most notorious resident of the early twentieth-century Ten Thousand Islands was Edgar Watson, a reputed outlaw who set up a small sugar plantation on an island about 10 miles southeast of Cho-

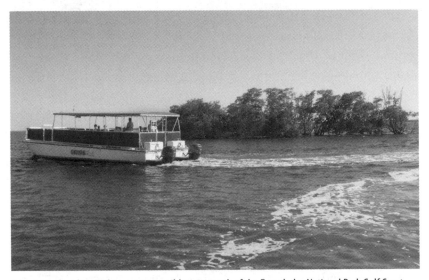

A boat tour heads into the mangrove wilderness north of the Everglades National Park Gulf Coast Visitor Center. Photo by author.

koloskee. Townsfolk suspected Watson of killing his workers in order to avoid paying their wages. Much of the Watson story is shrouded in myth, but its end is clear. Afraid for their own safety, the men of Chokoloskee gunned him down vigilante style in October 1910 at the landing to the town's trading post, the Smallwood Store.

The Watson Place now houses one of the many backcountry campsites that Everglades National Park maintains within the Ten Thousand Islands. It, like the entire region, can only be explored by boat.

In more recent years the maze that is the Ten Thousand Islands proved a perfect spot for a different type of outlaw. In fact, during the late 1970s and early 1980s marijuana smuggling was practically the town business of Everglades City. Drug Enforcement Agency raids in 1983 and 1984 ended those glory days and led to the arrest of 80 percent of the town's men.

The park's Gulf Coast Visitor Center, is, on its own, no site to see. It was constructed in 1966 on a relatively small waterfront parcel, and according to the park service's own planning literature, has become "functionally obsolete."

Still, it's a nice place to have a picnic lunch and to arrange for a paddling or boat excursion. Comfortable motorized boat tours head either into the Ten Thousand Islands or up the interior creeks and rivers that link the Ten Thousand Islands with the Big Cypress Swamp. Tours leave frequently every day of the year. Both circuits last between 1½ and 2 hours. Canoe and kayak rentals are also offered at the Gulf Coast site.

In addition, various concessionaires around the Everglades City area offer rentals and motorboat and paddling tours of the local waters. Some even offer pole boat tours, mimicking the old Seminole Indians' method of travel across the Everglades' often shallow waters.

Entry to the Gulf Coast Visitor Center is free. Grounds are open 24 hours. The ranger station and small interpretive center are open from 8:00 a.m. to 4:30 p.m. from mid-November to mid-April and from 9:00 a.m. to 4:30 p.m. the remainder of the year. Information: (239) 695-3311.

## Paddling the Western Tamiami Trail and the Ten Thousand Islands

Simply put, the Ten Thousand Islands and the surrounding rivers and marshes of the southwestern Everglades are a world-class paddling destination.

Paddle boarders, kayakers, and canoeists can easily spend days, even weeks, exploring the creeks, tunnels, and open waters of this region. Indeed, many of them do. Everglades City is the launching point for the 99-mile-long Wilderness Waterway, which ends at Flamingo, near the southern edge of Everglades National Park.

You don't have to paddle far, however, to get more than just a little taste of the southwestern Everglades. Excursions of just a few hours can transport paddlers from the freshwater of a cypress swamp, through sawgrass prairies, into the brackish waters of a mangrove-lined river and from there into the saltwater of the Ten Thousand Islands. Equally manageable trips will take paddlers from the mainland, through the Ten Thousand Islands' confusing maze, and then to isolated island beaches on the edge of the Gulf of Mexico.

Paddlers who navigate these myriad locales are apt to encounter alligators in the freshwater and, if they're lucky, crocodiles in the saltwater. Neither pose much of a risk, as long as you use common sense.

Manatees and bottlenose dolphins can frequently be seen in the Ten Thousand Islands. Songbirds, ducks, wading birds, and raptors are plentiful in a mix of habitats. Meanwhile, the confluence of fresh- and saltwater makes the area a magnet for a dizzying variety of fish, shellfish, and other marine life.

Paddling trails in Big Cypress, Collier-Seminole, the Fakahatchee, and the Ten Thousand Islands also offer cultural experiences. Rivers pass shell mounds that the Calusa Indians created many centuries ago with their garbage and for burial purposes. Various islands also sport the remains of homesteads from the pioneering days of the region around the turn of the twentieth century.

Whether going on a long trip or just a short one, paddlers should prepare properly for a jaunt through the swamps or into the Ten Thousand Islands. Tides are strong, so plan your paddle around them. If you're heading toward the Gulf, depart on an outgoing tide and return on an incoming tide. If your paddle will take you toward the interior, start on an incoming tide.

Make sure your GPS is working well. Or, if you're a bit old-fashioned, you should carry a compass and a navigational chart at a minimum. The Ten Thousand Islands have bewildered plenty of experienced boaters through the years, and journeys through the curvy and forking interior creeks of the western Tamiami region can be equally as confusing.

Bugs along the waterways of the mainland can be harsh during the summer months. If you decide to brave them anyway, bring strong bug repellant and consider purchasing a mosquito suit. A better choice from June through October is to hit the open water, where bugs are far fewer and the breeze dampens the heat. As with all of the regions discussed in this book, thunderstorms are frequent during summer afternoons, so paddling early is the safest choice.

Free and for-fee put-ins are available along the Tamiami Trail and in Everglades City and Chokoloskee. They include:

- Turner River launch, off Tamiami Trail, 6 miles east of FL 29 and the Everglades City intersection
- Seagrape Drive launch, off Tamiami Trail, 2.5 miles east of FL 29 (put-in accesses upper portions of Barron River and Halfway Creek)
- East River launch, on a gravel road off Tamiami Trail, 5 miles west of FL 29
- Blackwater River launch, within the main gate of Collier-Seminole State Park, 15.5 miles west of FL 29 along Tamiami Trail
- Gulf Coast Visitor Center at Everglades National Park
- Along the causeway dividing Chokoloskee and Everglades City
- Outdoor resorts near the entrance to Chokoloskee

There are no full-service paddling retail shops in Everglades City, but numerous marinas, lodges, and concessionaires rent equipment and offer guided tours.

For a taste of what the southwestern Everglades offers paddlers, it's a good idea to do both a trip into the Ten Thousand Islands and one into the creeks of the interior. A relatively simple Ten Thousand Islands paddle goes from the Gulf Coast Visitor Center to Sandfly Island. It's only about 1.5 miles each way, with the bulk of the journey being the crossing of Chokoloskee Bay. Once across, you'll enter Sandfly Pass and quickly come upon the Sandfly Island dock.

During the dry season it's fun to do the mile-long hike on the island, which passes through a tropical hardwood hammock and the ruins of an old homestead. Dense and diverse, the hardwood hammocks of the Keys and Everglades are dominated by tropical trees, such as cocoplum and Jamaican dogwood, living on the northern edge of their ranges. Those species share space with a smaller number of temperate trees from the north, most notably live oak. Unique to South Florida, tropical hardwood hammocks are home to numerous imperiled plant and animal species, including West Indian mahogany and white-crowned

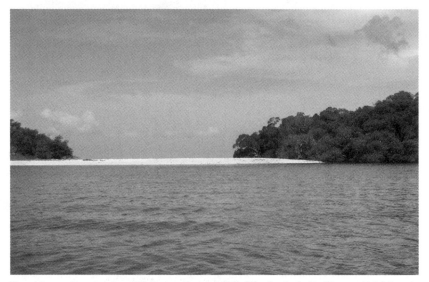

The white sand beach at Jewel Key is one of many isolated beaches in the Ten Thousand Islands. Photo by author.

pigeons. During the summer, though, you'll want to stay very close to the Sandfly Island dock to avoid the mosquitoes and the island's namesake biting sandflies (also known as no-see-ums).

After leaving the island, you can return to the visitor center or extend the trip a couple miles by circumnavigating the island. The route can be confusing, so be alert.

More adventurous souls can also continue beyond Sandfly Island to the end of Sandfly Pass, then cross a short section of the Gulf of Mexico to Jewel Key. The small island has a glimmering sand beach perched where the Ten Thousand Islands meet the open water. It's a wonderful place to swim, lunch, and rest. The Jewel Key paddle is approximately 13 miles round-trip.

A diverse and fantastic inland paddle is the 8-mile-long Turner River trail. Beginning just south of the Tamiami, it heads south through a combination of cypress swamps, lakes, sawgrass prairies, and dense mangrove tunnels. You might have to deal with some harmless spiders in the mangroves. There's also a good chance you'll see one or more alligators. But don't be deterred. They shy quickly away from approaching kayaks. Just use common sense.

Toward the end of the paddle, the river widens as it approaches Chokoloskee. Manatees sometimes occupy this section of the now brackish waterway. A Calusa shell mound sits on the river's left side, shortly before it lets out into Chokoloskee Bay.

It's possible to turn around at many points along the Turner, but if you go all the way to Chokoloskee you'll want to leave a car either on the causeway or at Outdoor Resorts. Local outfitters also will charge a fee to drive you to or from the Turner River put-in.

## Other Western Tamiami Trail Attractions

### Museum of the Everglades

*West Broadway, Everglades City*

Located in the 1920s commercial laundromat that serviced workers constructing the Tamiami Trail, Museum of the Everglades tells the tale of Everglades City and the road project that transformed the town and all of southern Florida. Gaze at a bust of developer Barron Collier

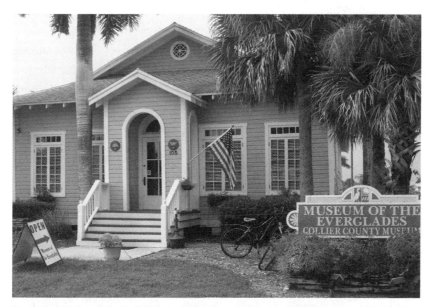

Museum of the Everglades, in Everglades City, is located in the commercial laundromat building that serviced workers constructing the Tamiami Trail in the 1920s. Photo by author.

and learn about his iconic 1923–28 Tamiami Trail project, then watch films about the project and about Everglades City's fascinating pioneer heritage. Open Monday through Friday from 9:00 a.m. to 5:00 p.m. and Saturday from 9:00 a.m. to 4:00 p.m. Entry is free. Information: (239) 695-0008.

### Smallwood Store

*Mamie Street, Chokoloskee*

Once the commercial center of a frontier town, the Smallwood Store on the southern tip of Chokoloskee is now a museum that tells the story of the rugged pioneers who settled this corner of the Everglades more than a century ago. Go inside to see throwbacks to the period, such as medicine bottles, coal-heated clothes irons, and the conch shell that Ted Smallwood blew each time the mailboat arrived on the island. Open 10:00 a.m. to 5:00 p.m. December through April and 11:00 a.m. to 5:00 p.m. May through November. Information: (239) 695-2989.

## Camping and Lodging

Collier-Seminole State Park has 120 RV and tent sites that are convenient to the park's marina and its other amenities. The campsite has bathroom and laundry facilities as well as a small playground and a campfire circle. Upgrades to the bathroom and campsites were slated for summer 2015. Information: (800) 326-3521.

Chokoloskee Island Park and Marina has 44 RV and tent sites. The sites are tightly situated, with little foliage separating them, so don't expect much privacy. But the campground does have a nice location on the Chokoloskee Bay as well its own marina and store. It's also just a three-mile drive from the restaurants and attractions of Everglades City. Information: (239) 695-2414.

Far more isolated camping experiences are available at numerous backcountry locations in the Ten Thousand Islands, including nine within Everglades National Park. The sites can only be reached by

water. Two sites, Crooked Creek and Sweetwater, are composed of platforms elevated over the water, known as chickees.

Jewel Key, which is located near the edge of the Gulf of Mexico, 6.5 miles from the Gulf Coast Visitor Center of Everglades National Park, is a nice beach site that is fairly easy to access. Several sites also sit in the interior of the Ten Thousand Islands, including the Watson Place, a grassy spot where the outlaw Edgar Watson farmed sugar in the early twentieth century. To the north of park waters, campers are allowed to pitch tents on island beaches within the Ten Thousand Islands National Wildlife Refuge and the Rookery Bay National Estuarine Research Reserve. Spots outside park boundaries are accessed first-come, first-served. Permits for sites within the park must be obtained in person at the Gulf Coast Visitor Center no sooner than one day ahead of the trip. Some beach sites have no bathrooms. The park service recommends burying waste at least six inches deep and away from the shoreline.

Collier-Seminole State Park also has a backcountry campsite on its canoe trail and another on its 6.5-mile hiking loop. Information: (239) 394-3397.

Considering its small size, Everglades City has a good selection of hotels and lodges, nearly all of which cater to ecotourists. Prices are reasonable, especially in comparison to nearby Naples. Many of the lodges sit along either the Barron River or Lake Placid, which borders the town to the east.

Everglades City's most famous hotel is the Rod and Gun Club, a classic white wooden edifice that was once owned by Barron Collier, namesake of the Barron River and of Everglades City's Collier County. Its expansive back porch offers broad views of the river. Information: (239) 695-2101.

Those on a budget can stay at the 1928 lodge building of the Ivey House Bed and Breakfast, which has private rooms but shared baths. More modern is the Ivey House Inn, which was built in 2001 and has private bathrooms. Information: (239) 695-3299.

Miller's World, located almost directly across the street from the Everglades Gulf Coast Visitor Center, is part marina, part motel. Lodging

there is in closely situated detached cabins, some of them along the canal that leads from Lake Placid into Chokoloskee Bay. Information: (239) 695-2082.

River Wilderness, along Lake Placid near the entrance to town, rents one- and two-bedroom suites with screened porches that overlook Lake Placid. Canoes are free for guests. Information: (239) 695-4499.

# 6

## The Big Cypress and the Eastern Tamiami Trail

The 58 miles of the Tamiami Trail that divide Everglades City from Miami-Dade County's agricultural district are home to a federal preserve, an Indian reservation, and a national park, but very few people.

Heading east from State Road 29, the first 36 miles of the route pass through the Big Cypress National Preserve. An expansive, swampy ecosystem that feeds freshwater into the Fakahatchee Strand and the Ten Thousand Islands of Everglades National Park, the Big Cypress protects 10 endangered or threatened animal species, including the Florida panther, and offers a wide array of recreational opportunities.

A handful of interesting, privately owned waypoints also sit along this central portion of the Tamiami. Among them are the smallest post office in the United States and a gallery owned by Florida's most acclaimed landscape photographer, Clyde Butcher.

Beyond the preserve sits the eastern Tamiami Trail. Most of those 22 miles pass through a landscape manipulated by the broad L-29 canal to the trail's north and, beyond the canal, the L-29 levee that climbs skyward enough to block the view of the adjacent marshland. Still, there are fun things to do on the eastern Tamiami. The Miccosukee Indian reservation is here. So are numerous airboat concessions, which offer exciting trips onto Shark River Slough and into the northeastern section of Everglades National Park.

For many, the highlight of eastern Tamiami Trail will be the park's Shark Valley section. It is home to one of South Florida's most popular

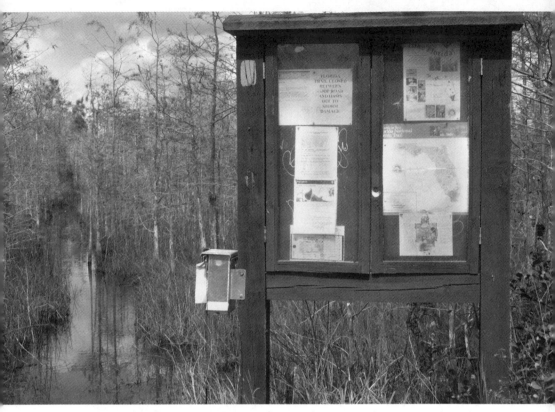

A soggy pathway in Big Cypress National Preserve marks the beginning of the 1,400-mile-long Florida Trail. By permission of Dan Campbell, Key Largo, Florida.

bicycling routes and offers a close look at the largest freshwater passageway in the famed River of Grass.

Undoubtedly, though, the Big Cypress offers the most intrigue on the central and eastern Tamiami. Its 729,000 acres encompass distinct habitats of hardwood hammock, pineland, sawgrass prairie, mangrove shoreline, and, of course, cypress swamp. Even better, unlike Everglades National Park, the Big Cypress remains a mostly healthy ecosystem, largely unscathed by the water diversion canals and agricultural fields that have left its larger National Park Service neighbor parched and burdened by fertilizer pollution.

Why the Big Cypress has avoided that fate is mainly a matter of geology and geography. Though it looks largely similar to the Everglades

proper, the Big Cypress is actually divided from the River of Grass by a ridge in the earth of just a few feet in height. To the east of that ridge, freshwater historically moved slowly south after flooding the banks of Lake Okeechobee during the summer wet season. To the west, in the Big Cypress, the swamp is directly dependent on the approximately 60 inches of rainfall it receives during an average year.

The Big Cypress's location—farther away than Everglades National Park from Miami and too far east to have been significantly impacted by Naples or Fort Myers—also saved it from the damage wrought by large-scale agriculture and development, including the associated flood protection systems.

Nevertheless, the Big Cypress only barely made it out of the twentieth century intact. Intensive logging operations during the 1940s and '50s decimated its old growth cypress trees, many of which had been standing for hundreds of years or longer. From 1944 to 1956 the area's primary logger, the Lee Tidewater Company, shipped 360 million board feet of cypress from the swamp.

An even bigger threat to the Big Cypress materialized in 1968, when Miami's Dade County broke ground on one runway and announced plans to build a massive international airport, complete with five more runways, along the eastern edge of the basin. Certain that the project would lead to an enormous development boom in the surrounding watershed, a cross section of conservationists, Native Americans, hunters, and others united in an effort to block it.

Among the airport's chief opponents was Nathaniel Reed, an adviser to then Florida Gov. Claude Kirk who would soon be appointed an assistant secretary in Richard Nixon's Department of the Interior. Persuaded by Reed and other influential voices, Nixon announced his support for federal purchase of the Big Cypress in 1971. Three years later, this southern Florida treasure joined the Big Thicket forest in southeast Texas in becoming the first national preserves in the United States.

The new designation was a compromise, conceived in order to keep the diverse coalition that fought against the airport together. Under the Big Cypress's status as a preserve, activities that would typically be

forbidden in a national park have been allowed to continue. Among them are hunting, off-road vehicle riding, and even oil exploration.

As of 2014, active oil production was underway on a total of 50 acres in the eastern and northwestern portions of the preserve, producing approximately a million barrels of oil annually. Off-road vehicle trekking, though it is controversial and leaves destructive footprints on the swamp, is perhaps the Big Cypress's most popular activity. To reduce the impact, the Park Service restricted ORV usage to a network of 278 miles of trails in 2011. Another 148 miles of trails are also planned, but their opening was delayed due to a legal challenge as of this writing.

Private landholders were also allowed to keep their Big Cypress properties as part of the preserve designation. There are more than 300 such inholders within preserve boundaries. Notably, one of them is Miami-Dade County, which completed its single runway in 1970 and now uses the would-be international airport site for pilot training.

Airports, oil platforms, and everything else aside, most visitors to the 1,140 square miles of Big Cypress won't notice a ruckus. Alligators and wading birds are far more widespread than man's imprint in this vast wilderness.

## Top Big Cypress–vicinity Eco-destinations

### Scenic Drives

Thanks to its network of more than 40 miles of scenic roads, visitors to the Big Cypress swamp don't have to get wet to see the backcountry.

Two circular routes, one called Loop Road, the other called the Turner River, Upper Wagonwheel, and Birdon Road Loop, make up these drives.

The better of the two is Loop Road, a 27-mile detour off the Tamiami Trail that has its termini four miles west of the Oasis Visitor Center at a place called Monroe Station and 16 miles to the east of Oasis, on the westerly edge of the Miccosukee Indian reservation. Only the eastern seven miles of Loop Road are paved, while the remainder of it is gravel and dirt.

The mysterious beauty of Big Cypress National Preserve is on full display at Sweetwater Strand along Loop Road. By permission of Dan Campbell, Key Largo, Florida.

The road owes its existence to James Franklin Jaudon, whose Chevelier Corporation constructed eastern portions of the Tamiami Trail. Jaudon intended to route the trail along what is now Loop Road, in Monroe County, where he would build a city named Pinecrest. He broke ground in 1921 but ran out of money two years later. The now-legendary Barron Collier eventually took over the Tamiami Trail project, shifting the route north to its current configuration so that it would run instead through the new Collier County that he had cajoled the Florida Legislature into creating. The paved section of Loop Road now reaches slightly beyond what once was the small town of Pinecrest.

Allow at least 75 minutes for the drive, but take more time if you are able. The lightly trafficked route runs past hardwood hammock, pinelands, and sawgrass prairies. Mainly, though, it passes through

strands of cypress. Numerous culvert crossings along the road offer beautiful views into the mysterious world of the swamp. Drive slowly at the culverts so you can look to the sides for lounging alligators and wading birds on the hunt. In spring, when the swamp is at its driest, gators sometimes line up 20 in a row. If you see something at a culvert crossing, or even if you don't, pull over for a better view. You can stop just about anywhere along Loop Road.

Arguably the route's most spectacular point is Sweetwater Strand, five miles from the Monroe Station entrance. In fact, if you don't have time to drive all of Loop Road, it's still more than worth it to make the round-trip to Sweetwater. A striking, almost movie-perfect example of a swamp, Sweetwater features large cypress trees that are heavily covered by ferns, air plants, and other bromeliads. Wading birds typically fish between knotted cypress roots while hawks like to lurk in the tree branches. It's a great place to take a picnic lunch or for quiet contemplation.

The Turner River, Upper Wagonwheel, and Birdon Road Loop runs for 16.4 miles on the north side of the Tamiami Trail, near the western edge of the preserve. Enter the loop either on Turner River Road, four miles east of the Big Cypress Welcome Center, or on Birdon Road, 0.7 miles east of the welcome center.

The route traverses roads of gravel and mud that were constructed to facilitate logging in the 1950s. Look for birds, alligators, and fish in the borrow pits that parallel the road.

The drive's highlight is the three miles that make up Upper Wagonwheel Road. An expansive sawgrass prairie dotted with islands of cabbage palm sits on both sides of the road. Look for birds standing idly in the roadway, and scan the prairie for white-tailed deer.

An alternative to completing the entire route is to cut west off of Birdon Road to Lower Wagonwheel Road. Lower Wagonwheel continues on for less than three miles, until it hits Highway 29 on the preserve's western boundary. The road is bordered to the north by an attractive cypress swamp. Stop along the way and poke through the willow and other foliage for a better view.

## Hiking the Big Cypress

Like other places in southern Florida, no dramatic mountains or sheer climbs beckon to hikers in the Big Cypress Preserve. But with every one of its 729,000 acres available to foot traffic, the preserve can still be a great place to hike, particularly if you are willing to get wet.

The Big Cypress is a dynamic ecosystem, where a foot of change in elevation can turn wet ground to dry ground and transform habitats. No matter when you hike here, expect to see the landscape evolve from shaded stands of cypress to open prairies and from pine tree-covered rocklands to dense forests of hardwoods, where temperate trees such as oaks and maples live side-by-side with tropical trees like cocoplum and Jamaican dogwood.

Brilliant isolation is often a reward for hiking just a couple miles into the Big Cypress backcountry. Wildlife sightings are also a common occurrence. Hawks and wading birds roam the skies. White-tailed deer run through the prairies. River otters fish the clear freshwater of the cypress domes. Threatened or endangered species in the Big Cypress include the Florida panther, the Everglades mink, and red-cockaded woodpeckers, which need healthy slash pine forests to survive. Among Big Cypress's plant life are 36 orchid species.

Unlike Everglades National Park to its east and south, Big Cypress Preserve is largely unaffected by southern Florida's network of water diversion canals. As a result, the preserve is wetter and more ecologically healthy than its more famous neighbor. Don't expect much dry ground between June and October. And though much of the landscape is dry between March and early May, it's still a good idea to be prepared for mud, and maybe a little water, on hiking trips throughout the year. Long pants are also a smart bet, as trails are often overgrown in spots.

As in the rest of southern Florida, be wary of thunderstorms on summer afternoons and go armed with bug spray for hiking in the Big Cypress. There's a very good chance you won't need it during the dry season. Even in the summer, bugs sometimes stay away from the more exposed areas, such as sawgrass prairies, around midday. But the

The Fire Prairie Trail offers some of the driest hiking in Big Cypress National Preserve. By permission of Steve Gibbs, Key Largo, Florida.

mosquitoes can also be brutal, especially near hammocks and other areas where the foliage is dense.

Big Cypress Preserve maintains three primary marked hiking trails, where no motorized vehicles are allowed. In addition, some 426 miles of off-road vehicle backcountry trails are open to hikers. Go during the week to take advantage of these trails without lots of mechanized competition.

If you're looking for a route that is likely to be dry, even in the wet summer months, try the Fire Prairie Trail. The entrance sits in a remote spot, 14 miles off the Tamiami Trail, on the lightly traveled Turner River Road. The trail runs for 2.6 miles each way along an elevated pathway that was built for oil exploration. The first quarter of the trail goes through a dense cypress swamp. It then opens into an expansive sawgrass prairie dotted with appealing islands of cabbage palm. The path ends abruptly at the old oil platform. Keep your eyes peeled for deer in the prairie as well as a variety of wading birds during the wet months.

To get the full experience of hiking in the Big Cypress though, you need to get at least a little wet. Otherwise, it would be like hiking in the Rockies without climbing a hill.

If the thought of slogging worries you, it shouldn't. The swamps and the prairies of the Big Cypress are clear down to the limestone or muddy bottoms and the water is usually warm. Alligators, of course, live in swampy habitats, but you should be safe if you practice common sense. Don't walk anywhere in which you can't see to the bottom and be careful if you walk through ditches along roads and paths.

The preserve's most famous hiking route is its 40-mile section of the Florida Trail. The 1,400-mile trail winds its way all the way to Pensacola, but it begins off Loop Road in the south part of the Big Cypress, 13 miles from the Oasis Visitor Center.

The section of the route that heads north from Oasis is the most accessible hiking trail in the preserve and can be jammed on winter weekends, in part because it tends to be dry at that time of year. Head across the Tamiami to the southern portion of Florida Trail, however, and you'll find a different experience. The ground is wetter and the crowds are thinner, especially once you make it to Roberts Lake Strand a couple miles in. You can also enter the trail from Loop Road.

Experienced hikers might also want to chart their own paths in the Big Cypress. With few landmarks, the going can easily be disorienting though, so take a compass and a GPS. Whether you are on an established trail or making your own, the preserve requires everyone who is traveling outside of built facilities to complete a free backcountry permit. Permits can be found at trail heads and online at http://www.nps.gov/bicy/planyourvisit/backcountry-permits.htm. The preserve also suggests that hikers wear bright orange vests during hunting seasons, which run primarily in the fall and spring.

Arguably, the most unique and beautiful hiking in the preserve comes in the form of slogging through cypress swamps. If you catch it right, the interplay of water and sun-splotched shade, combined with the cypress knots, ferns, and wildlife, can make for a truly meaningful adventure. However, wading into cypress domes and strands can be intimidating for the uninitiated. Look for the ranger-led swamp walks

that the preserve conducts during the busy winter and spring months. Information: (239) 695-4758.

### Clyde Butcher's Big Cypress Gallery

The images of renowned photographer Clyde Butcher have done more to dispel the popular perception of the Everglades as a monotonous landscape than any advocacy campaign ever could.

Shooting only in black and white, his vivid photos of vast prairies, endless moonlit skies, and intricate sun-dabbled cypress swamps have been teaching people for a generation that they'll see the beauty of the Everglades if they only stop to look.

Many of Butcher's famed images are displayed for sale at his Big Cypress Gallery, located in the middle of the Tamiami Trail, a half mile east of Big Cypress Preserve's Oasis Visitor Center. The 13-acre gallery property, on which Butcher lived with his wife Niki during the 1990s and part of the 2000s, also has a short circular path through a picture-perfect cypress swamp, providing even casual motor tourists with an opportunity to experience firsthand the landscape that so inspires Butcher.

The story of why he turned his lens on the swamp in the first place is equal parts heartrending and inspiring. On Father's Day 1986, Butcher's high school–aged son Ted was killed by a drunk driver. Devastated, Butcher began tromping into the wilds of the Big Cypress, day after day, in search of a measure of serenity. Soon thereafter, while suffering through his grief as he manned an art show booth in Ann Arbor, Michigan, Butcher made a life-changing decision. He would throw away all of his color images of popular subjects, such as shorelines and sunsets, in order to focus exclusively on black and white photographs with a soul: photos of the Big Cypress, the Everglades, and the Florida that most people never saw.

The images were an immediate hit. But more than that, the work helped Butcher heal, setting him on the road to being not only a legendary photographer of the Everglades, but one of the ecosystem's lead protagonists.

In addition to his own images, Clyde Butcher's Big Cypress Gallery features works by Niki Butcher and other Florida landscape photographers. The gallery also offers guided swamp walks on weekends between October and March and rents two cottages, one of which used to be the home of Clyde and Niki. Open 10:00 a.m. to 5:00 p.m. daily. Information: (239) 695-2428.

## Other Big Cypress–area Attractions

### Big Cypress Welcome Center
*Tamiami Trail, three miles east of the intersection with State Road 29*

Exhibits and a film, *Rangers*, provide information at this less-frequented of the two Big Cypress visitor centers. Its highlight, though, is the manatees that can sometimes be seen from the small boardwalk out back. Open daily, 9:00 a.m. to 4:30 p.m. Information: (239) 695-4758.

### Ochopee Post Office
*Tamiami Trail, four miles east of intersection with State Road 29*

Occupying a mere 56 square feet, the Ochopee Post Office is the smallest in the United States. In fact, it's barely big enough to fit the one clerk

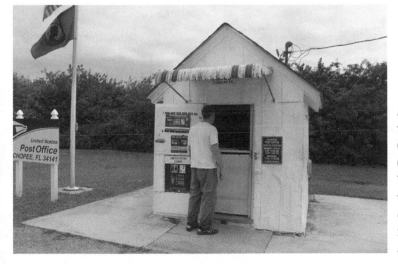

A popular stop for tourists, the Ochopee Post Office along the Tamiami Trail is the smallest post office in the United States. Photo by author.

who regularly mans it. The building was converted from an irrigation shed in 1953 after a fire ravaged the local general store. Buy a postcard or mail a letter to get a coveted Ochopee postmark. Open weekdays from 8:00 a.m. to 10:00 a.m. and 12:00 p.m. to 4 p.m., as well as Saturday mornings from 10:30 a.m. to 11:30 a.m.

## Kirby Storter Boardwalk

*Tamiami Trail, 7.5 miles west of the Oasis Visitor Center*

This 0.5-mile boardwalk provides a high-and-dry taste of the swamp. The path works its way gradually from a sawgrass prairie dotted with bald cypress to a deeper strand of large, mature cypress; then it ends with a lookout over what has the appearance of a pond, but is actually a slow-moving river, called a slough.

Look for turtles, alligators, and plenty of bird life along the way. A covered rest area midway along the boardwalk is a good place to picnic or take cover during one of the Big Cypress's many sudden summer thunderstorms.

## Oasis Visitor Center

*Tamiami Trail, 16 miles west of the Big Cypress boundary and 21 miles east of State Road 29*

Undoubtedly, the most popular feature of this stopping point is the short boardwalk that overlooks an often alligator-laden canal. Still, it's worth going inside the visitor center to watch the 25-minute film on the Big Cypress and to get current information on wildlife sightings, prescribed burns, and the condition of various trails. Open daily from 9:00 a.m. to 4:30 p.m. Information: (239) 695-1201.

# Joanie's Blue Crab Cafe

Since 1987, Joanie Griffin has been serving southern lunches with an Everglades flair out of a one-time cattle barn along the Tamiami Trail, four miles east of the turn-off to Everglades City.

Step inside the 1930s-era red wooden Joanie's Blue Crab Cafe building, with its wrap-around porch, and you'll quickly learn that the casual look is more than just motif. Beer is self-serve out of ice-filled coolers on the floor. Wooden support beams are covered with local memorabilia as well as postcards from around the world. Meanwhile, a message above the cash register reminds customers that they aren't in Naples or Miami anymore.

"If you want fast food, keep traveling 42 miles west or 66 miles east," it reads.

Those who have the patience to sit for a meal on country time will do well to order the Joanie's special: fresh crab cakes packed with 95 percent blue crab meat. Other offerings include gator salad and frog legs. (239) 695-2682.

No one is in a hurry at Joanie's Blue Crab Cafe on the Tamiami Trail. Photo by author.

## East Tamiami Trail Attractions

### Miccosukee Village

On the western edge of Miami-Dade County, population 3 million, sits the Miccosukee Indian reservation, population 640. But despite their tiny numbers, the Miccosukee have managed to maintain a distinct identity.

You can learn about that identity, and about the tribe's history, at the Miccosukee Village, located on the Tamiami Trail, 19 miles west of the trail's intersection with Krome Avenue.

The village has the look of a roadside tourist trap. But it shouldn't be quickly dismissed. Demonstrations of traditional Miccosukee handicraft techniques like dressmaking and woodcarving are conducted by tribe members, for whom the practice is still very much a part of their lifestyle. Indeed, the Miccosukee proudly maintain their traditions and independence. The reservation has its own court system and police force, while its school teaches the native Mikasuki language.

Though it lacks artifacts, a highlight of the village is its museum of Miccosukee history. Today's tribespeople are descendants of the Creek Indians of Georgia, and more recently, of the approximately 100 proud Mikasuki speakers who chose to retreat deep into the Everglades during the Second Seminole War of 1835 to 1842 rather than accept relocation to reservations in Oklahoma.

Those Indians lived quietly off the Glades for approximately 100 years, transporting themselves via rivers and sloughs and residing in open-ended, thatch-roof dwellings called chickees.

That lifestyle declined with the completion of the Tamiami Trail in 1928 and with the drainage of sizable portions of the swamps that the Indians depended on. In response, many Miccosukee moved their villages to the highway's edge, where they could make a living selling crafts and other products to passing tourists.

During the 1950s, the Miccosukee turned their attention to receiving official recognition as a tribe from the United States government, but negotiations with federal authorities were difficult. The tide turned in

1959, however, after a delegation of Miccosukee embarrassed American authorities by traveling to Cuba, where Fidel Castro recognized them. The Miccosukee received formal American recognition in 1962.

The history museum at the Miccosukee Village tells stories like these and more, and also plays two short films about the tribe's culture.

The village also offers alligator shows and airboat rides and sells hand-made crafts. At its restaurant, be sure to try the traditional frybread or Indian tacos. Open 9:00 a.m. to 5:00 p.m. daily. Information: (305) 552-8365.

## Shark Valley

Tourists and South Florida locals alike mainly descend on Shark Valley to traverse its 15-mile bicycle path and to see alligators and wading birds. But the northernmost entrance to Everglades National Park also provides a close-up look at the broad sawgrass river that is the very heart of this, the world's most famous wetland.

Located less than a mile east of the Miccosukee Village, the Shark Valley bike trail cuts a circle around a section of the Shark River Slough. To the untrained eye, the slough looks similar to the sawgrass prairies that can be seen elsewhere in the park and the Big Cypress Preserve. But looks can be deceiving.

The Shark River Slough is actually a shallow trough in the earth, about three feet deeper than its surrounds, that is essentially a broad, slow-moving river. Historically, the slough cut a 50-mile swath through South Florida, conveying freshwater from Lake Okeechobee to the estuaries on the southwest edge of the Florida peninsula. When Marjory Stoneman Douglas dubbed the Everglades the "River of Grass," she was mainly referring to the Shark River Slough.

Today, the slough is only a shadow of its former self, carved up and dried out by urban expansion, sugar fields, and South Florida's 2,000 miles of levees and canals that were built for flood protection. It is now just 25 miles wide and only begins on the south edge of the Tamiami Trail. To the north of the trail, water management has replaced the natural flow and much of the water is siphoned off or dumped through

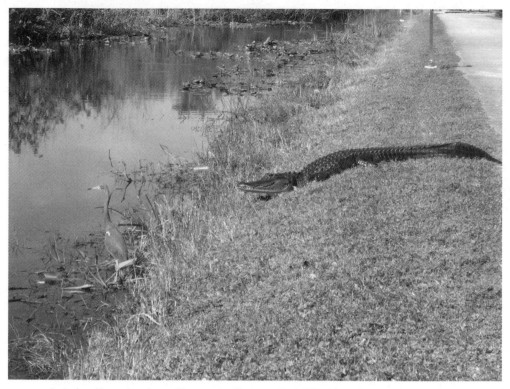

A tricolored heron is undeterred by a nearby alligator at Shark Valley in Everglades National Park. Photo by author.

canals out to sea before it even reaches Everglades National Park. In fact, average annual water flow into the park is now only about 40 percent of its historic, predrainage level. Getting more water into Shark River Slough so it can flow through the national park is a primary goal of Everglades restoration.

Even in its distressed state, however, Shark River Slough serves as a peaceful backdrop to Shark Valley and a home to lots of wildlife. Visitors to Shark Valley are likely to see many alligators during the dry winter months, when they congregate in the narrow canals off the paved bike path. Dozens of bird species regularly visit Shark Valley as well, often hunting undeterred on the canal bank even as alligators are just feet away.

For those who don't want to bicycle, guided tram trips traverse the 15-mile Shark Valley pathway, leaving from the visitor center hourly during the busy late December through April season. Visitors can also walk portions of the pathway or take two short side trails. The Bobcat Boardwalk ventures into a small tree island, called a bayhead, that juts out of the slough. The Otter Cave Hammock Trail goes through a hardwood hammock. Look down at the solution holes as you walk, both for footing and because of their intricate appearance.

For many, the highlight of Shark Valley is the observation tower that stands at the end of the loop, seven miles from the visitor center. From its highest viewing point, 45 feet up, it's possible to see 18 miles over the slough on clear days.

Tram reservations are recommended during the busy winter and spring season. Visitors can bring their own bicycles or rent on-site.

Visitors head toward an Everglades tree island on the Bobcat Boardwalk at Shark Valley. Photo by author.

The Shark Valley entrance does not provide access to other portions of Everglades National Park. Gates are open 8:30 a.m. to 6:00 p.m. daily. Visit www.sharkvalleytramtours.com for more information, or call the visitor center at (305) 221-8776.

### Airboating the Eastern Everglades

Prior to the 1930s and 1940s, transit through the shallow sawgrass rivers of the Everglades was mainly accomplished via dugout canoe. But the popularization of airboats was a game-changer. The flat-bottomed boats, propelled by elevated, caged engines, allowed for much easier access into remote Everglades hunting grounds, as well as to and from the island camps and homesteads of rugged pioneers and Miccosukee and Seminole Indians.

You don't have to be a hunter, however, to experience this unique mode of conveyance. Indeed, airboat tour concessions proliferate along both the east and west sides of the Tamiami Trail. As of 2015, nine operators were providing airboat tours along the eastern trail and a similar number were doing business near Everglades City.

The tours have their detractors. Airboats cut paths through the sawgrass, damaging habitat and impacting wildlife. They are also exceptionally loud. Because of these concerns, airboats are off-limits in most of Everglades National Park. The exception is in the park's northeastern portion, where airboating had become a popular pastime before the National Park Service acquired the land in 1989. No new commercial airboat operations will be allowed to open in that area, but grandfathered operations, including the original Coopertown Airboats, have been allowed to remain.

Even with its downside, airboat tourism has been a boon to the Everglades. Each year, many thousands of people who otherwise would be unlikely to journey any farther into the Florida wilds than the closest beach are introduced via airboat to the importance and beauty of the River of Grass. Airboat guides routinely talk about Everglades ecology as they glide through the marsh.

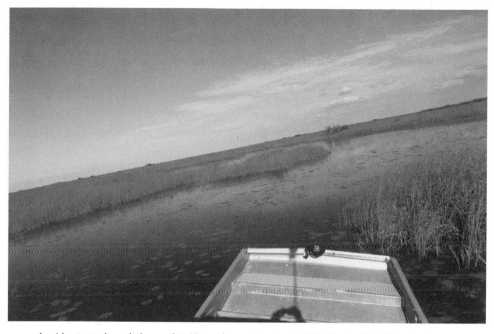

An airboat cuts through the marsh in Miccosukee territory, north of the Tamiami Trail. Photo by author.

Airboat concessions along the eastern Tamiami Trail differ in a few key ways. The concessions that lie closest to Miami are larger than the ones a few miles to the west, inside the Miccosukee reservation. That can be a good thing if you want to couple your airboat experience with an alligator wrestling show. But it also means that unless you pay a premium for a private tour, you will likely ride on a large airboat that can seat two dozen or more people.

Though the airboats operated by the Miccosukee Village proper are also large, the privately owned Miccosukee concessions elsewhere on the reservation tend to use smaller boats, sometimes holding no more than six people. In fact, at some of these operations it's common to take a tour that includes just the people in your party, and without paying extra. Aside from providing better access to the guide, small airboat trips can be more exciting. Think of zooming down the highway in a sports car rather than a bus.

Another differing factor among the airboat trips along the eastern Tamiami is where they go. The concessions outside the reservation sit on the south side of the highway and head into Everglades National Park, where water levels are generally unnaturally low due to the existence of the large L-29 levee on the north side of the trail. Concessions in Miccosukee territory head north from the highway into the Francis S. Taylor Wildlife Management Area, where water levels, buoyed by that same levee, are unnaturally high.

Finally, ask vendors whether their rides include stops, and if so, where. Trips leaving from the Miccosukee side of the trail generally make visits to old Indian camps, adding a certain romanticism to the excursion and providing insight into the Miccosukee lifestyle in the days before the 1928 opening of the Tamiami Trail.

Two eastern Tamiami Trail concessions that use small airboats and stop at a swamp island are Osceola and Osceola Panthers. Osceola, the newest airboat operator on the east trail, uses six-seat boats and stops at the ancestral camp of Buffalo Tiger, who was the Miccosukee's first elected leader after federal recognition came in 1962. Information: (786) 459-5924.

Osceola Panthers runs eight-seat boats and visits a Miccosukee island camp that is more than 100 years old. Information: (305) 220-1377.

### Camping and Lodging

Big Cypress National Preserve operates seven campgrounds that are open to individual preserve visitors, including three in the preserve's remote northwest corner that cater primarily to ORV users.

Three of the other four campgrounds—Midway, Monument Lake, and Burns Lake—sit along the Tamiami Trail. Each features tent and RV sites surrounding a lake.

Midway, located approximately three miles east of the Oasis Visitor Center, is the only one of those sites that is open year-round. It has 26 RV sites and 10 tent sites and is equipped with running water, electric hook-ups, and toilets.

Monument Lake, four miles west of Oasis Visitor Center, is open August 15 to April 15. It also has 26 RV sites and 10 tent sites, as well as drinking water and toilets. Monument Lake does not have electric hook-ups.

Eight miles west of Monument Lake, the Burns Lake Campground has 15 combination RV/tent sites. Its operating dates of August 15 to January 26 cater to the Big Cypress hunting season. Toilets are provided, but not water or electric.

The more isolated Mitchell Landing campground is located off Loop Road, seven miles from the road's eastern intersection with the Tamiami Trail. Its 11 combination RV/tent sites are well separated and sit on the edge of a hardwood hammock. Toilets are provided, but not water or electric. Mitchell Landing is open August 15 to April 15.

Reservations are required for all designated campsites in Big Cypress National Preserve. Reserve your site online at www.recreation. gov. Book early for the busy winter months.

A bit more than three miles west of Burns Lake lies the Big Cypress Trail Lake Campground. It's a private inholding within Big Cypress boundaries that has 101 RV and tent sites surrounding three small lakes. The sites are closely situated and not especially pretty, but Trail Lake definitely scores high for novelty. Its office is also billed as the research headquarters for the Skunk Ape, a mythical Bigfoot-like creature that allegedly lurks in the Glades. Information: (239) 695-2275.

For those who really want to rough it, most of the Big Cypress National Preserve is open to backcountry camping. To spend a night off the beaten track, all you need to do is carefully provision yourself, then fill out a permit either online at http://www.nps.gov/bicy/planyourvisit/backcountry-permits.htm or at one of the hiking and ORV trailheads throughout the preserve.

Backcountry camps must not be made within half a mile of any developed area. In addition, backcountry camping is not allowed in the northwesterly Bear Island unit of the park, which is popularly frequented by ORV enthusiasts.

There are few lodging options along the central and eastern Tamiami Trail. One exception is Clyde Butcher's Big Cypress Gallery, where the

famed photographer's former home, as well as another house, is rented out for quiet swamp getaways. Butcher's one-time home, called "The Cottage," has two bedrooms and sits perched against a serene swamp pond. The second unit, called "The Bungalow," is a one-bedroom king suite. It fronts the woods but is a bit less isolated than the Cottage. Information: (239) 695-2428.

The Miccosukee Resort and Casino sits on the eastern edge of the Tamiami, on the corner of Krome Avenue. With its crowds and fast-paced atmosphere, the 302-room complex definitely stands in contrast to its rural surroundings. Still, the resort can be fun for those who like a little action. Don't expect table games like blackjack and craps here. The gambling is mainly limited to slot machines, bingo, and poker. Information: (877) 242-6464.

Other lodging that is accessible to the Big Cypress National Preserve and the eastern Tamiami Trail is farther afield, in Miami, Everglades City, Marco Island, and Naples.

# 7

<br>

# Redland, Homestead, and Biscayne National Park

Lying just west of Miami's sprawl, between the Everglades and the Florida Keys, the communities of Redland and Homestead are South Florida's breadbasket.

They are centered on the 24-mile-long Krome Avenue, which runs past farms and fields into downtown Homestead and ends at U.S. 1, where the 20-mile span of highway between the mainland and the Keys begins.

Nine miles east of downtown Homestead, meanwhile, sits the more traditional eco-attraction of Biscayne National Park. Ninety-five percent covered by water, the 173,000-acre preserve protects coral reefs, isolated islands, mangrove shoreline, and southern Biscayne Bay.

While large swaths of the park are pristine, the agricultural corridor around Krome Avenue offers little in the way of untouched landscapes. Areas to the road's east and west are instead composed mainly of farmers' fields. Estates—modest, grandiose, and rustic—dot the landscape. The farmers cultivate avocados, strawberries, tomatoes, onions, squash, and a wide variety of tropical fruits that are rarely seen elsewhere in the United States. Indeed, the Homestead Chamber of Commerce boasts that nearly half of the winter vegetables consumed in the United States are grown in South Florida.

The Homestead and Redland areas got their start with the coming of Henry Flagler's railroad in 1904. The fields of Redland were originally centered on a narrow ridge between modern-day U.S. 1 to the east of Krome Avenue and Redland Road, approximately a mile to the west

Vendors sell local summer avocados along Krome Avenue in Redland. Photo by author.

of Krome. Beyond Redland Road the landscape dipped several feet, and the resulting seasonal flooding of the Everglades made farming impossible.

Canals, constructed mainly in the early 1960s, were a game-changer for the area. By capturing and sequestering much of the Everglades' south-moving water sheet flow, they opened more acreage to year-round agriculture. Modern-day Redland, fortified by this network of canals, now extends some four miles west of Redland Road.

While the canals made growing possible, they shrunk the Everglades and disrupted its natural rhythms. One of the central challenges of Everglades restoration is to allow more water to flow once again into the southern Everglades while maintaining protections against flooding in Redland and surrounding areas.

That task has become more crucial as agricultural tourism has grown in the Redland-Homestead vicinity. Seizing on that momentum, a group of local businesses and attractions teamed up in 2006 to jointly market themselves as the Historic Redland Tropical Trail. The

Trail consisted of 10 businesses as of 2015, but they are by no means the area's only attractions. Merely by traveling Krome Avenue and the surrounding east and west cross streets you will encounter several "U-Pick" farms and numerous fruit stands. Vendors often park along the roadway, hawking avocados in the summer and tomatoes and straw-berries in the winter and spring. Orchids are another popular product. And any visitor passing through Homestead or Redland should stop at one of the many places that offer tropical fruit milkshakes.

South of Redland, Krome Avenue becomes commercial as it runs into downtown Homestead. The city of 65,000 was decimated in 1992 by Hurricane Andrew. The evidence of that storm is long since gone to all but experienced eyes, but Homestead remains an economically disadvantaged community.

Still, while definitely not a tourist mecca, the city does draw visitors on their way to Everglades National Park and the Keys. Downtown Homestead has a few quaint historic buildings and lodges, as well as several popular Mexican restaurants. In fact, the many Homestead residents of Mexican and Central American origin give the city a feel unlike other parts of Miami-Dade County, where Cuban Americans and individuals from other parts of the Americas are more common. Those interested in experiencing Homestead's Mexican and Central American culture should take a short stroll past the shops on the downtown Washington Avenue corridor, a block east of Krome.

Along the coast, nine miles farther east, the Dante Fascell Visitor Center at Biscayne National Park has a Homestead address, but it and the remainder of the preserve have little else in common with the city's downtown corridor. Biscayne National Park clearly gets less attention than its nearby cousin in the Everglades, in part because it is difficult to access without a private boat. But if you can get there, you won't regret it. The park offers a rich combination of cultural and natural attractions. Meanwhile, its location in the shadow of Miami makes it a vital player in protecting the imperiled reefs, seagrass, marine mammals, and fish of South Florida.

# Homestead's Mexican Restaurants

Homestead is ground zero for good Mexican food in South Florida.

Several Mexican restaurants in or near the city's downtown go about their business the right way, making their own chips, tortillas, and tostados and using locally grown produce, especially avocados, when they are in season. Prices, meanwhile, are generally only a fraction of those you will find at many less authentic Mexican kitchens.

The following are among Homestead's best Mexican options:

- Taqueria Morelia—Try the red enchiladas, a specialty of this restaurant's namesake city of Morelia in Michoacan state, where owner Ramiro Ramirez grew up. The restaurant also features a bar with a choice of a dozen salsas and condiments. Be careful though: some of the sauces will set your mouth ablaze. Don't be scared off by Taqueria Morelia's location in a building that it shares with a service station. 64 W Palm Drive, one mile east of Krome Avenue.

- El Toro Taco—The Hernandez family has been serving tacos, enchiladas, tostados, and much more at this downtown Homestead restaurant since 1975. Try the guacamole, made during the summer months from the Hernandezes' own avocado grove. 1 S Krome Avenue.

- Casita Tejas—Also in the heart of Homestead's town center, this restaurant has been serving a combination of Tex-Mex and more traditional Mexican fare since 1987. Try the flautas, corn tortillas that are rolled with shredded meat and cheese and then quick-fried to enhance the crispiness. 27 N Krome Avenue.

- La Quebradita—Toward the northern edge of downtown Homestead, this popular restaurant has a homier interior than most of its local competitors as well as a nice

outdoor patio. In addition to classic Mexican offerings such as chicken mole poblano, La Quebradita serves several seafood dishes, including a whole fried red snapper, called guachinango in Spanish. 702 N Krome Avenue.

Specializing in seafood, La Quebradita is one of several excellent Mexican restaurants in Homestead. Photo by author.

## Top Eco-destinations

### Biscayne National Park

Perhaps more than anywhere else, this 300-square-mile marine park captures South Florida's ever-present tension between development and conservation.

From the center of the park, on Biscayne Bay, it's possible to experience a wonderful sense of isolation. Stare in the correct direction and all that's visible is the water, the outline of mangrove islands, and perhaps a passing pleasure craft. Look in another direction, however, and you realize that you're not so isolated at all. On the horizon sits downtown Miami, which lies barely a handful of miles from the northern park boundary. Turn your head to the southwest and there sits the Turkey Point nuclear power plant.

Biscayne National Park is indeed a place of contrasts, and not just because of how sharply it divides the natural world from the urban one. Its four distinct ecosystems comprise ocean and bay, mainland and island. Though it is 95 percent covered by water, the park boasts southeast Florida's longest stretch of mainland mangrove shoreline. It also contains nearly 50 coral rock islands and is home to the northernmost end of the Florida Keys reef tract. More than 600 species of fish have been sighted within Biscayne National Park's waters.

Natural attributes, though, are just one portion of the park's appeal. In common parlance, the Florida Keys extend from Key Largo to Key West, covering the islands that were first connected in 1912 by Henry Flagler's railway and are now joined by the Overseas Highway. But geographically the Keys extend through Biscayne National Park, and even farther north, to Virginia Key just off Miami.

These northern islands of the Keys boast 10,000 years of human history. The Tequesta tribe of Indians lived on them. According to lore, so did the notorious eighteenth-century pirate Black Caesar. The park's Caesar Creek now sports his name.

In more modern times, islands in the park became an early and mid-twentieth-century playground for the rich and famous. Presidents

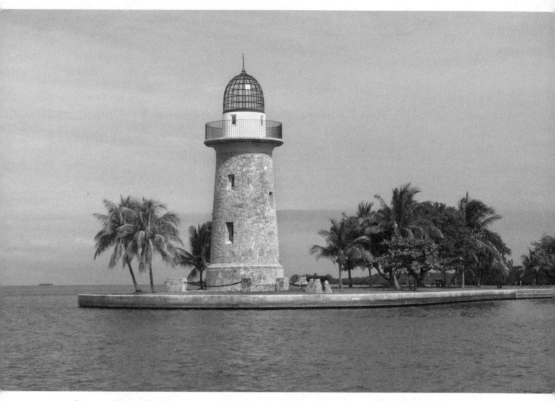

Biscayne National Park's most recognizable landmark, the 65-foot Boca Chita lighthouse, offers a stunning panorama of downtown Miami and Miami Beach, Biscayne Bay, and the Atlantic Ocean. Photo by author.

Harding, Hoover, Johnson, and Nixon all vacationed on Adams Key. The park's most famous structure, the Boca Chita lighthouse, was built in the 1930s by water heating mogul Mark Honeywell.

The same warm sunshine, clear waters, and easy proximity to Miami that drew the likes of presidents and business moguls to the south Biscayne Bay islands inevitably began to draw developers. By the early 1960s, building plans were rampant. A group of landholders on Elliott Key, now the largest island in the park, incorporated as Islandia and began lobbying for a causeway that would fuel a new resort community. Other proposals included a jetport dredged out of the south bay, and along its shoreline, a petrochemical plant and an industrial seaport.

In response, conservationists banded together with the goal of having southern Biscayne Bay set aside as a rare marine national park. The fight was headed by Lloyd Miller, a Pan American Airlines employee who was the leader of the local Izaak Walton League. Many others would eventually join the battle.

One of many poignant moments in what would turn out to be a nearly decade-long struggle occurred when a bay advocate named Lane Guthrie convinced local officials to join him at a then-existing power plant along the bay so he could show them how reckless plant owner Florida Power and Light was being with the environment. Guthrie dyed a bunch of peanuts orange, flushed them down the plant's toilet, then took the officials out to the bay, where the peanuts surfaced. He used the event as the catalyst to produce bumper stickers that read, "Nuts to Dirty Industry."

By early 1968, park advocates were on the cusp of victory. Nevertheless, property owners on Elliott Key struck one more blow. In February of that year they bulldozed the footprint of a six-lane highway down the middle of the island. Narrower, but still visible today, the would-be road is now a hiking trail called the "Spite Highway."

President Johnson inaugurated Biscayne National Monument in October of 1968. The preserve was expanded and designated as a national park in 1980. Today, approximately 500,000 people visit it annually, though many don't even realize they've motored across the watery boundary into a federal preserve.

Sadly, for those who don't own boats, access to Biscayne National Park was difficult during the several years that preceded publication of this book. At the time of writing, the park service didn't offer any ferry services or tours onto the bay, to the park's reefs, or to its islands from its Dante Fascell Visitor Center outside Homestead. Park staff said the goal was to resume such services in 2016, though a further delay was possible. In the absence of an official park concessionaire, several Miami-based touring outfits were the only commercial enterprises permitted to take customers into the park. Call (305) 230-7275 for a list of permit holders.

If you do find your way into its confines, Biscayne National Park offers a diverse list of stopping points and recreational opportunities.

## Stiltsville

Located in the far northern edge of the park, the seven wooden houses that make up Stiltsville are what remains of a once vibrant and unregulated community of homes and nightclubs that rose about a mile off Key Biscayne during the 1930s. The homes sit elevated over the bay on wooden beams or concrete pilings. They're fun to look at, but you're not allowed to dock at them. To stay in the homes, apply for a usage request at http://www.stiltsvilletrust.org.

## Boca Chita Key

The park's most popular stopping point, this 32-acre island is also arguably its most beautiful spot. Boca Chita is dominated by its 65-foot ornamental lighthouse, built by former island owner Mark Honeywell. The lighthouse is opened intermittently, mainly on winter and early spring weekends. From the top, the stunning panorama includes downtown Miami and Miami Beach, Biscayne Bay and its islands, and the Atlantic. Boca Chita also has an expansive picnic and camping ground and a short half-mile walking trail. Mosquitoes aren't always present, but come prepared.

## Elliott Key

This 7-mile-long island is the largest in the park. Formerly occupied by pioneer families who farmed pineapples, Elliott Key now offers a swimming area, bayfront picnicking, a campground, fishing, and hiking. The quarter-mile boardwalk along the narrow island's Atlantic shore is a fun place to look for sea beans that wash ashore from many parts of the world. It is forbidden to remove native beans from the park, but those that come from elsewhere are fair game. Do your homework before you go.

Even the trash on Elliot Key's oceanside, which unfortunately also washes ashore, can be interesting. In fact, it is so diverse that home-

The quarter-mile boardwalk along the Atlantic side of Elliott Key affords great views and is a fun place to look for sea beans that wash ashore from many parts of the world. Photo by author.

steaders used to treat it like a supply store, pioneer woman Charlotte Arpis Niedhauk wrote in "Charlotte's Story," her memoir of life on Elliott Key during the Great Depression.

The 7-mile Spite Highway hiking trail has grown in from the 60-foot-width cleared by Islandia landowners in 1968 to 10 feet today. It cuts a straight path through the hardwood hammock on the center of the island. Steer clear in the summer unless you really like mosquitoes.

## *Dante Fascell Visitor Center*

Biscayne National Park's only facility on the mainland has a small interpretive center and art gallery, a theater that shows films about the park, picnic tables, a jetty for fishing, and a nice porch overlooking the water. Open daily from 9:00 a.m. to 5:00 p.m. To get there, take SW 328th Street east from U.S. 1 until you get to the end of the road, approximately five miles.

## Paddling

The lagoon and narrow creeks that surround Totten Key, Old Rhodes Key, and the several smaller islands on the southern edge of Biscayne Bay offer remote and beautiful paddling with little to no competition from boats. The clear tidal creeks are outstanding for viewing snapper, barracuda, snook, nurse sharks, and other marine life. The highlight of any southern Biscayne Bay paddle is the approximately mile-long Jones Lagoon, where roseate spoonbills nest, magnificent frigatebirds cruise the skies, sea turtles pass through, and upside-down jellyfish cover the bottom.

## Diving and Snorkeling

Biscayne National Park is dotted with precisely 5,429 patch reefs, according to park literature, as well as the northern edge of the Florida Keys reef tract, making it a prime location for divers and snorkelers alike. The reefs benefit from their relative remoteness from the popular Upper Keys dive operations, and crowds are further thinned because operators have difficulty getting a commercial permit to operate on them. Beginning in 2016, a new Marine Reserve Zone will protect 37 percent of the park's reef tract from fishing.

One of Biscayne National Park's most prominent dive sites is Long Reef, to the east of Elliott Key and within the new Marine Reserve Zone. Dives there range in depth from 20 to 60 feet. Alongside Long Reef is the *Mandalay*, a 128-foot schooner that ran aground in 1966. The boat sits in just 10 feet of water, making it desirable for snorkelers as well as divers.

The *Mandalay* is one of six wrecks on Biscayne National Park's Maritime Heritage Trail. The Fowey Rock lighthouse, in the northeast portion of the park, is the seventh site on the trail.

# Lionfish Invasion

It was only in 2009 that the first lionfish was spotted off the Florida Keys. But the venomous native of the Indian Ocean and the southern Pacific Ocean has since emerged as one of the biggest threats to the local marine environment.

Prodigious breeders with enormous appetites, lionfish overwhelm native Florida reef fish, which aren't evolutionarily adapted to fend them off. All told, lionfish consume more than 50 types of fish, competing directly for food with important native species, such as grouper and snapper. Making matters worse, they have no predators in their adopted Atlantic habitat—save for humans, that is.

Aware of the peril the lionfish pose to diversity along the reef, governments and conservationists are fighting back. Florida's fish and wildlife agency, called the FWC, and the Florida Keys National Marine Sanctuary

*(continued)*

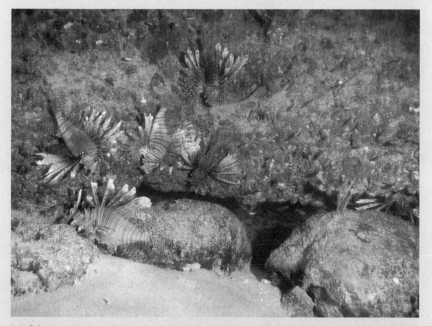

Lionfish, an invasive species that is native to the southern Pacific and Indian Oceans, can be found throughout the Keys, including in remote Riley's Hump near the Dry Tortugas. These images were taken several hundred feet underwater by a remotely operated camera. Courtesy of the Florida Keys National Marine Sanctuary.

actively encourage fishermen and divers to catch as many lionfish as they can. The sanctuary has even made lionfish harvesting legal in preserves where no other fishing is allowed.

Meanwhile, the nonprofit Reef Environmental Education Foundation holds lionfish derbies, offers online tutorials on safe handling of the venomous fish, and has worked to promote lionfish as a table food.

So if you see lionfish on a menu, order it. Its white flesh is firm and tasty and every bite you take will help the environment.

## Knaus Berry Farm and Other "U-Pick" Farms

One of the most commonly asked questions about Knaus Berry Farm is, "Why is the line so long?" Well, once you take your first bite of a Knaus sticky bun, black bottom cake, or herb dinner roll, you'll know the answer.

A long line of people wait for their chance to purchase fresh baked goods at Knaus Berry Farm in Redland. Photo by author.

Open since 1959 at its current location, just under two miles east of Krome Avenue on 248th Street, Knaus farm remains a family operation run by the daughters of cofounder Ray Knaus. They're members of a German Baptist religious sect known as the Dunkers and wear traditional attire that the uninitiated often confuse with Amish.

Timing their operations with the winter growing season, the Knaus farm and bakery are open daily except for Sunday from approximately Halloween until mid-April. It's best to go on weekdays, however. On Saturdays, customers are sometimes stacked hundreds deep waiting for traditional, fresh-made baked goods that are certainly among the best available in all of South Florida. Bring cash, since Knaus doesn't accept anything else. Information: (305) 247-0668.

In addition to the bakery, Knaus Berry Farm offers produce from its fields as well as three other Redland staples: tropical fruit milkshakes, U-Pick strawberries, and U-Pick tomatoes.

Other well-established U-Pick farms near the Krome Avenue corridor are Sam and Philly's, 16790 Krome Avenue, and Burr's Berry Farm, 12741 SW 216th Street, five miles east of Krome. Both also sell milkshakes and homemade products such as jams and salsa.

Many less flamboyant produce stands in Redland also offer customers the opportunity to select tomatoes and strawberries directly from the vine. Just get in a car and head along Krome Avenue. If it's winter, a U-Pick farm won't be far away.

## Fruit and Spice Park

You'll find exotic fruits all around the Redland-Homestead area, but no single locale can boast as eclectic a selection as this unique Miami-Dade County park.

Located in the central Redland area, on Redland Road and 248th Street, Fruit and Spice Park grows more than 500 different fruits, vegetables, herbs, nuts, and spices. Best of all, visitors to the park can eat any fruit they see that has fallen to the ground.

Set on 40 acres, the park grows 160 varieties of mangoes alone. It also cultivates more than 50 types of avocado, 75 banana varieties, and

Jackfruit are the largest fruit in the world that grow on trees. Here they grow at Fruit and Spice Park in Redland—one of more than 500 fruit, vegetable, herb, nut, and spice species found in the park. Photo by author.

some 70 species of bamboo. Among the many exotic fruits that Fruit and Spice Park grows are Brazilian Jaboticaba berries, African sausage fruit, which is used primarily for medicinal purposes, and jackfruit, which can weigh 50 pounds or more, making it the largest fruit in the world that grows on trees. Take a photo as you stroll past the jackfruit trees and try one if you can. Their sweet, fleshy insides make for a great afternoon snack.

Many of the trees at Fruit and Spice Park are the legacy of its first superintendent, Mary Calkins Heinlein. The daughter of a pioneering Redland family, Heinlein was one of the chief advocates for the creation of the tropical fruit park, which Dade County purchased in 1944. She served as park superintendent until 1959, often planting trees out of her own nearby nursery.

Today's park visitors can view those trees on a leisurely stroll through the manicured grounds or during hour-long guided tram tours, which

are offered three times daily. If you find a freshly fallen piece of fruit, eat it. Just don't remove any fruit from the property. Miami-Dade County doesn't allow it.

Even visitors who don't have any luck scavenging the ground won't leave Fruit and Spice Park without sampling its offerings. The park lobby features a free tasting station of various in-season fruits. If you're lucky, on a summer day you might even get to try a delicious white sapote, with its taste and texture like vanilla custard.

Fruit and Spice Park is open daily from 9:00 a.m. to 5:00 p.m. Information: (305) 247-5727.

### Schnebly Redland's Winery and Miami Brewing Company

Owners Pete and Denisse Schnebly bill their business as "the most exotic winery in the world." They might be right.

Open since 2005, their Schnebly Redland's Winery, located four miles west of Krome Avenue at 302 SW 217th Ave., produces 10,000 to 12,000 cases of wine per year without using a single grape. Instead, Pete and Denisse make their nectar from tropical fruits grown in the fields of their own produce company, Fresh King, Inc., as well as at other Redland farms.

You've probably never tried wine made from fermented starfruit, coconut, mango, passion fruit or guava. But each is on offer in the Schnebly tasting room. So, sometimes, is a seasonal wine made from the lychee nut.

Schnebly also boasts that it makes the only avocado wine in the world. In fact, there are two avocado wines on the tasting menu, and the vintner is regularly experimenting with different avocado varieties.

The Schnebly palate isn't for every wine aficionado. Flavor profiles differ sharply from most grape-based wines and many tend toward the sweet. But while the southernmost continental U.S. winery definitely takes itself seriously, it's not seeking to position itself alongside a classic Napa operation. Case in point: Schnebly describes its Sweet Avocado wine as "a flavor that reminds you of a sunny day in the Florida Keys."

If beer is more your speed, you might want to stop at Schnebly as

well. In 2012, Pete and Denisse opened the Miami Brewing Company on their 20-acre property. As with the Schnebly wines, their four beers make use of the tropical fruits of the Redland area. Most notably, Big Rod Ale, a blonde, has a heavy taste of coconut.

Miami Brewing Company also makes a brown ale, a wheat ale, and an American IPA. Mango is an important ingredient in Shark Bait, the cleverly named wheat ale.

Visitors to Schnebly can enjoy wine and beer tastings daily. Tours are offered hourly throughout the afternoon on Saturdays and Sundays and include explanations of the wine-making and brewing processes. If the tour makes you thirstier, when you're done you can continue imbibing underneath a tiki hut in the winery's courtyard, surrounded by waterfalls and tropical landscaping.

The winery and brewery are open Monday through Thursday from 10:00 a.m. to 5:00 p.m., Friday and Saturday from 10:00 a.m. to 11:00

Robert Moehling serves a customer at his landmark fruit stand in Homestead, just as he has been doing since 1959. Photo by author.

p.m., and Sunday from 12:00 p.m. to 5:00 p.m. Information: (305) 242-1224.

### Robert Is Here

In 1959, six-year-old Robert Moehling set some cucumbers by the side of the road and held up a sign that read, "Robert Is Here." He's been selling fresh produce on the route into Everglades National Park ever since.

Though his business, located on the corner of Palm Drive (344th Street) and 192nd Avenue, has since become a South Florida landmark, at its core it's still an old-fashioned fruit stand. Moehling grows much of his produce on 60 acres he has pieced together around the Homestead area. Locals and tourists alike descend on the market for strawberries and sweet onions in the winter and mangoes in the summer.

These days, though, this open-air attraction is as well known for its fruit milkshakes as it is for produce. The shakes come in dozens of flavors, including exotic ones like black sapote, sometimes called chocolate pudding fruit. On busy days at Robert Is Here, the milkshake line stretches deep into the parking lot.

Naturally, the exotic fruits that Moehling uses in his milkshakes are also on offer in their naked form. So, if you've never tried sour sop or dragon fruit, just ask about them. If you're lucky, Moehling himself might still be the guy who cuts you a sample.

Robert Is Here is open daily from 8:00 a.m. to 7:00 p.m. It is closed from the day after Labor Day until the first weekend in November. Information: (305) 246-1592.

## Other Redland-Homestead Attractions

### The Bonsai Garden

*14775 SW 232nd Street, 3.5 miles east of Krome Avenue*

Learn about the contemplative horticultural art of bonsai, take in the approximately 30,000 bonsai trees on site, and perhaps even make a

purchase. Founded in 1987, The Bonsai Garden features 30 species of trees and has potted specimens as old as 200 years. They cost as little as $15, but as much as $40,000. Open Monday through Saturday, 9:00 a.m. to 4:30 p.m. Information: (305) 258-0865.

### R. F. Orchids

*28100 SW 182nd Ave., just west of Krome Avenue*

Stop at this lush five-acre nursery to choose among the approximately 1,000 to 2,000 orchid varieties that are on-site at any time. The largest retail orchid vendor in South Florida, R. F. Orchids specializes in the vanda variety of the plant, which is known for its large flowers and bold, bright colors. Free walking tours of R. F. Orchids' private residential garden are offered on Saturdays and Sundays at 11:00 a.m. and 3:00 p.m. Customers are treated to a complimentary cup of limeade mixed with passion fruit. Open Tuesday through Sunday, 9:00 a.m. to 5:00 p.m. Information: (305) 245-4570.

### Coral Castle

*28655 South Dixie Highway, Homestead*

From 1923 to 1951, Edward Leedskalnin single-handedly, and without machinery, carved 1,000 tons of coral rock, refusing to let anyone watch him work. The result was Coral Castle, an engineering wonder that fuels constant speculation about Leedskalnin's methods, including theories that he had supernatural powers. Even if you don't believe in the paranormal, you can marvel at Leedskalnin's two-story stone tower, view his perfectly timed sundial and tour his coral sculpture garden. Open 8:00 a.m. to 6:00 p.m. Sunday through Thursday and 8:00 a.m. to 8:00 p.m. Fridays and Saturdays. Information: (305) 248-6345.

## Everglades Outpost

*35601 SW 192nd Ave., Homestead, on the road to Everglades National Park*

This nonprofit rehabilitates approximately 300 native animals per year, mainly possums and raccoons. But it also serves as a home to confiscated or unwanted exotic species, including a camel, a zebra, a brown bear, and two Bengal and Siberian tiger mixes. See those animals and plenty of alligators and crocodiles as you walk the property, then visit the small indoor museum and snake exhibit. Open Friday through Tuesday, 10:00 a.m. to 6:00 p.m. Information: (305) 247-8000.

## Everglades Alligator Farm

*40351 SW 192nd Ave., Homestead*

This facility houses 2,000 alligators, as well as a sampling of turtles, snakes, crocodiles, and other creatures. Its alligator and snake shows, as well as its airboat rides, might not be popular among ardent conservationists. But the airboat guides do pepper visitors with information about the Everglades, and the rides offer people a real-life experience in a sawgrass marsh. Open daily, 9:00 a.m. to 6:00 p.m. Information: (305) 247-2628.

## Camping and Lodging

In the central Redland area, east of Krome Avenue, Miami Everglades Resort offers 25 tent sites, 22 cabins, and more than 200 RV spaces on a 34-acre property. The RV sites are tightly packed but the tent grounds are more spacious. The resort's many amenities include a swimming pool and hot tub, shuffleboard and volleyball courts, an 18-hole miniature golf course, and horseshoe pits. Information: (305) 233-5300.

Biscayne National Park offers camping on Boca Chita and Elliott Keys. Both islands can only be reached by boat. As of this writing the National Park Service had no concessionaire to ferry campers to the islands, though officials hoped to have one contracted sometime in 2016.

Camping at Boca Chita is in a waterside grassy area. Grills and toilets are provided, but not washroom facilities. Bring your own food and water.

Elliott's main camping area is along the bay. Individuals can use a group campsite along the ocean when it is vacant. Restrooms with sinks and cold water showers are provided. Sites on both islands are rented on a first-come, first-served basis. Camping fees are waived between May 1 and September 1. Call (305) 230-7275 for more information and to find out the current state of getting transportation to the islands.

Hotel Redland in downtown Homestead offers 12 quaint and uniquely appointed rooms in the oldest building in the city center. Five of the rooms access a large communal balcony. Downstairs, the huge wraparound porch is popular with guests during nice weather, while the Whistlestop Bar serves drinks and southern comfort food. The hotel was built in 1904. It was remodeled in 2001. Information: (305) 246-1904.

West of downtown Homestead, Paradise Farms Bed and Breakfast offers four rustic bungalows within the privacy of a working five-acre organic farm. The morning meal is served in front of a natural pool and typically includes fruit grown on-site. Of the four bungalows, only the Guest House has a private bath and air conditioning. The other rooms share communal baths and are equipped with fans. Guests are free to taste the fruit and edible flowers they see growing around them. Information: (305) 248-4181.

Everglades International Hostel, southwest of downtown Homestead on the way to Everglades National Park, offers dormitory-style lodging and two private rooms as well as a funky vibe. The backyard garden is complete with a treehouse, a waterfall, and a fire pit. The hostel also has a communal kitchen. Campers are allowed to pitch a tent in the garden. Information: (305) 248-1122.

U.S. 1, cutting through Homestead and Florida City, also has a variety of chain hotels and motels.

# 8

~~~~~~~~~~~~~~~

Everglades National Park

Spanning 1.5 million acres, Everglades National Park is a place of shallow water and low land, sawgrass and cypress, mangroves and marsh. The Everglades and its surrounds are the only place on earth where alligators and crocodiles cohabit. Sixty-seven threatened or endangered species of plants and animals call the Glades home. Dolphins, manatees, and sharks swim the southern estuaries. Panthers roam the prairies.

These are just some of the reasons that Everglades National Park is an International Biosphere Preserve and a UNESCO World Heritage site. It's also the third-largest national park in the lower 48 states, and with its founding in 1947, became the first to be preserved not for its natural beauty but for its ecological significance.

"Here are no lofty peaks seeking the sky, no mighty glaciers or rushing streams wearing away the uplifted lands," President Harry Truman exclaimed in his December 6, 1947, dedication speech. "Here is land tranquil in its quiet beauty, serving not as the source of water but as the last receiver of it."

Indeed, on first blush Everglades National Park can be underwhelming. Flat prairies of sawgrass are punctuated by small forests of pine and hardwood. Water flows so slowly that it can appear static to the untrained eye. Heat, humidity, and the Everglades' famed mosquitoes sometimes make park visits a test of resolve.

But on closer inspection, the allure of the park emerges. It sometimes comes in subtle ways, like in the reflection of water rippling under a

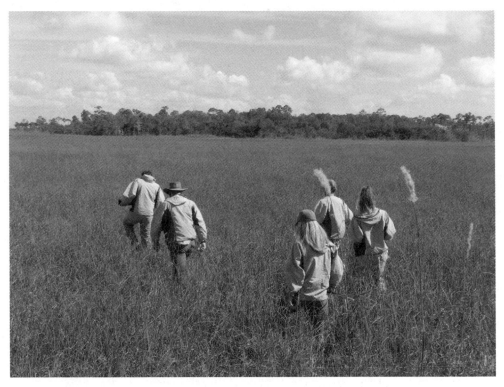

Hikers slog through a freshwater prairie along the Ingraham Highway. Photo by author.

cypress grove. At other times, the appeal is more obvious. More than 350 bird species color the Everglades sky. Almost 300 fish species swim its waters.

Famously dubbed the "River of Grass" by the late author Marjory Stoneman Douglas in her 1947 battle cry for conservation, the Glades once cut a wide swath through central and southern Florida, starting north of Lake Kissimmee near present-day Orlando and running south from Lake Okeechobee to Florida Bay. Efforts to drain the swamp began in the late nineteenth century, and though they never quite succeeded, the growth of cities and farms, as well as the construction of a vast network of canals, dams, and reservoirs, has interrupted the slow-moving north-to-south sheet flow of water that is the lifeblood of the Everglades system. Today, the Everglades are just one-half their

historical size. The portion of the famed wetland that is now Everglades National Park covers only a fifth of the historic Everglades ecosystem.

Efforts to create the national park began in earnest in the 1920s, during the first Florida land boom. They were led by landscape architect Ernest Coe, who in 1928 founded the Tropical Everglades National Park Association. By 1934, Coe and other advocates had won congressional approval of the park. Inauguration had to wait another 13 years while land was acquired.

Still, because the park sits at the bottom of the Everglades drainage basin, it is vulnerable to the damage done in less protected environs to its north. In the years after Everglades National Park was established, it sat helpless as sugar farms south of Lake Okeechobee polluted the water. Meanwhile, canals and dams built by the U.S. Army Corps of Engineers in the 1960s protected South Florida's fast-growing population from floods, but left the park parched.

Improvements are now underway. In 2013 the Corps finished a one-mile bridge along the Tamiami Trail, allowing more water to move south under the highway into the national park. A second bridge, spanning 2.6 miles, has already been funded and groundbreaking is targeted for 2016.

The sheer size of Everglades National Park would surprise many who haven't looked closely at a regional map. It spans much of extreme southern Florida as well as the waters along the peninsula's southern edge. Visitors can access the park via water or at three vehicular entrances. Two of the entrances, accessing park facilities in Everglades City and along the Tamiami Trail, are covered separately in chapters 5 and 6 of this book. The main park entrance, though, and most of its facilities are accessed 10 miles southwest of Homestead, on the park's eastern edge. The entrance is always open and the visitor center, named in honor of the conservationist Coe, is open daily from 8:00 a.m. to 5:00 p.m. during the mid-December to mid-April high season and from 9:00 a.m. to 5:00 p.m. during the remainder of the year.

Everglades National Park can be a fascinating place year-round. Habitats transform with water levels, which rise during the wet summer

Cypress Domes

Jutting out of the sawgrass prairies of Everglades National Park are numerous small, circular clusters of bald cypress trees. Called cypress domes, they are among the park's most exquisite places.

The domes lie within shallow depressions of the prairie, where the limestone bedrock has collapsed into solution holes in which water-needy cypress trees are able to flourish. The smallest trees grow on the edge of the domes. The trees grow larger as the land sags toward the middle of the dome, where the highest trees are found.

Crossing the breach from a prairie to a cypress dome can be a powerful sensory experience. The wind, if it is howling, goes quiet, while the yellows of the sun and sawgrass are replaced by the browns of shade and cypress trunks.

The domes support their own community of fish and plant life. Crayfish swim around tree trunks. Carnivorous bladderwort plants ingest insects. Knots of cypress roots jut sharply out of the swampy bottoms.

Perhaps most exciting though are the alligators, which frequently take refuge in the relatively deep water of cypress domes, especially during the

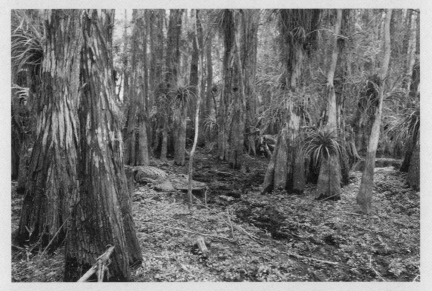

During the months of early spring, even alligators have difficulty finding water in the normally wet cypress domes. By permission of Garl Harrold, www.garlscoastalkayaking.com.

dry season. They even sometimes carve deeper hollows into the dome floor, creating gator holes.

Visiting cypress domes typically requires a slog through mud or water in areas that aren't carved out as trails. Some domes can be difficult to reach and navigate during the wet summer and fall seasons. Everglades National Park runs ranger-led walks into the domes several times a week during the dry season. Sign up at the main Ernest Coe visitor center or call (305) 242-7700. Otherwise, ask a ranger for advice on getting to a dome safely and without adversely impacting the surrounding prairie, or ask for suggestions on a responsible private tour operator.

and lower during the dry winter. Still, the often overpowering heat, humidity, and mosquitoes keep most people away from June through September. Pleasant weather typically returns in November. January through April mark the best time to visit the park, both because of the weather and because wildlife viewing peaks as dry conditions force animals to congregate into the remaining wet spots.

Top Eco-destinations

Anhinga Trail

In theory at least, wildlife sightings are never a guarantee. But visitors are very likely to get more than just a glimpse of many of the Everglades' most famous inhabitants when they walk the Anhinga Trail.

Located four miles from the main Everglades National Park entrance at the Royal Palm Visitor Center, the Anhinga Trail is a three-quarter-mile combination of pavement and boardwalk that winds its way through the sawgrass of Taylor Slough.

A slow-moving shallow river, Taylor Slough is the most important freshwater source for Florida Bay to its south. It is also a critical habitat for wildlife, especially during the winter months when surrounding wetlands go dry.

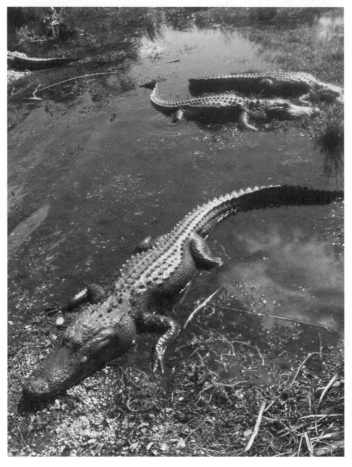

Alligators gather near the Anhinga Trail in Everglades National Park during the dry season. By permission of Garl Harrold, www. garlscoastal kayaking.com.

The portion of Taylor Slough near the Anhinga Trail is especially wet, a result of its having been deepened in 1922 to provide fill for the Old Ingraham Highway, which first connected Homestead to Flamingo. As a result, the boardwalk teems with life. During the winter, alligators can often be spotted by the handful resting on the slough's bank or ambling through the water. Nearby, the trail's namesakes, anhinga birds, dive for fish, then perch in spread-wing posture on the surrounding foliage in order to regulate their body temperatures. Herons, egrets, turtles, and other wildlife are also common sights.

Winter is hatchling season for the birds of the Anhinga Trail. Look for mothers feeding their new progeny in nests just off the path from

January through April. In March and April ready your ears as well for the mating-season bellows of alligators. Their sound is a bit like a lion's roar.

The action at the Anhinga Trail slows down during the summer, when the rain turns the marshes wet again and wildlife fans out to the wider hunting grounds. But even during the wettest months you're more than likely to see a few alligators and a decent amount of birdlife around the boardwalk. Look carefully as well for softshell turtle hatchlings during the summer.

The Anhinga Trail's lone drawback is that it gets quite crowded during prime winter hours. If you can, visit on an off-day to avoid the traffic, or go during the day for the scenery and return with a strong flashlight at night for a quieter, more primal experience.

If you do have to endure the crowds, the Anhinga Trail is still worth the effort. Miami's Florida International University has even labeled it "one of the best places to watch wildlife in the world!"

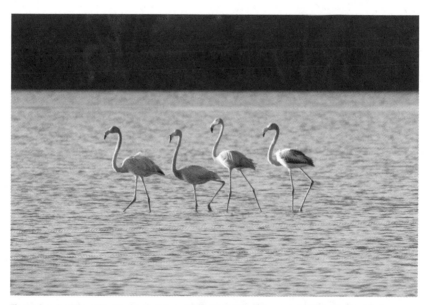

Flamingos don't breed in Florida, but they do like to make an occasional visit to the Everglades settlement named in their honor. Here they prance in the flats near Flamingo. By permission of Garl Harrold, www.garlscoastalkayaking.com.

Call (305) 242-7700 to learn about ranger-led activities at the Anhinga Trail, including a starlight walk.

Flamingo

Set along the northern shoreline of Florida Bay, Flamingo is the end of the road in Everglades National Park.

In the winter, it's an ecotourist's paradise, with weather that is ideal for kayaking, hiking, fishing, camping, or a simple picnic with a view. But in summer, the blazing sun and Flamingo's multitude of mosquitoes, horseflies, and sandflies discourage most from making the 38-mile trek from the Everglades National Park entrance, giving the area the feel of an outpost.

That's exactly what the original Flamingo, 4½ miles west of the modern version, was from the late 1800s until the creation of the park in 1947. During those years, residents of the small village mainly made their living fishing, farming, and providing charcoal to Key West. For a time in the early 1900s they also profited from hunting wading birds for their plumes, which were all the rage for hats in the northeast's most expensive fashion houses. Game warden Guy Bradley, whose job it was to protect endangered birds from the onslaught, was murdered by a plume hunter in 1905 on Oyster Keys, approximately two miles south of Flamingo. The crime turned Bradley into Florida's first environmental martyr. His body was found adrift the next day near the island that would be named Bradley Key in his honor.

Flamingo's residents were relocated when the park was founded. But modern visitors can still see a few remnants of the old fishing village while hiking the Coastal Prairie Trail. Bradley is honored not only by Bradley Key but also by the half-mile-long Guy Bradley pathway, which connects Flamingo Marina with the campground.

Today, Flamingo offers several amenities, especially during the busy winter months, when its campground fills and day-trippers abound. Year-round motorized boat tours give visitors a taste of either Florida Bay or the backcountry waterways that lie to the north. The full-service marina and store also rents bicycles, kayaks, canoes, houseboats, and

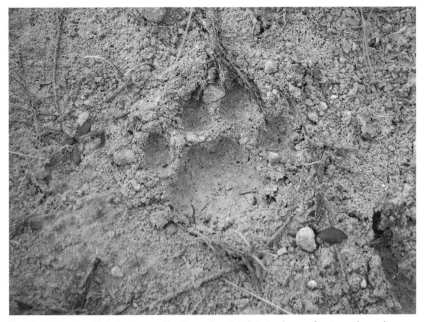

You'll have to get really lucky to see a Florida panther. But their tracks are often in evidence along the pineland trails of Everglades National Park. By permission of Dan Campbell, Key Largo, Florida.

skiffs. The Buttonwood Cafe is open during the dry winter and early spring seasons, as is a visitor center.

Among Flamingo's ranger-led activities are bird walks and informational talks about the federally protected American crocodiles, which are frequently seen within the Flamingo complex.

Call (305) 242-7700 for information about Flamingo or (239) 695-3101 for boat tours and rentals.

Hiking the Park

For a place that is most renowned for its waterborne opportunities, Everglades National Park offers a surprising variety of hiking.

The park's trails can loosely be divided into two categories: inland pineland trails near the main gate and coastal trails near Flamingo. For the most part, the inland trails are more hospitable. The ground there tends to be higher and drier and mosquitoes are less abundant.

The trails near Flamingo, including Christian Point, Snake Bight/ Rowdy Bend, and the Coastal Prairie Trail, are often wet and exceptionally buggy. In the summer they are all but impassable. But if you're the type of hiker who likes a vista as the payoff for making it to the turnaround spot, the Flamingo area trails offer more enticement. The most prominent of them all end along isolated patches of Florida Bay.

With its flat terrain, Everglades hiking isn't as physically grueling as the hikes available in many other national parks. Exceptions to that rule are the slogs over wet ground, where the difficulty level of hiking ramps up. If slogging sounds unappealing, don't write it off without some thought. The water one encounters in the sawgrass prairies that border the pinelands is usually comfortably warm and beautifully clear down to the craggy limestone bottom. In fact, when it's not too deep it's hardly a bother.

Hikers in the park should proceed with a keen eye on the subtleties of the Everglades. Tiny dips in elevation take one from the mahogany and poisonwood trees of the hardwood hammock to the sharp sawgrass of the prairie and from there to serene, though potentially alligator-laden cypress domes. It's also lots of fun to scour the soft marl trails for tracks of the iconic Florida panther. Reclusive and mainly nocturnal, the cats roam the Everglades pinelands but are rarely seen. Look up pictures of panther prints online before you go so that you won't confuse their tracks with those of bobcats, which also reside in the park.

Despite the presence of panthers and alligators, hiking in the Everglades is as safe as just about any other outdoor activity. Neither animal views humans as prey. Exercise common sense and don't walk through water that you can't see clear through to the bottom.

Whichever trail you take in Everglades National Park, long pants are a good idea as the paths can sometimes be overgrown. Also, be sure to take strong bug spray. In the pinelands you'll often find the trail blissfully bereft of bugs, but it's better to err on the side of caution. On the trails closer to Flamingo, expect the mosquitoes to be nearly unbearable in the wet summer months. If you still want to give one of them a try, couple your spray with full mosquito suits. The combination should

Burmese Pythons

It was only in 2000 that scientists declared that Burmese pythons had established themselves as a breeding population in Everglades National Park. Since then, the invasive snake from Southeast Asia has become one of the most immediate concerns to the park's ecosystem.

Reaching as long as 19 feet, pythons have been decimating the small native mammals which share this 1.5 million acres. By 2011, for example, the population of raccoons and opossums in areas of the park where pythons were most numerous had decreased by 99 percent. The snakes will also eat wading birds and even deer and alligators.

Some 150,000 Burmese pythons were thought to live in the Everglades as of 2014. The good news is that they're reclusive and tend to hang out in remote, often nearly inaccessible regions. As such, you're unlikely to encounter one on a trip to the park. Even if you do, pythons almost never attack humans, except in self-defense.

The bad news is that scientists have yet to figure out an effective way to control the python population. Eradication, meanwhile, is viewed as all but impossible.

Still, on the off chance that you do encounter a python on your visit to the Everglades, make sure to contact park authorities so that they can remove it. Call (888) IveGot1.

A Burmese python rests along Everglades National Park's Bear Lake Road. Photo by Josh Gore, Florida Keys Free Press; reproduced by permission of rights holder Cooke Communications.

keep the bites away, though you still might find yourself dealing with the irksome noise of hundreds or even thousands of skeeters buzzing around your head.

There are many hiking routes through the pinelands, as trails criss-cross one another. Some of the trailheads are marked not by signs, but by gates. Ask for the pinelands trail map at the park entrance and inquire with the rangers about which trails are dry.

An especially nice pinelands route is the six-mile circle known as the Pinelands Ecotone. The trail runs north of the Ingraham Highway, beginning at either Gate 9 or Gate 11. The off-road portion will take you 4.6 miles along the transition zone, or ecotone, between a slash pine rockland and a sawgrass prairie. As you walk, notice the intricate formations within the limestone solution holes and keep your eyes out for white-tailed deer. You'll reach the Ingraham Highway after completing a semicircle. Then, depending on which gate you began at, turn right or left toward your car and walk along the usually uncrowded roadway for the final 1.3 miles of the hike.

A nice dry season choice in the Flamingo area is the Snake Bight/Rowdy Bend trail, a 7.6-mile route that cuts through a combination of hardwood hammock and buttonwood-shrouded coastal prairie. The midpoint of the route is a boardwalk that looks on Florida Bay, and more specifically on Snake Bight, a tidal sand flat that is revered by fishermen and is a haven for wading birds. Bring binoculars to look for roseate spoonbills and maybe even flamingos.

For shorter routes, you can walk either the Snake Bight or Rowdy Bend trail there and back. The longer circle route includes a 2.7-mile walk along the Ingraham Highway. Pick up a Flamingo hiking trails map at ranger stations in Flamingo or at the park entrance.

Paddling the Park

Everglades National Park's mix of open water, bays, ponds, and twisting inland creeks makes it a top-flight destination for kayakers, paddle boarders, and canoeists.

Marked trails and ad hoc routes travel through brackish lakes, into narrow mangrove tunnels, and along Florida Bay to the isolated Cape Sable beaches on the southernmost point of the mainland United States.

On coastal routes you might see manatees, stingrays, and even sawfish. Large colonies of wading birds gather on the flats of Florida Bay. Schooling preyfish sometimes burst from the water in response to coordinated attacks from bottlenose dolphin pods. Crocodiles rest on shorelines and also make their way into the brackish and fresh lakes of the Everglades' near interior, where they sometimes mingle with their freshwater cousin, the alligator.

Along with gators and crocs, the inland Everglades paddling trails have many subtle charms. Look for air plants, a type of bromeliad, growing out of the branches of mangroves and other trees. As you pass over shallow bottoms notice the periphyton—a beige, pellet-shaped mixture of algae, bacteria, and other ingredients that makes up the base of the Everglades food chain. Lingering near the periphyton you may see the largest freshwater Everglades snail, the apple snail, which serves as almost the entire diet for the locally endangered snail kite, a bird of prey.

The main section of Everglades National Park, meaning the area accessed through the Homestead entrance, has seven designated paddling put-ins, six of which lie either at Flamingo or directly off the Ingraham Highway. The well-marked highway put-ins include Nine Mile Pond, Noble Hammock, Hells Bay, West Lake, and Coot Bay Pond. The put-in at the Flamingo Marina is the access point for any paddle on Florida Bay. The seventh put-in, providing access to the Bear Lake Canoe trail that cuts through the interior to Cape Sable, is located at the end of the gravelly one-lane Bear Lake Road, two miles from Flamingo. Ask for a paddling brochure at a ranger station.

Kayak and canoe rentals are offered within the park at the Flamingo Marina, (305) 695-3101. Reserve at least a day in advance. Another rental option is Garl's Coastal Kayaking, which has locations in Key Largo and at the Robert Is Here fruit stand in Homestead. You can rent

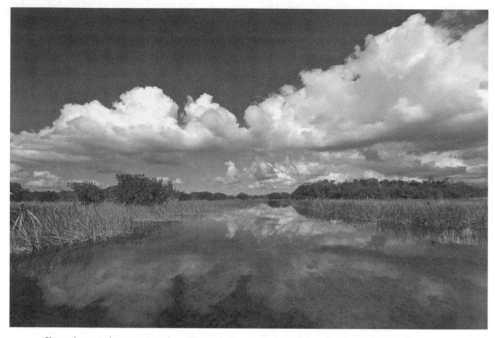

Sky and water almost merge along Nine Mile Pond, a freshwater paddling trail in Everglades National Park. By permission of Garl Harrold, www.garlscoastalkayaking.com.

a rack for transport or Garl's will deliver your canoe, kayak, or paddle board to the put-in. In addition, Garl's offers Everglades paddling tours along with more comprehensive tours of the park. Information: (305) 393-3223.

The top paddling routes in the Everglades vary by the season. During the summer you'll probably want to stay on Florida Bay, where the mosquitoes offer few problems and the breezes make temperatures tolerable. Interior routes are better in the winter, in part because the bug and weather conditions improve, but also because lower water levels concentrate wildlife into the wet areas that remain.

One good place to spot winter wildlife is on the Nine Mile Pond trail. The 5.3-mile paddling route crosses the pond, then makes its way through a maze of tree islands, mangrove-lined creeks, and a shallow sawgrass prairie. It's easy to get lost on the trail, so pay close attention to the 116 directional PVC pipes, each of which is numbered. During the driest months of February, March, and April portions of the trail

might become too shallow for navigation, but you can always pull your boat to deeper water.

Though it is freshwater, Nine Mile Pond and the two little ponds beside it have for many years been home to a large crocodile, who can often be seen along the bank. The pond is also popular with alligators, especially in the winter. Keep your eyes out and remember that alligators have the rounded snouts and crocodiles the more pointed ones. Crocodiles are also lighter in color than alligators.

Just a few miles down the road from Nine Mile Pond is the Hells Bay paddling trail. The trail goes 5.5 miles to the Hells Bay chickee platform, where you can camp if you have a backcountry permit. Closer chickees are located on Pearl Bay and at Lard Can. Before you get to any of these lovely, isolated bays, however, you'll paddle through a labyrinth of grassy marsh and mangrove islands. It's a fun trail, especially if you enjoy a technical challenge. But pay close attention. Some 160 PVC pipes mark the way, and getting lost would surely ruin your day.

Once you do reach the bays, take some time to relax and absorb the solitude. It's even possible to see bottlenose dolphins passing through.

If it's a bay paddle you seek, the choices are more or less unlimited. Just remember that the going can be challenging on windy days. Don't overestimate your strength.

For a short jaunt, head to Bradley Key, approximately a mile from Flamingo. It's one of just four islands in Florida Bay that visitors are allowed to explore. The remaining islands are closed to the public in order to protect nesting birds and other wildlife.

A nice middle-distance route is the round-trip from Flamingo to Snake Bight. Just take a left out of Flamingo Marina and stay close to the shoreline for three to four miles until you reach the Snake Bight flats. Look for dolphin on the way. You'll know you're reaching Snake Bight when you begin to see wading birds feeding on the distant flats. Depending on the tide, the birds might even appear as if they are levitating.

The bight is a hangout for roseate spoonbills, herons, egrets, and, occasionally, migrating flamingos, among other species. Make sure to check the tides before you go so that you don't get caught in the flats as

the water goes out. Also, give the birds a wide berth so as not to disturb them.

Serious paddlers can also take multiday excursions either in Florida Bay, or up the Wilderness Waterway toward Everglades City, using the Park Service's network of nearly 50 backcountry camping sites.

Fishing Florida Bay

Approximately one million visitors each year make their way to Everglades National Park. Many come from far and wide to see the River of Grass of the popular imagination, a place of vast sawgrass prairies, abundant alligators, and unrelenting mosquitoes. But if you ask South Floridians to name their favorite park activity, there is a good chance the answer will be fishing in Florida Bay.

Lying mostly within the boundaries of the national park and separating the Upper Keys from the mainland, Florida Bay is an 850-square-mile estuary that is fed by the north-to-south sheet flow of the Everglades. It never gets more than 10 feet deep and averages just three feet in depth.

For first-time visitors, as well as those who don't fancy sticking a hook through a fish's mouth, Florida Bay is still a breathtaking place to go, even without rod and reel. Stand on the shoreline at Flamingo, or in the Upper Keys, and it looks more or less like an ocean dotted with mangrove islands. But once on the water, there's no mistaking its uniqueness.

The bay is made up of nearly 50 basins that are several feet deep and separated by mud banks that are inches deep, also called flats. Seagrass, which serves as a nursery for shrimp, lobster, game fish, and much more, covers most of the bay bottom. Herons, egrets, roseate spoonbills, and other wading birds, sometimes hundreds or thousands of them, congregate on the flats when the tide is out. With the right timing, motoring through Florida Bay can make you feel like you're caught in a National Geographic film.

The same fish that attract wading birds to the flats also attract anglers. Devoted fishermen visit the Keys and Everglades from around

Anglers go after the "Backcountry Slam" of snook, redfish, and spotted sea trout on the flats of Florida Bay. By permission of Eric Bass, Eric Bass Photography, Layton, Florida.

the world to go after what's known as the "Backcountry Slam": snook, redfish, and spotted sea trout. Just as prized are permit fish, tarpon, and bonefish, a silver, torpedo-shaped fish that is known for its powerful runs once hooked.

The environmentally sensitive will be pleased to know that much of the fishing in Florida Bay is of the catch-and-release variety. For example, it's illegal to take bonefish from Florida waters. Tarpon and permit are rarely eaten. And while snook is revered for its taste, each angler is allowed to take just one a day, and only during six months of the year.

Fishing in Florida Bay without an experienced companion is a tall task for novices. Even serious anglers love to say that it took them years to learn the nuances of where and when to cast a line within this very intricate body of water. Learning to navigate the bay's tidal mud flats and narrow channels is also no simple challenge. Flamingo Marina and

marinas in the Keys rent the flat-bottomed skiffs, also known as flats boats, used by Florida Bay anglers. But you'll get around with greater safety, and almost surely catch more fish, if you charter a guide. Flats guides operate out of Flamingo and throughout the Upper and Middle Keys.

Those who do decide to navigate Florida Bay on their own will be required to obtain a special permit from the National Park Service. Everglades National Park plans to implement the permit program sometime in 2016. Under its auspices, applicants will be required to take an online Florida Bay primer and to pay a fee. At least initially, the permits are expected to be good for one year.

Once on the water, be cautious to avoid tearing up the seagrass with your propeller. The grass takes years to recover and according to the park, Florida Bay is already marred with more than 12,000 such scars. If you do run aground, don't try to motor your way out. Instead, trim your engine and call a ranger for assistance.

After all, it's Florida Bay. The fish are likely to still be there, even if you have to wait a few hours.

Other Everglades National Park Attractions

Nike Missile Tour
Daniel Beard Center

In the wake of the Cuban Missile Crisis, and with the Cold War still raging, the U.S. Army built four South Florida bases to house the cutting edge Nike Hercules anti-aircraft missiles. The best preserved of those bases lies 160 miles from the Cuban coast, within Everglades National Park. Fortunately, no missiles ever had to be launched from the 22-building installation, which operated from 1964 to 1979. Nevertheless, the base's very presence within a national park serves as an unnerving reminder of an era that's not so long past.

The National Park Service offers daily ranger-guided tours of the base from December through April. Highlights of the tour include a restored Nike Hercules missile and a walk-through of the launch area.

Tours are offered first-come, first-served. Check with the park for the schedule. Information: (305) 242-7700.

Pahayokee Overlook

Off the Ingraham Highway, 13 miles from the main park entrance

This boardwalk of less than a fifth of a mile is manageable for practically anyone. The end of the boardwalk features an elevated platform with an expansive vista of Shark River Slough, a wide, marshy river that is both the main source of freshwater into the park and the Everglades' largest tributary to the estuaries of extreme Southwest Florida and the Gulf of Mexico. The boardwalk also passes a dwarf cypress grove, where wading birds often wait in-hunt for small fish.

Mahogany Hammock Trail

Ingraham Highway, 20 miles from the main park entrance

This half-mile-long elevated boardwalk circles its way through a hardwood hammock. Along the way it passes a wide variety of flora, including gumbo limbos, which are nicknamed "tourist trees" for the red, peeling skin of their bark. The highlight of the trail is the largest living mahogany tree in the Unites States. It stands 90 feet tall and has a circumference of 12 feet.

Camping

There is no lodging within Everglades National Park, but there is plenty of camping.

Long Pine Key campground, seven miles from the park entrance, has 108 sites for tents and RVs and is open from late November through March. The campground has restrooms and water, but no showers or electrical hook-ups. It sits alongside a small pond, and close to the network of pinelands hiking trails. Campsites are rented first-come, first-served. Reservations are not accepted.

The more popular Flamingo campground is open year round. It has

234 drive-up sites and 40 walk-up sites. Nine sites are on the Florida Bay shoreline. The campground has showers. Forty-one RV sites have electrical hook-ups. Come prepared for mosquitoes, even in the winter. Call (877) 444-6777 for reservations, recommended during the busy December through April season.

Everglades National Park has an extensive network of backcountry campsites, including more than a dozen within Florida Bay, along the park's southwest coastline and within the interior bays on the southerly Flamingo side of the park. Camping sites sit variously on the beach, on ground, and on chickee platforms.

A nice interior campsite is on isolated Hell's Bay. Campers at the three Cape Sable sites enjoy the remote sandy beaches. Always be prepared for mosquitoes and sandflies.

Permits for backcountry sites must be obtained in person at the Flamingo Visitor Center no sooner than one day ahead of a trip. Reservations are not accepted. Some beach sites have no bathrooms. The park service recommends burying waste at least six inches deep and away from the shoreline at sites where bathrooms are not provided.

9

~~~~~~~~~~~~~~~~~~~~~~~

# The Upper Florida Keys

If the Keys are the American Caribbean, then the Upper Keys are the port of entry for the large majority of visitors, who make the trip via automobile from the Florida mainland.

Encompassing 50 miles and six main islands from Key Largo in the northeast to Long Key in the southwest, the Upper Keys offer plenty of what any new Keys visitor is likely to expect. Even from the Overseas Highway, views of the azure waters of the Atlantic and of Florida Bay abound. Sunsets are spectacular, and so are the sunrises for those who can wake up early enough to take a look. As for the vibe, the Upper Keys are unhurried and laid back almost to the extreme. Don't bother worrying about whether slacks are necessary, even in the most high-end restaurants.

Visitors who stay awhile, though, will soon learn that the area offers more diversity, both in its landscape and culture, than at first meets the eye. In the northern reaches of Key Largo, along County Road 905, lie more than 8,000 acres of federally and state protected land, most of it comprising the largest remaining contiguous patch of tropical hardwood hammock in the United States. The hammock contains more than 80 species of trees and is also home to threatened and endangered animals, including the distinctive Schaus swallowtail butterfly and the Key Largo woodrat. In addition, Crocodile Lakes National Wildlife Refuge on North Key Largo shelters the threatened American crocodile.

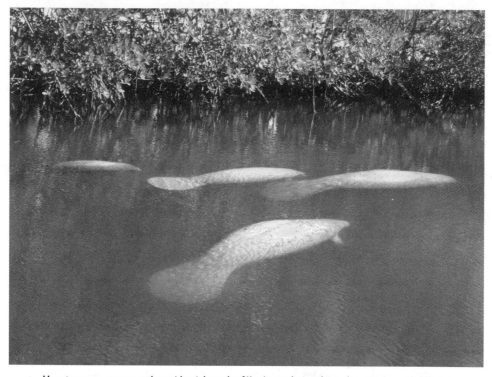

Manatees converge upon the residential canals of Key Largo during the cooler winter months. Photo by author.

Farther south, the hammock gives way to the waters, but even they are exceptionally diverse. The narrow mangrove creeks that are common near shorelines on both side of the Overseas Highway can feel almost otherworldly.

Florida Bay, the shallow 850-square-mile estuary to the west of the Upper Keys, is dominated by seagrass meadows and is a nursery for juvenile fish and crab species as well as a haven for manatees and prized game fish, such as tarpon. The Atlantic Ocean, to the east of the Upper Keys, contains reefs populated by a seemingly limitless barrage of colorful denizens like parrot fish, sergeant majors, and unfortunately, the invasive lionfish. Goliath groupers, commonly called jewfish, and Caribbean reef sharks, are also frequent sights on the reefs.

Beyond the reefs, about six miles off the Upper Keys, the Atlantic plunges quickly to a depth of hundreds of feet and more. Swordfish,

grouper, mahi mahi, and many other species call this area home. A line of undersea mountains, called humps, runs down the Upper Keys about 15 miles offshore and is popular with fishermen.

The communities of the Upper Keys also offer their share of variety. Key Largo, to the north, is as close as one will come in the area to a working-class town. From a tourism standpoint, it caters most notably to the diving crowd. Tavernier, near mile marker 90, is the second-oldest town in the Keys, behind only Key West. Swankier Islamorada is centered on Upper Matecumbe Key and styles itself as "The Sportfishing Capital of the World." It is home to several high-end hotels, a growing collection of ambitious restaurants, and a developing arts scene. On Long Key sits the tiny town of Layton, where the population of less than 200 lives a largely rural lifestyle, surrounded by ocean rather than fields.

## Top Eco-destinations

### Dagny Johnson Key Largo Hammock Botanical State Park

Located in rural North Key Largo, this 2,400-acre park preserves a diverse subtropical forest, is home to 84 protected plant and animal species and offers some of the best hiking in the generally hiking-light Florida Keys. It also pays tribute to an Upper Keys environmental legend.

Dagny Johnson was the leader of the Upper Keys Citizens Association, which fought successfully through the 1970s, '80s, and '90s to block development of neighborhoods throughout North Key Largo. One of those neighborhoods, located on County Road 905, a half mile north of the Overseas Highway, was to be a 2,800-home community called Port Bougainville. Developers had begun constructing roadways, parking lots, bridges, and buildings by the time Johnson's efforts led the state to acquire Port Bougainville for parkland in 1982.

Much of that land has since been restored, but visitors today can still see footprints of the neighborhood that never was while hiking or bicycling the two miles of trails off the main park entrance. Naturalists

Cyclists cruise amid the trees at Dagny Johnson Key Largo Hammock Botanical State Park. The park also has several miles of unpaved biking trails. By permission of Josh Gore, Key Largo, Florida.

will want to look for wild cotton and mahogany mistletoe, among numerous other unique plant species. They'll also enjoy seeking out the park's champion spicewood, white ironwood, Bahama strongbark, and milkbark trees. Meanwhile, crocodiles can sometimes be found in canals dug out for neighborhood construction.

If you want to travel a bit farther afield, Dagny Johnson park also has a backcountry area about eight miles north of the main entrance, at power pole 94 on County Road 905. Beyond a barricade informing people that entry is allowed only by permit lies six miles of old County Road 905.

It's a nice bicycling locale that passes beneath the ever-encroaching hammock and features a few interesting sights. To the left near the head of the trail you'll see an old gatehouse and parking lot that were once part of the Cold War–era Nike Missile base. Permits for the trail are free, but must be picked up at the John Pennekamp Coral Reef State Park office about 15 miles south.

# Alabama Jack's

If you like places that are a little funky, maybe a little junky, and more than a little bit fun, then detour off U.S. 1 onto Card Sound Road to visit this relic of Old Florida.

Open since 1947, Alabama Jack's is an open-air restaurant and bar that floats on two barges in what was once the fishing village of Card Sound. These days there's little left of the village, which sits halfway between Homestead and the Keys, save for Alabama Jack's, that is. In fact, the restaurant bills itself as Downtown Card Sound.

Go there for the traditional Saturday or Sunday afternoon dancing and you'll know why. A combination of leather-clad bikers, western outfitted Homestead country folk, tourists, and even a few residents of the posh Ocean Reef Club in nearby North Key Largo pack the bar. Old ladies hike up their skirts. Young men cheer. And they all tap their feet to live country music. (305) 248-8741.

Alabama Jack's is at its best on Sunday afternoons. Old ladies hike up their skirts. Young men cheer. And everybody taps their feet to live country music. Photo by author.

Always carry mosquito repellent throughout Dagny Johnson park during the wet summer and fall months. The park is open every day from sunup to sundown. Information: (305) 451-1202.

### John Pennekamp Coral Reef State Park

Each year, nearly a million visitors enter the gates of John Pennekamp Coral Reef State Park at mile marker 102.6 in Key Largo, mainly to explore its spectacular undersea environment.

They owe the privilege, in large part, to the advocacy of the park's namesake, longtime *Miami Herald* editor John Pennekamp. In the late 1950s, with merchants removing corals and conch from the reefs at an alarming rate, Pennekamp helped spearhead an urgent push to protect the Upper Keys marine environment. Using his bully pulpit at the *Herald*, he was instrumental in getting then-governor Leroy Collins to sign off on the preserve.

When it opened in 1963, Pennekamp became the first undersea park in the United States.

Paddlers and boaters will enjoy wending through the mangrove labyrinth in the park's nearshore waters, but unless you just want a short jaunt, you're better off renting kayaks elsewhere and bringing them into the launch. Otherwise, you won't be allowed to venture outside an often crowded marked trail.

The reefs, though, are Pennekamp's hallmark. Snorkel, dive, and glass bottom boat trips leave from the visitor center several times a day. Reservations are recommended, as trips often fill up on weekends and holidays. If you're normally a landlubber, try to take your excursion on a calm day, as the seas offshore can be rougher than the novice might expect.

Numerous private concessions also ferry enthusiasts to the popular dive and snorkel spots within and near Pennekamp waters, including the famous nine-foot Christ of the Deep Statue, located just outside the park boundary in the Florida Keys National Marine Sanctuary.

Its emphasis on underwater attractions aside, many Pennekamp visitors choose not to stray more than a few dozen yards from shore.

Instead, they fish, swim off the park's two man-made beaches, visit its small aquarium, and walk any or all of three short nature trails.

During the less buggy times of year, a nice excursion away from the Pennekamp crowds is the half-mile-long Grove Trail. It passes through a pleasantly shaded hardwood hammock and reaches its turnaround point at the last working Key lime grove in Key Largo. The 2.5-acre field, originally planted in the 1940s, also produces guavas, mangoes, and avocados. If you see fallen fruit, feel free to take a sample.

John Pennekamp Coral Reef State Park is open from 8:00 a.m. to sunset daily. Information: (305) 451-6300.

## Windley Key Fossil Reef Geological State Park

Tucked along mile marker 85 of the Overseas Highway, Windley Key Fossil Reef Geological State Park offers a look at Keys history, both human and natural.

The 32-acre park contains 1.5 miles of hiking trails through the hammock. But it is the site's three limestone quarries that are its highlight.

The largest of those, called the Windley Quarry, was purchased by Henry Flagler in 1908. Workers mined the ancient coral rock, also known as keystone, and used it to form the bed of Flagler's Overseas Railroad.

Flagler completed his railway in 1912, but Windley Quarry was used for production of ornamental building keystone until 1968. The state purchased the site in 1985, sparing it from a developer's plan to build condominiums there.

Visitors to Windley Key park get a hands-on lesson in Upper Keys geology as they walk along the quarry walls. The stone started as coral reefs some 100,000 years ago, when sea level was 25 feet higher than today. During the ice age that followed, the sea plummeted, exposing the reefs. Some of those reefs hardened into the coral rock subsurface that now forms much of the Florida Keys.

The rock still carries reminders of its former life. Observant visitors will recognize the patterns of brain coral and star coral in the quarry walls.

Windley Key park is open Friday through Monday from 9:00 a.m. to 5:00 p.m. Guided tours are offered at 10:00 a.m. and 2:00 p.m. from Friday through Sunday. Information: (305) 664-2540.

### Theater of the Sea

When it opened on the site of one of Henry Flagler's Overseas Railroad quarries in 1946, Theater of the Sea became the world's second-ever marine mammal theme park. Today, it's that genre's longest continuously operating park on the planet.

Encompassing 17 acres on Windley Key, at mile marker 84.7, Theater of the Sea offers an array of marine life shows. Children squeal with delight as dolphins tail dance and sea lions balance balls on their noses. There are also parrot shows and opportunities to swim with stingrays or paint with a dolphin, sea lion, or even an alligator.

Some environmentalists will chafe at the dolphin and sea lion shows, with their use of captive animals. Already controversial, marine mammal captivity became an even hotter topic in the wake of the 2013 CNN documentary *Blackfish* about the treatment of SeaWorld whales.

Theater of the Sea is aware of its critics, which could be one reason it preaches a heavy dose of conservation. Guides stress environmental stewardship as they shepherd visitors through the property's exhibits. At last count, 13 endangered Kemp's Ridley, hawksbill, and green sea turtles—all of them rescued because of injuries that rendered them incapable of surviving in the wild—live in the park's seawater pools. One of Theater of the Sea's alligators, meanwhile, was rescued from a Texas bathtub.

The park is open daily from 9:30 a.m. to 3:30 p.m. Allow 2½ hours to see all the shows. Information: (305) 664-2431.

### Florida Keys History of Diving Museum

Located just north of downtown Islamorada in a building that also houses a storage facility, the Florida Keys History of Diving Museum exemplifies the cliché, "Don't judge a book by its cover."

Once inside the mile marker 83 locale, visitors are treated to one of the world's largest collections of diving artifacts, laid out to chronicle mankind's 5,000-year history of undersea exploration. Museum patrons will learn how innovations that emerged from diving have influenced everything from warfare to food collection to medical science.

The museum was the vision of Islamoradan Sally Bauer and her late husband, Joe. Intellectuals by inclination, and diehard dive enthusiasts, the Bauers traveled the globe for 40 years meticulously putting together the collection that in 2006 became the core of the History of Diving Museum.

It features everything from an exhibit about the 4,700-year-old Epic of Gilgamesh text, which contains the first written reference to diving, to an extensive display on the rise of SCUBA technology in the mid-twentieth century, which facilitated diving's ascent as a recreational sport. Another unique museum exhibit is the parade of nations, featuring dive helmets from 45 countries. Those who want to dive deeper into underwater exploration history can visit the dive museum's extensive library and reading room.

For a more frivolous experience, museum visitors can touch a 70-pound silver bar and time how long they can hold their breath.

The Florida Keys History of Diving Museum is open from 10:00 a.m. to 5:00 p.m. daily. Information: (305) 664-9737.

**Indian Key Historic State Park**

From the Overseas Highway just a few hundred yards away, the 9-acre island that makes up Indian Key Historic State Park looks like little more than a pretty spot on the horizon. But despite its diminutive size, Indian Key has a big story to tell.

Strategically located near reef-strewn shipping lanes, for a brief spell in the 1830s the island was the hub of the lucrative Upper Keys ship salvaging industry. Indian Key's nearly exclusive property owner in those days was a wrecker named Jacob Houseman. During his prime, Houseman lorded over everything from the island's hotel to its cisterns. He

Spanish bayonet plants frame the old cisterns on Indian Key Historic State Park off Islamorada's Lower Matecumbe Key. Only 13 acres, the island was the Dade County seat prior to being raided by Seminole Indians in 1840. By permission of Steve Gibbs, Key Largo, Florida.

even managed to convince Florida's legislative council to tap the tiny island as the first Dade County seat.

But Houseman's moment in the sun was brief. His unscrupulous business practices, combined with the 1835 outbreak of the Second Seminole War, took such a toll on Houseman's fortune that he was compelled to mortgage the island to the esteemed botanist Henry Perrine, who was conducting research on tropical plants.

Five years later, in August 1840, Seminole Indians attacked and looted the key, burning all but one of its buildings. Houseman and most of the island's 50 to 70 residents escaped, but an estimated seven people were killed, including Perrine.

Today, visitors to Indian Key stroll through remains of the old town and visit Houseman's grave. A three-story raised platform offers spectacular views of the island and the surrounding turquoise waters. From the shoreline, visitors snorkel the shallow flats or merely take a swim.

Indian Key is only reachable via a brief boat ride or a 15-minute kayak or paddleboard trip from the Tea Table Fill at mile marker 78.5. Boats and kayaks are available for rental at nearby Robbie's Marina, (305) 664-9814. The island is open daily from 8:00 a.m. until sunset. Bring walking shoes and a picnic lunch, and don't be surprised if you have the whole place to yourself. Information: (305) 664-2540.

## Paddling the Upper Keys

With their mysterious mangrove tunnels, ample marine life, and many nearby offshore islands that are easy to explore, the Upper Keys have plenty to please the paddler.

From Islamorada south, flushing from ocean tides imparts a brilliant Caribbean blue-green look to the water. Farther north, on places such as the aptly named Blackwater Sound off central Key Largo, the more nutrient-laden freshwater flowing in from the Everglades gives the water a dark hue.

Unique to the Upper Keys, and especially the Key Largo and Tavernier areas, is the expansive network of offshore islands on the oceanside. Off Key Largo, paddlers will find Rattlesnake Key and El Radabob

# Florida Keys Hurricane Memorial

On Labor Day, 1935, the most powerful hurricane ever recorded in the United States passed across Upper Matecumbe Key and Lower Matecumbe Key of present-day Islamorada, decimating everything in its path.

The Labor Day Hurricane walloped the Matecumbes with sustained winds of 185 miles per hour and a storm surge that swallowed the islands whole. All but one of the 61 buildings that stood before the storm in what is now central Islamorada were destroyed. Henry Flagler's great "miracle," the Overseas Railroad, was ripped from the ground.

At least 406 people, but likely more, died in the Labor Day Hurricane at a time when the permanent Upper Keys population numbered less than 700. Accounting for the majority of the dead were more than 250 World War I veterans who were on temporary assignment in the area working on a bridge project.

Located just east of the Overseas Highway at Mile Marker 81.5, the Florida Keys Hurricane Memorial honors those who perished in the storm. The 18-foot-high coral rock monument was dedicated in 1937. A crypt at the memorial's base houses the remains of many of the Labor Day Hurricane's victims.

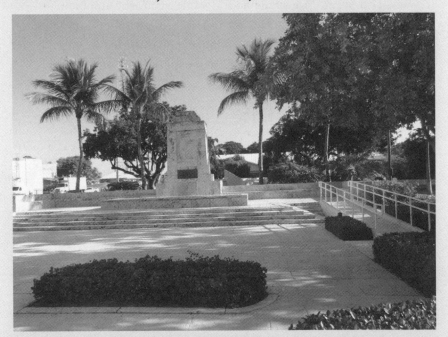

The Florida Keys Hurricane Memorial in central Islamorada honors the more than 400 people who perished in the Labor Day hurricane of 1935. The storm is the strongest to make landfall in the United States since recordkeeping began. Photo by author.

Key, where they can explore beaches and narrow mangrove creeks. Farther south they'll encounter Rodriguez, Dove, and Tavernier Keys.

Islands on the bayside are also popular to explore, especially Lignumvitae Key Botanical State Park off Islamorada and Nest Key, within the boundaries of Everglades National Park, where camping is allowed.

The adventure-minded will find a meandering and sometimes bewildering network of mangrove tunnels and creeks all along the northern oceanside half of Key Largo, including within the boundaries of John Pennekamp Coral Reef State Park. Paddlers who want to mix a little history into their journey can visit Indian Key, then snorkel the nearby *San Pedro* wreck site, which is also managed by the state.

Herons, egrets, and ospreys are common sightings along the mangrove shorelines of the entire Keys. Lucky paddlers might even get a look at a beautiful roseate spoonbill.

Be prepared for spider webs in the mangrove tunnels. But don't let that stop you from training your eyes under the surface in search of snook, snapper, and barracuda, as well as upside-down jellyfish. Shallow seagrass meadows are great habitat for stingrays and nurse sharks. Manatees, too, can occasionally be spotted feasting on the seagrass of Florida Bay. It's even possible to encounter a feeding pod of bottlenose dolphin during open-water paddles.

In Key Largo and Tavernier, free and for-fee put-ins are fairly easy to find on both the ocean and bay sides. Convenient launch sites include:

- Garden Cove, off mile marker 106.5, oceanside
- John Pennekamp Coral Reef State Park, mile marker 102.6, oceanside
- Sunset Park, off mile marker 95.2, bayside
- Harry Harris Park, off Burton Drive, mile marker 92.6, oceanside
- Old Settlers Park, mile marker 92, oceanside

In Islamorada, put-ins can be found along the Tea Table and Indian Key causeway area, mile markers 77.5 through 79.8. Other public put-ins and boat ramps can be found at:

- Plantation Tropical Nature Preserve, mile marker 90.8, bayside
- Founders Park, mile marker 87, bayside
- Whale Harbor, mile marker 83.5, oceanside
- Blackwood Lane, mile marker 81.9, bayside
- Library Beach Park, mile marker 81.5, bayside
- Anne's Beach, mile marker 73.5, oceanside

On Long Key, put-ins are available on the south edge of the Channel Five Bridge, mile marker 70.7, bayside; in Long Key State Park, mile marker 67.4, oceanside; and on the north edge of the Long Key Viaduct, mile marker 66.7, oceanside.

The two largest paddling shops in the Upper Keys are Florida Bay Outfitters, mile marker 104, bayside, and Backcountry Cowboy, mile marker 82.2, bayside. Paddle!, in the Casa Mar plaza, mile marker 90.8, oceanside, caters primarily to paddle boarders, but also has kayaks. Those shops, as well as concessionaires throughout the islands, also rent kayaks and paddleboards.

Two very different, but especially nice, Upper Keys paddles begin at Garden Cove in Key Largo and along the causeway in Islamorada.

The Garden Cove paddle offers many miles of sparsely visited mangrove creeks within Pennekamp Park. From the put-in, paddle either south toward North Sound Creek, or east, around Rattlesnake Key. If you circle the key, you'll get a short open ocean experience and can stop at the small, though unfortunately littered, beach on the island's east side. Whichever direction you go, you'll eventually wind up in North Sound Creek, from where you can explore the numerous narrower mangrove creeks that snake through the mainland and El Radabob Key. Don't be afraid to check out little openings into the mangrove thicket, but also don't hesitate to turn around. Some of the creeks come to a dead end.

From the north edge of the causeway in Islamorada, just south of mile marker 80, an especially fun paddle is to head north-northeast for about a mile to the Horseshoe Key bird rookery, where pelicans, herons, cormorants, and more make their home. From Horseshoe Key, head northwest a mile or so to the back side of Shell Key. A narrow

no-motor zone creek will take you into a lagoon in the middle of the island. It's a great place for lunch or a swim. Once you're properly relaxed, finish circling the island, then head due south, back to the causeway.

## Diving and Snorkeling the Upper Keys

Stretching 220 miles, from Biscayne National Park, north of Key Largo, to the Dry Tortugas, some 70 miles beyond Key West, the Florida Keys Reef Tract is the third-largest barrier reef in the world. But while there is plenty of good diving and snorkeling all the way along the Keys, it is off the Upper Keys where many of the best preserved reefs are found.

Key Largo likes to bill itself as "The Diving Capital of the World," and though residents near Australia's Great Barrier Reef might protest the label as hyperbole, there is little doubt, at least when it comes to the

Goatfish and sergeant majors swim near the engine housing of the *City of Washington* wreck off Key Largo. Best known as the ship whose crew assisted survivors of the USS *Maine* the night it exploded in Havana in 1898, the *City of Washington* sank on Elbow Reef in 1917. Courtesy of the Florida Keys National Marine Sanctuary.

United States, that Key Largo truly is the diving capital. The small town of little more than 10,000 full-time residents boasts more than 20 dive and snorkel shops, which ply the wrecks, barrier reefs, and patch reefs of John Pennekamp Coral Reef State Park, the Florida Keys National Marine Sanctuary, and sometimes Biscayne National Park.

The shops have the luxury of choosing among dozens of reefs and six wrecks for their twice- or three-times daily trips. Wind and current conditions, which influence visibility, play a major role in where the captains head on a particular excursion. For those who wish to visit a specific reef, some shops go to sites on a weekly schedule, depending on the weather.

Islamorada, which has cast its tourist lot more with sportfishing than with snorkeling and diving, has just a handful of dive shops. But there's still plenty to see along the reef ledge off the town's four islands. Islamorada's charters choose among dozens of dive and snorkel locations, many of which are 40 to 60 feet deep, or about twice the depth of most of the reefs that are closer to Key Largo. Greater depth can be a problem when visibility is low, but you're more likely to see the biggest fish, including bull sharks, in such areas.

Some 260 fish species reside along the Florida Keys reefs, as well as 65 stony coral species. Barracuda, the stunning yellowfin damselfish, and the equally interesting wrasse, with its rainbow of colors, are among the most commonly seen fish. Elkhorn and staghorn corals, both of which are federally listed as threatened under the Endangered Species Act, as well as brain corals, are among the more distinctive corals in the Keys.

As in other parts of the world, corals throughout the Keys have struggled in recent decades. Coral cover in the 3,840-square-mile Florida Keys National Marine Sanctuary has declined by nearly half since rigorous monitoring began in 1995, and the decline was already underway as long ago as the late 1970s. Pollution, direct impacts from people visiting the reefs, more extreme water temperatures, ocean acidification brought about by global warming, and the 1980s die-off of the reef grazing long-spined sea urchins have all taken their toll. Seven of the

coral species found in the Florida Keys National Marine Sanctuary are federally protected as threatened.

Still, there is a lot left to see on the reefs off the Upper Keys. Furthermore, some of the local dive shops participate in the Florida Keys National Marine Sanctuary's Blue Star Program, which certifies operators that take special steps to conserve the coral reefs. To see the current participants, check the program's website at http://floridakeys. noaa.gov/onthewater/bluestar.html.

The Upper Keys reefs offer diverse experiences. French Reef, off Key Largo, is known for its many tunnels and caves. The Molasses Reef complex is one of the most visited formations off Key Largo, and for a reason. Comprising a series of reefs divided by sandy chutes—known as spur-and-groove formations—many people believe Molasses is the most spectacular reef in Florida. The reef tract off Islamorada also has lots of spur-and-grooves and significantly less traffic than the most popular Key Largo sites. Meanwhile, the Christ of the Deep statue, two tons of bronze that sits in 25 feet of water about six miles off Key Largo, is especially popular with snorkelers. Eleven reefs off the Upper Keys are designated Florida Keys National Marine Sanctuary Preservation Areas, where fishing, lobstering, and all other marine harvesting are prohibited.

Because of the technical skills required to explore them, the Upper Keys wrecks are mainly a draw for avid divers. The seas off Key Largo sport six often-frequented wrecks, including, most famously, the *Spiegel Grove*. Lying in 135 feet of water, the retired naval vessel is an enormous 510 feet long and 84 feet wide. It was intentionally sunk as an artificial reef in 2002 in a botched effort that left the ship upside-down on the sea floor. Technicians eventually rolled the *Spiegel Grove* over to its starboard side; then, in 2005, the currents of Hurricane Dennis turned it onto its keel, as was originally intended.

Some veteran Upper Keys divers prefer exploring the *Duane*, a 310-foot Coast Guard cutter that sits about a mile south of Molasses Reef. While the *Spiegel Grove* has more nooks and crannies to check out, the *Duane* hosts a more robust community of sea life.

The 269-foot freighter *Eagle* is the primary wreck site for divers departing from Islamorada. The Dutch-made ship was split in two in 1998 by Hurricane Georges.

While wreck diving is not for the newly initiated, beginning divers can get out on the reef with an instructor by enrolling in a one-day Discover SCUBA course. Standard Open Water Certification courses last two to four days. Shop around for prices.

Snorkeling requires no training, although participants should be at least reasonably fit, especially on rougher days.

Among the popular Key Largo dive and snorkel shops are Horizon Divers, Keys Diver, Rainbow Reef, and Sea Dwellers. Farther south, Conch Republic Divers and Key Dives are among the offerings in Tavernier and Islamorada.

Summer, with its warm water and calmer days, is the most popular time to snorkel or dive the Upper Keys. To beat the crowds, go in September or October, while the water remains warm.

### Bicycling the Overseas Heritage Trail

With its year-round warm weather and endless expanse of ocean views, one would think the Florida Keys would be an outstanding place to bicycle. The reality, however, isn't so cut-and-dried.

Bike paths in the Keys often run alongside or very close to the Overseas Highway, meaning that the going can be quite noisy. In addition, significant sections of the highway, including the Seven Mile Bridge, don't have a bike trail at all, so you'll have to ride within just a few feet of the fast-moving vehicles along U.S. 1. Even where there is a trail, the path sometimes crosses the highway.

Despite those drawbacks, every year many bicyclists make the 106.5-mile trek from where the Overseas Highway begins in Key Largo to its termination in Key West. For them and others, the good news is that the Keys bicycling infrastructure is very much on the upswing, mainly due to the ambitious Florida Keys Overseas Heritage Trail project, which the state of Florida commenced in 2000. Plans call for the trail

to eventually run next to the entire Overseas Highway, and to cross 19 historic bridges that were once part of Henry Flagler's "Railroad That Went to Sea."

As of 2014, 78 miles of bicycle and pedestrian trails already existed alongside, but separate from, the highway, and numerous other sections were in the construction or planning stages. Ten more miles were slated to be complete by the end of 2015. In addition, in 2014 the Keys' Monroe County government constructed a 12-mile bicycle lane along the rural County Road 905 in North Key Largo.

Perhaps the prettiest completed section of the Overseas Heritage Trail runs through the Lower Keys, between Lower Sugarloaf Key and Stock Island. The longest stretch of completed trail runs along the entire Upper Keys, from mile marker 106 in Key Largo to mile marker 72, beyond Lower Matecumbe Key and near the northern edge of the towering Channel 5 Bridge. Much of the Upper Keys path, however, is loud and unappealing.

To catch a nice Upper Keys section, start at the unnamed bayside park near mile marker 80, then ride three miles across the Tea Table and Indian Key fills to Robbie's Marina on Lower Matecumbe Key. Continue down Lower Matecumbe to lengthen the trip. In the Middle Keys, an especially nice section of the Overseas Heritage Trail runs along Grassy Key between mile markers 58 and 54. It passes through Curry Hammock State Park and alongside mangroves and Grassy Key's unique rockland hammock habitat.

Off the Overseas Heritage Trail, mid-length bike routes can be found in many spots throughout the Keys. The Old Road, which parallels U.S. 1 through most of Islamorada, offers lightly trafficked routes on Plantation Key, Windley Key, and Upper Matecumbe Key, roughly between mile markers 90 and 81. To do the whole route, however, you'll have to rejoin U.S. 1 to cross the Snake Creek and Whale Harbor bridges. In Marathon, the bike path along Sombrero Beach Road, between the beach and the Overseas Highway, runs for two miles one-way. In the Lower Keys, numerous roads that get minimal traffic offer pleasant bicycling. Try the Middle Torch Key Causeway near mile marker

28, gulfside, or Niles Road on Summerland Key, near mile marker 25, gulfside.

If you like off-road bicycling, the Keys have a smattering of trails, including at Dagny Johnson Key Largo Hammock Botanical State Park and within the National Key Deer Refuge.

## Other Upper Keys Attractions

### African Queen

*Mile marker 100, oceanside, in the Port Largo canal*

Private cruises are offered on the steamboat that starred in the famous 1951 Humphrey Bogart and Katharine Hepburn film of the same name. *African Queen* trips last 1.5 hours and go through Key Largo's main commercial and upscale residential canal. Call (305) 451-8080 to book.

### Coral Restoration Foundation

*Off mile marker 99.2, oceanside, on Seagate Boulevard*

In the first 13 years after it began work to restore endangered corals in 2001, the Coral Restoration Foundation planted approximately 4,000 staghorn corals at more than 200 reef sites in the Upper Keys. At this small science center, visitors can learn about the foundation's coral nurseries, see elkhorn coral samples and read about the threats coral reefs face from climate change and human activities. Open weekdays from 9:00 a.m. to 5:00 p.m. Admission is free. Information: (305) 453-7030.

### Key Largo Fisheries

*Off mile marker 99.2 on Ocean Bay Drive*

This working fish house sells lobster, stone crab, yellowtail snapper, and other seasonal fresh catch, as well as seafood offerings from other regions. At its outdoor cafe you can lunch on the shore of Lake Largo while watching the activity in Key Largo's commercial fishing hub.

Open 10:00 a.m. to 6:00 p.m. Closed Sundays. Information: (800) 432-4358.

### Florida Keys Wild Bird Center

*Mile marker 93.6, bayside*

This rescue and rehabilitation facility takes in an estimated 1,000 birds during a typical year. Most are eventually released, but those that wouldn't be able to survive in the wild are housed permanently at the center's Lara Quinn Wild Bird Sanctuary. Walk the sanctuary's boardwalk to see 19 aviaries housing dozens of bird species. The boardwalk ends at Florida Bay. Wild birds often gather around the boardwalk as well in hopes of grabbing a little food. Open daily from sunrise to sunset. Information: (305) 852-4486.

### Florida Keys History and Discovery Center

*Mile marker 82.1, oceanside*

Go to this museum that opened in 2014 to see permanent exhibits about the history of Keys sportfishing, about the islands' historic Tequesta and Calusa Indian populations, about the wreckers and pirates who used to call the Keys home, and about Florida Bay and the Keys reefs. The museum also displays various rotating exhibits and houses a modern 35-seat movie theater that runs history-related films. Located within the grounds of the Guy Harvey Outpost Islander Resort, Florida Keys History and Discovery Center is open Thursday through Sunday, 10:00 a.m. to 5:00 p.m. Information: (305) 922-2237.

### Lignumvitae Key Botanical State Park

*Mile marker 77.5*

This 280-acre island sits about a mile offshore in Florida Bay and offers something for nature and history lovers alike. The park's main attraction is the 1919 Matheson House, which takes visitors back to the simple but difficult lifestyle of early twentieth-century Keys settlers. Outdoor

Moonlight shines on a black mangrove along the edge of Anne's Beach in Islamorada. By permission of Garl Harrold, www.garlscoastalkayaking.com.

enthusiasts can also see the park's namesake lignum vitae trees, which are renowned for lifespans that are counted in millennia. The park can be reached only by boat. Matheson House tours are offered at 10:00 a.m. and 2:00 p.m., Friday through Sunday. Bring bug spray. Water taxis are provided at Robbie's Marina. Call (305) 664-8070.

### Anne's Beach

*Mile marker 73.5, oceanside*

A narrow spit of sand that all but disappears at high tide, Anne's Beach is nevertheless a pleasant place to take in the view and escape from the hot Islamorada sun. The beach is surrounded by mangroves, which provide numerous semiprivate coves for visitors. It's also part of a Village of Islamorada park that has a well-maintained quarter-mile boardwalk as well as five covered picnic pavilions. The shallows that extend

out from shore are an ideal place to unfold a chair and dangle your feet in the water. Anne's Beach is also a popular launch for kiteboarders. Open daily from sunrise to sunset. Admission is free.

### Long Key State Park

*Mile marker 67.4, oceanside*

This narrow park just south of the town of Layton has an inland paddling trail and is a destination on the Great Florida Birding Trail. Its 1.1-mile Golden Orb walking route is part boardwalk, part trail. The route passes through mangroves and hardwood hammock and along a coastal berm with ocean views. In addition, an observation tower along the boardwalk provides views over Long Key. Swimming, fishing, snorkeling, and camping are other popular activities at the park. Open daily, 8:00 a.m. to sunset. Information: (305) 664-4815.

## Camping and Lodging

Long Key State Park, with its 60 oceanfront campsites, offers the best camping in the Upper Keys. Each site is equipped with a picnic table, ground grill, water, and electric. The campground's only downside is its close proximity to the Overseas Highway. But the ocean breeze and the park's many amenities help make the annoyance fairly minor. Book early, especially if you're traveling during the popular winter and spring months.

In Key Largo, John Pennekamp Coral Reef State Park offers 47 camping and RV sites, also with picnic tables, grills, water, and electric. The sites aren't as ideally situated as those at Long Key, taking up an area slightly off the water that is bordered by hammock. But you won't hear as much traffic at the Pennekamp campground. Campsites at both state parks can be booked online up to 11 months in advance through ReserveAmerica at www.reserveamerica.com, or by calling (800) 326-3521.

Fiesta Key RV Resort is a privately owned camping and RV site at mile marker 70 on the northern tip of Long Key. Occupying the entire

small island, the campground comes with plenty of amenities, including a pool and restaurant. What it doesn't offer is much in the way of seclusion. The 28-acre resort has 300 RV sites to go along with its 60 camping sites and a 20-room hotel. Information: (305) 249-1035.

For a backcountry camping experience, go to North Nest Key, about 6 miles off Key Largo in Florida Bay. The island is accessible only by boat or kayak, and there are no amenities, save for a lone outhouse. But the view is spectacular and there can be lots of sea life. Be prepared for bugs any time of year, but especially from May through October. North Nest Key is within Everglades National Park. Call (239) 695-2945 for a permit either the day of the trip or one day before.

The Upper Keys have a large selection of hotels and motels. Prices tend to be high, especially around Christmas and from February through Easter. Many lodges are on the water and offer small man-made beaches.

An especially popular motel is Island Bay Resort in Tavernier, which earned a top 15 national ranking in Trip Advisor's small-lodge category from 2012 to 2014. Information: (305) 852-4087.

Amy Slate's Amoray Dive Resort in Key Largo offers an affordable combination of rooms and suites. As the name suggests, this lodge on the shore of Florida Bay has its own dive and snorkeling operation and also offers bay ecotours and sunset cruises. A protected saltwater swim area and small beach add to the charm. Information: (305) 451-3595.

For a premium price, Jules' Undersea Lodge in Key Largo offers what are surely the most unique accommodations in the Keys. The world's first underwater hotel, it sits in a sheltered lagoon and can only be accessed by diving to the entrance 21 feet below the surface. Guests of the lodge's two rooms must either be certified divers or take Jules's half-day Discover SCUBA diving course. Rooms feature 42-inch round windows that offer views of surrounding marine life.

Those who are looking for more of a beach getaway will enjoy the much larger Fisher House in Islamorada, which is known for its immodestly named World Famous Tiki Bar. Information: (305) 664-2321.

If you're looking for swank, Cheeca Lodge and Spa in Islamorada offers more than 200 rooms as well as many resort amenities. Information: (305) 664-4651.

The Moorings Village and Spa in Islamorada is a smaller high-end resort. Its 18 cottages sit along a man-made beach dotted with coconut palms.

The Upper Keys also have several national chain hotels and a small selection of budget options.

# 10

~~~~~~~~~~~~~~~~~~~

The Middle Florida Keys
and the Lower Florida Keys

Farther from the crowded mainland than the Upper Keys, and lacking the cachet of Key West, the Middle and Lower Keys are often overlooked. But they have much to offer outdoor-minded tourists.

Stretching from Conch Key at mile marker 63, to the northeast tip of the Seven Mile Bridge, at mile marker 47, the Middle Keys center on Marathon, the Keys' second-largest city. The area's 16-mile sweep of highway crosses seven islands and passes alongside several others, most notably the popular resort community of Duck Key and the upscale island town of Key Colony Beach.

The Lower Keys begin at mile marker 40, beyond the sweeping vistas along the Seven Mile Bridge, and continue for 33 miles until reaching the greater Key West area at Boca Chica Key. Aside from the northern islands of Biscayne National Park, it's the least developed area of the Keys archipelago, and the most consistently spectacular to drive through. More than half of the 42 bridges on the Overseas Highway are in the Lower Keys. They overlook the Atlantic Ocean and the Gulf of Mexico, as well as wide expanses of tidal flats and mangroves. The bridges connect keys with names like Bahia Honda, Torch, Ramrod, Cudjoe, Sugarloaf, Saddlebunch, and Big Coppitt, to name a few.

The Middle Keys are home to a state park, the most popular pedestrian bridge in the Keys, and perhaps the most unique of all of South Florida's wildlife rescue facilities—a turtle hospital. Offshore to

A lemon shark prowls a hard bottom in the shallow waters of the National Key Deer Refuge. By permission of Garl Harrold, www.garlscoastalkayaking.com.

the west, the shallow estuary of Florida Bay gives way to the Gulf of Mexico, while to the east, the Middle Keys reef line is populated by sea turtles, shellfish, and more than 400 fish and coral species.

About six miles off the Middle Keys, the reefs end and the ocean plunges sharply. In the depths, blackfin tuna, swordfish, and amberjack are among the fish that abound. They're especially plentiful 27 miles offshore at the Marathon Hump, a below-the-sea mountain that rises from 1,150 feet of depth to within 480 feet of the ocean's surface.

The lone Lower Keys' state park, on Bahia Honda Key, is known for its picture postcard beach, which has frequently been ranked by magazines as one of the best in the United States.

The Lower Keys have plenty of other public land as well. The National Key Deer Refuge, centered on Big Pine and No Name Keys, protects the diminutive does and stags that give the preserve its name. Sixteen other federally listed plant and animal species also reside in the refuge.

Offshore, the Key Deer and Great White Heron national wildlife refuges run along the gulfside from Bahia Honda to Key West, encompassing the expansive Lower Keys backcountry. A mix of sand bars, wide channels, and remote mangrove islands, the backcountry is an outstanding and uncrowded paddling locale.

The communities of the Middle and Lower Keys each have the informal vibe that is a hallmark of the entire island chain. Marathon is easily the largest of those towns with a city limit that stretches 13 miles and incorporates 13 islands. The town's name is a reference to the long hours worked by the early twentieth-century laborers who constructed the Overseas Railroad.

Marathon is still known today as something of a working-class town, at least by Florida Keys standards. But it's now a resort destination as well, offering plenty of good seafood restaurants and several waterfront hotels. The town has the only community playhouse in the Keys outside of Key West and its Sombrero Beach is thought by many to be the nicest city-run beach on the islands.

Key Colony Beach, which connects to Marathon via a short causeway at mile marker 53.5, is an incorporated island community with a population of fewer than 1,000 people. It's an upscale town that is popular among retirees and part-time Keys residents. Ocean Drive, along the Atlantic, has several resorts and condominiums.

Big Pine Key is the second largest island in the Florida Keys and the most populated island in the Lower Keys. Still, with fewer than 5,000 people, Big Pine has a more rural feel than you'll find in Marathon and the Upper Keys. Thus far, chain businesses have mainly stayed away, and lodging is primarily of the mom and pop variety. Adding to the countrified ambiance are the Key deer, which can often be seen roaming the island's neighborhoods.

Top Eco-destinations

Curry Hammock State Park

This 970-acre park encompasses all or parts of four islands and protects a combination of rockland hammock, seagrass beds, and tidal swamps.

Located at mile marker 56.2, along the Overseas Highway, the main visitor area of Curry Hammock sits on Little Crawl Key. Its white sand beach, relatively rare in the Keys, draws sun worshipers throughout the year. Meanwhile, the park's mainly rock-free shoreline, with its ideal, gradual drop-off into the ocean, is a magnet for kiteboarders from throughout the region. On windy weekend days, their dozens of kites radiate color as they soar silently through the sky.

Curry Hammock was named a state park in 1991, in large part due to the donation of its namesake, Lamar Louise Curry. Born in Key West in 1906, Curry became a much-lauded high school social studies teacher in Miami. A middle school in west Miami-Dade County is also named in her honor.

Along with bathers and kiteboarders, Curry Hammock draws kayakers, walkers, and birdwatchers. Paddling trails within park waters circumnavigate Little Crawl Key, a 1.5-mile jaunt, and stretch south toward Fat Deer Key and the community of Key Colony Beach, making for a five-mile trip. The routes pass through a twisting mangrove creek as well as various lagoons and channels. Take the quarter-mile jaunt from Little Crawl Key to Deer Key for shelling on the low tide and for spotting rays and starfish when the tide is in.

Naturalists are likely to enjoy Curry Hammock's 1.5-mile hiking trail through the rockland hammock, where they'll encounter gumbo limbo, pigeon plum, poisonwood, and numerous other hammock natives. The trees grow somewhat smaller in the rocklands than they do in higher elevation hammock communities, such as the one found in Key Largo's Dagny Johnson state park.

Birders visit Curry Hammock to see a wide variety of species, including the threatened white-crowned pigeon and, during the spring and fall, migratory hawks.

Curry Hammock State Park is open daily from 8:00 a.m. to sunset. Information: (305) 289-2690.

Pigeon Key and the Old Seven Mile Bridge

Now a popular spot for outdoor enthusiasts and history buffs alike, Pigeon Key, south of mile marker 47, was once the living quarters for workers who built the Old Seven Mile Bridge and the southern section of Henry Flagler's Overseas Railroad.

Construction of the 128-mile railroad took seven years, and during trying times the project was derisively referred to by critics as "Flagler's Folly." But when the line reached Key West in 1912 it was hailed as one of the great engineering marvels of its time.

During Pigeon Key's peak in the first decade of the twentieth century, the five-acre island housed 400 railway workers. Eight of the island's buildings are now on the National Register of Historic Places, including the assistant bridge tender's house, which has been converted into a museum housing railroad artifacts and photographs.

Also listed on the National Register of Historic Places, the Old Seven Mile Bridge was used by trains until the Labor Day Hurricane of 1935 destroyed portions of the railroad, spelling the line's doom. The bridge was subsequently transformed for automobile use, serving that purpose until 1982, when it was replaced by the modern Seven Mile Bridge. Now free of motorists, the Old Seven's spectacular water views make it one of the premier pedestrian locales in the entire Keys. Walk the bridge to look out below for dolphins and other sea life.

Until 2013, structural deficiencies threatened the bridge's future as a recreational attraction. But concerted efforts by advocates played a role in convincing state and Keys governments to reinvest in the Old Seven. A $77.5 million refurbishment of the bridge is scheduled to begin during the second half of 2017 and to last until late 2020. It will be closed to pedestrians during construction.

Guided tours of Pigeon Key, as well as ferry service to and from the island, are offered three times each day. When available, the more heart-healthy way to make the 2.2-mile trip from adjacent Knight's Key

is to walk, jog, or bicycle on the Old Seven. However, in 2014 Monroe County closed the short wooden ramp that connects the bridge to Pigeon Key for safety reasons. Like the bridge itself, the ramp is scheduled for repair. However, at the time of this writing it is uncertain whether it will be reopened before the bridge work commences.

Use of the Old Seven is free. Fees are charged for ferry service and, when it is available, for pedestrian entrance to Pigeon Key. The ferry has long launched from the Pigeon Key Foundation Visitors Center on Knight's Key, mile marker 47, just to the northeast of the Old Seven. However, as of this writing the future of the center beyond 2016 is uncertain, as it is slated to be displaced by a new hotel project. The hotel developer promises to help the Pigeon Key Foundation find a suitable new home. Information: (305) 743-5999.

The Turtle Hospital

Florida's seas are home to five federally endangered or threatened turtle species. Fortunately, habitat protection, combined with the institution of a variety of turtle-friendly government regulations, has led to a strong rebound in those populations since the 1980s.

The Turtle Hospital, too, has played at least a small role in that process. Since opening along the Marathon bayside in 1986, this rescue and rehab facility has treated and released to the wild more than 1,500 imperiled sea turtles.

Oddly, the hospital indirectly owes its founding to the mass immigration of Cubans to South Florida in 1980. Over the six months of what came to be known as the Mariel Boatlift, an estimated 125,000 Cubans made the crossing to Florida, many in leaky boats, for the promise of a better future.

The plights of those Cubans brought an Orlando-based Volkswagen repairman named Richie Moretti to Marathon. Moretti's intent was to rescue refugees from the Florida Straits. The federal government said no to that plan, but Moretti had discovered Marathon. He purchased an old motel and six years later began using the motel's saltwater pool to rehab sea turtles. Today, Moretti likes to say that he came to the Keys

The green turtle named Mickey swims in one of the pools at the Turtle Hospital in Marathon. A boat collision left Mickey with shell damage that makes him overly buoyant. The weights on the back of his shell help him dive. Photo by author.

to help people who were drowning, but ended up helping sea turtles instead.

Visitors to the Marathon Turtle Hospital get to see the rehab process in action. Ninety-minute tours teach patrons about Florida's five sea turtles: the green, loggerhead, hawksbill, Kemp's Ridley, and leatherback. Visitors also see the turtle operating room.

The facility's highlights are the numerous turtle pools outside. On an average day the hospital has approximately 40 turtles on-site. About a third of those are permanent residents, whose condition won't allow them to survive the wild. The remaining patients are recovering from ailments such as shell damage caused by boat collisions and flipper amputations made necessary by trap rope entanglements. Discarded plastic bags, which turtles ingest, and fishing line, which also cause entanglements, are additional perils to these popular sea creatures. The most common surgery undertaken by the Turtle Hospital is the

removal of tumors from green turtles afflicted with a deadly virus called Fibropapilloma.

On the tours, visitors have ample time to look at all the turtle pools and to learn the stories of many of the individual turtles. They even help feed the patients.

The Turtle Hospital is located on the corner of 24th Street and U.S. 1 in Marathon. Tours are offered daily, on the hour, from 10:00 a.m. to 4:00 p.m. Information: (305) 743-2552.

Bahia Honda State Park

The Florida Keys aren't typically known for beaches, but don't tell that to regular visitors of Bahia Honda State Park, located at mile marker 37 on the Overseas Highway, a few miles southwest of the Seven Mile Bridge.

Encompassing the entirety of Bahia Honda Key as well as the nearby Little Bahia Honda Island, the park's 2½ miles of oceanfront and gulf-front expanse include three distinct white sand beaches, all highlighted by Bahia Honda's calm turquoise waters. They're regarded by many as the Keys' most beautiful beaches, but humans aren't their only regular visitors. Sand flats just offshore serve as low tide feeding and resting points for numerous shorebirds, including plovers, sanderlings, and ruddy turnstones, with their calico cat–like color pattern.

Beaches, though, are just one diversion at this 139-acre Lower Keys jewel. Fishing, paddling, and especially snorkeling are also popular. In fact, Bahia Honda is considered to be among the top nearshore snorkeling locations in the Keys. Head just a hundred or so yards from the beach and you stand a good chance of seeing tropical fish, lobster, conch, soft corals, and even small coral heads.

Back landside, the park has two walking trails. The 0.6-mile Silver Palm Trail features the largest grove of its namesake native palm species in the United States. Silver palms are named for the color of the underside of their fronds. Along the trail is the national champion silver palm, which stands 29 feet tall.

The Old Bahia Honda Bridge, which formed part of Henry Flagler's Overseas Railroad, makes for an interesting backdrop to the idyllic Calusa Beach at Bahia Honda State Park. By permission of the Florida Department of Environmental Protection.

A second walking trail leads onto the Old Bahia Honda Bridge, which was part of the Henry Flagler railroad until the rail line was destroyed by the great Labor Day Hurricane of 1935. Pedestrians are only allowed to go to where the bridge meets the water. Still, the elevated views, especially at sunrise and sunset, are likely to make you want to stay awhile.

Bahia Honda State Park is open daily from 8:00 a.m. to sunset. Information: (305) 289-2690.

Stargazing in the Florida Keys

You've probably heard of the star constellation known as the Southern Cross. But did you realize that you don't have to go all the way to the Southern Hemisphere to see it?

In fact, one doesn't even have to leave the continental United States to get a look at the constellation that inspired a 1982 Crosby, Stills, and Nash hit. From the Florida Keys, the four stars of the Southern Cross are visible low on the horizon during winter and spring. April and May offer the best viewing, as the constellation rises in the sky during the premidnight hours.

Southern Cross sightings are just one reason that the Keys are a great place to view the cosmos. Year-round warm weather, lots of clear nights, and some of the lowest levels of light pollution on the East Coast also draw amateur and professional astronomers alike. Indeed, rural patches of the Keys are some of the only places on the eastern seaboard where light pollution doesn't prevent one from viewing the outline of the Milky Way galaxy.

Anne's Beach in Islamorada and Bahia Honda State Park are two of the best spots in the Keys to escape the lights and catch the stars. If, like most people, you don't travel with a telescope, see if the Florida Keys Astronomy Club is holding its monthly star viewing during your visit. The events are free, but you need to book ahead.

For more information, visit the club's Facebook page.

National Key Deer Refuge

This 84,000-acre preserve of land and water spreads over a patchwork of 25 islands and is already a working testament to the effectiveness of conservation.

When the refuge was established in 1957, fewer than 50 Key deer, the smallest of all the North American deer species, remained. Today some 600 to 700 deer are estimated to live on Big Pine and No Name Keys, where the refuge is centered. Drive the roads of Big Pine or walk the trails of the refuge and you're likely to see them, grazing in yards or in

A Key deer stops for the camera just outside the National Key Deer Refuge on Big Pine Key. Numbering less than 50 in the late 1950s, an estimated 600 to 700 of the species live in the Lower Keys today.

the forest. Another 100 Key deer, which only grow to a bit more than two feet tall, live on surrounding islands.

There likely would never have been Key deer to begin with if not for the distinct geological differences between the Lower Keys and their island cousins to the northeast. While the Middle and Upper Keys are formed from the fossilized remains of ancient coral reefs, the Lower Keys have sturdier bedrock of oolitic limestone, a product of the islands' long ago lives as exposed sand bars.

Forests of slash pines, called pine rocklands, have emerged out of that Lower Keys bedrock, which unlike the porous Upper Keys limestone, retains rainwater during the dry Keys winter season. The year-round freshwater reserves have also sustained the Key deer, especially on Big Pine and No Name Keys.

Astute visitors to the Key Deer Refuge's main facilities, located on Big Pine Key, will quickly observe that the habitats of the island bear a surprising resemblance to patches of Everglades National Park and other natural portions of the southern Florida mainland. The preserve's two short, designated walking trails traverse through a rockland of pines and thatch palms. Meanwhile, Blue Hole, the most popular attraction in the preserve, is a former quarry that has evolved into the Keys' only freshwater lake.

Alligators, seen on some of the lower keys but on no other parts of the island chain, ply Blue Hole. Anhingas, also a novelty on the island chain, dry their wings in trees along the lake shore. Meanwhile, freshwater fish like bluegill and bass swim beneath the surface. Interestingly, Blue Hole also houses populations of tarpon and other saltwater fish that got caught in the lake during the 2005 storm surge of Hurricane Wilma and have been able to adapt.

While the National Key Deer Refuge doesn't have many marked trails, most of the unpaved fire roads on the preserve are open to hikers and bicyclers. With some creative routing, it is possible to assemble a trek of five miles or longer.

For an ecologically diverse route, try the fire roads on No Name Key, which wander through a combination of pine rockland and hardwood hammock. Trails can get wet throughout the year, so be prepared. Plan to do some slogging if you're hiking or bicycling the Key Deer Refuge during the June through October wet season.

The refuge is open daily from 30 minutes before sunrise to 30 minutes after sunset. Its visitor center is located in the Big Pine Key Plaza, a quarter mile off the Overseas Highway near mile marker 30. The visitor center is open weekdays from 8:00 a.m. to 5:00 p.m. Information: (305) 872-2239.

Paddling the Middle and Lower Keys

Island hopping, mangrove tunneling, and more than 200,000 acres of protected national wildlife refuge waters are among the highlights of paddling in the Middle and Lower Keys.

Pelicans roost on a mangrove island in the backcountry of Great White Heron National Wildlife Refuge. Photo by permission of Steve Gibbs, Key Largo, Florida.

Distinct differences in geography distinguish the paddle routes in the two regions. In the Middle Keys, islands are spaced farther apart than they are elsewhere on the island chain. For Marathon-area paddlers, fewer islands translate to fewer protected routes. Nevertheless, outstanding excursions can be found, especially in and near Curry Hammock State Park, and through Boot Key just east of central Marathon.

Paddling in the Lower Keys is arguably better than anywhere else in the Keys. It is highlighted by the shallow backcountry on the gulfside, most of which is part of either the Key Deer or the Great White Heron refuge.

The Great White Heron National Wildlife Refuge is the larger of the two, encompassing 111,000 acres of water as well as 6,000 acres of

islands. At the time of the refuge's founding in 1938, its namesake bird, which in the United States nests almost exclusively on the Keys and other islands around extreme South Florida, was being wiped out by hunters supplying feathers for the decorative hat industry. Today the refuge is a nesting, feeding, and roosting area for 250 bird species.

You're likely to see more than a few of those species as you paddle through either of the Lower Keys refuges or around the many small islands that lie between the main Florida Keys isles and refuge boundaries. It's even possible to spot key deer swimming between the islands.

Alluring as the backcountry paddling is, it shouldn't be undertaken without a few precautions. Be mindful of the tides and especially the winds, which when blowing from the east can make an outward trip feel easy and turn a return journey into a mighty battle, or worse. In addition, the islands can look the same after a while, so carry a GPS or a compass and a chart. Also be sure to make mental notes of landmarks near the put-in and along your route.

All islands within the Great White Heron National Wildlife Refuge are closed above the mean high tide line. In addition, there are seasonal closures extending 300 feet offshore to protect bird rookeries on some islands. For specifics, refer to the refuge's management plan at http://www.fws.gov/nationalkeydeer/pdfs/Backcountryplan.pdf.

Free and for-fee put-ins are widely available throughout the Middle and Lower Keys. Middle Keys launches include:

- Tom's Harbor Key, mile marker 60.4, gulfside
- Curry Hammock State Park, mile marker 56.2, oceanside
- Oceanfront Park, mile marker 52, oceanside, on 98th Street behind city hall
- Sombrero Beach, off mile marker 50, oceanside, end of Sombrero Beach Road

Lower Keys launches include:

- Bahia Honda State Park, mile marker 36.8, gulfside
- Long Beach Road launches 1 and 2, off mile marker 33, oceanside

- No Name Key launch 1, off mile marker 30, gulfside, eastern edge of No Name Key Bridge
- Summerland Key, off mile marker 24.9, gulfside, end of Niles Road
- Harris Channel launch, mile marker 16, gulfside
- Geiger Key launch, off mile marker 10.8, oceanside, beyond Geiger Key Marina at the end of Geiger Road

Marathon's two standing paddling shops are Keys Kayak, located on the Overseas Highway at 105th Street, oceanside, and Wheels-2-Go!, on the corner of the Overseas Highway and 60th Street. Both shops offer paddleboard and kayak sales along with a limited assortment of accessories. Vendors throughout the Middle and Lower Keys offer kayak and paddleboard rentals as well as guided tours.

For a wonderful paddle near Marathon, head to the Sombrero Beach put-in for the short journey into Boot Key.

The paddle starts in wide Sister Creek but then journeys into a collection of lakes and mangrove tunnels filled with snapper, upside-down jellyfish, and the occasional nurse shark. There are lots of routes within Boot Key, and the going can get confusing, so it's a good idea to ask for a map at a local kayak shop. But if you don't have one, look to the radio towers for guidance.

Relaxing in just one of the three Boot Key lakes would be a morning or afternoon well spent. The island is also an excellent place to spot birds, especially migrating raptors, including falcons and hawks. Just offshore of Boot Key, the tiny islands of West Sister Rock and East Sister Rock are surrounded by hard bottoms that make for fun snorkeling.

One of countless nice Lower Keys paddles departs from the end of Niles Channel Road on Summerland Key, mile marker 24.9. As you exit the put-in ramp, make sure to find a bearing. The beaten up wooden bridge about a quarter mile into the paddle should do the trick.

There are many routes you can take from this launch, with no particular one being the best. Whichever direction you choose, you're sure to do some island hopping, run into a few swimming holes, and, unless you're unlucky, see plenty of bird life.

A fun way to start, however, is to head north for about a half mile, past the bridge and along Wahoo Key. It's shallow here, so make sure the tide is high enough.

Past Wahoo Key you'll see another island straight ahead. Stay to its right; then keep going north for another mile or so to reach a tiny circular key that is home to roosting cormorants.

If you are on the water during a decent blow, make sure to stop on the lee side of islands, both for a rest and for the strong sensory experience of moving suddenly from a turbulent world of choppy seas to an unruffled world of calm and quiet.

Diving and Snorkeling the Middle and Lower Keys

The reefs off Marathon and the Lower Keys don't get as much attention as their cousins in Key Largo. Still, even avid snorkelers and divers will find more than enough options in the Marathon and Big Pine Key vicinities to keep them happy.

More than a dozen dive and snorkel shops service the Middle and Lower Keys. Some of those Marathon shops visit 50 or more dive sites. Others focus on a couple dozen locations. At shops closer to Big Pine Key, the options are more limited. Still, all divers leaving from both Marathon and Big Pine are close to deep water wrecks, as well as federally protected reef preserves, where fishing of all kinds is prohibited.

Marathon sits near the middle of the 220-mile-long Florida Keys Reef Tract. The only living barrier reef in North America, the tract is home to 260 fish species, as well as 65 stony coral species and 55 soft coral species. Boulder star coral and rough cactus coral are among seven federally threatened coral species in the Keys.

As in other parts of the world, corals throughout the Keys have struggled in recent decades. Coral cover in the 3,840-square-mile Florida Keys National Marine Sanctuary has declined by nearly half since rigorous monitoring began in 1995, and the decline was already under way as long ago as the late 1970s. Pollution, direct impacts from people visiting the reefs, disease, ocean acidification, extreme water

temperatures brought about by global warming, and the 1980s die-off of the reef grazing long-spined sea urchins have all taken their toll.

Still, there is a lot left to see on the reefs off Marathon and the Lower Keys. Furthermore, some of the local dive shops participate in the Florida Keys National Marine Sanctuary's Blue Star Program, which certifies operators that take special steps to conserve the coral reefs. To see the current participants, check the program's website at http://floridakeys.noaa.gov/onthewater/bluestar.html.

Two of Marathon's most popular shallow water dive and snorkeling sites are Sombrero Reef and Coffins Patch, both of which are protected from fishing, lobstering, and all other marine harvesting as a result of their status as Florida Keys National Marine Sanctuary Preservation Areas.

Sombrero, which surrounds the 160-foot Civil War–era lighthouse of the same name, is known as one of the best spur-and-groove formations in the Keys. It has stands of threatened elkhorn coral, and some local divers enjoy it for the small but navigable passageways through the coral structure.

Coffins Patch, comprising six separate reefs, took root in the aftermath of the great Labor Day Hurricane of 1935, when a ship en route to the Keys lost its cargo of empty coffins. Sitting in very shallow water, the reef is a top-notch snorkeling site. It is known for its outstanding pillar coral, a threatened species, and for its large fish, including grouper and the bright yellow-striped butterflyfish.

In deeper water off Marathon sits The Gap, a reef that is popular for its vertical wall and known for its large, healthy coral heads. The Gap's location in approximately 50 to 80 feet of water means that it supports more large fish than most shallow water sites.

Advanced divers leaving from the Marathon area often like to visit the Thunderbolt, a 189-foot World War II vessel that was intentionally sunk in 1986 to become an artificial reef. The Thunderbolt sits 120 feet deep and is frequented by Goliath grouper and octopus, among many other species.

In the Lower Keys, the main diving attractions are the Looe Key reef complex and the *Adolphus Busch* wreck. Like Sombrero Reef, Looe Key

Healthy pillar coral, listed federally as a threatened species, livens up Looe Key Reef, five miles off Big Pine Key. Courtesy of the Florida Keys National Marine Sanctuary.

is a spur-and-groove formation, meaning that it is made up of a series of finger reefs divided by sandy chutes. The reefs range from nearly 30 feet deep to surface level, providing excellent opportunities for snorkelers and divers alike. Benefiting from its status as a Florida Keys National Marine Sanctuary Preservation Area, Looe Key is known for its vibrant combination of living coral and ample fish life. In fact, so valued is Looe Key that it was set aside as a stand-alone national marine sanctuary in 1981, nine years before it was incorporated into the newly created and larger Florida Keys sanctuary. Parrotfish, jacks, surgeon fish, and barracudas are just a few of its resident species.

The 210-foot-long *Adolphus Busch* lies in 116 feet of water four miles to the south of Big Pine Key. The freighter was featured in the 1957 Rita Hayworth and Jack Lemmon film *Fire Down Below* some four decades before it was intentionally sunk in 1998 as an artificial reef. It is named for the founder of the Anheuser-Busch brewing company, whose grandson helped finance its sinking. A dozen holes were drilled

Delicious, but Limited

For most visitors to southern Florida, and especially to the Florida Keys, at least one nice seafood dinner is an important part of the itinerary—and with good reason. Stone crab, spiny lobster, mahi-mahi, yellowtail snapper, and grouper are just the most common local catch you'll find on menus throughout the region. Try harder and you can also sample less prevalent, but equally delicious offerings, such as hogfish, swordfish, tilefish, and more.

Though savoring a fresh seafood meal is a quintessential Keys experience, it's important to recognize that the stone crab, grouper, or whatever else is on your plate isn't limitless.

Perhaps the best way to understand this lesson is to consider two species, the queen conch and the green turtle. Conch is so closely associated with the Keys that it is the slang word used by locals to identify native residents of the island chain. However, any conch found on a Keys menu these days is from the Caribbean. That's the way things have been since 1975, when the state of Florida banned commercial harvesting after decades of overexploitation had led to a collapse in the local queen conch population. More than forty years later a recovery is under way, but there is much progress still to be made.

Similarly, at the turn of the twentieth century green turtle processing was a staple industry in Key West. But these days the green turtle isn't on any local menus. Federally listed as endangered in the seas around Florida, the processing of green turtle was effectively banned in 1971 and its importation was forbidden in 1978. Poignantly, the popular Green Turtle Inn in Islamorada now serves a turtle soup made from farmed snapper turtle.

For now, the Keys' three largest commercial fisheries—yellowtail snapper, stone crab, and spiny lobster—are faring well. Sensible regulations, supported by commercial fishermen, should help things stay that way.

into the vessel at the time it was sunk. Those holes now provide light for technical divers who explore the ship.

While wreck diving is mainly for people who possess an Advanced Diver Certification, beginning divers can get out on the reef with an instructor by enrolling in a one-day Discover SCUBA course. Standard Open Water Certification courses last two to four days. Shop around for prices.

Snorkeling requires no training, although participants should be at least reasonably fit, especially on rougher days.

Among the popular Marathon dive and snorkel shops are Tilden's Scuba Center, Abyss Dive Center, A Deep Blue Dive, and Captain Hook's. In the Lower Keys, Looe Key Dive Center and Strike Zone Charter are among the offerings.

Summer, with its warm water and calmer days, is the most popular time to snorkel or dive throughout the Keys. To beat the crowds, go in September or October, while the water remains warm.

Other Middle and Lower Keys Attractions

Dolphin Research Center
Mile marker 58.9, gulfside

Watch bottlenose dolphins being trained, or go a step farther and swim with a dolphin at the only one of the Keys' four captive dolphin facilities that operates as a nonprofit. As of 2014, 24 dolphins, 19 of which were born at Dolphin Research Center, resided in one of the 11 pools that the facility has cordoned off along the edge of the Gulf of Mexico.

Among the research performed at the center are studies related to dolphins' thinking and analytical skills and their parenting styles. The center also has four sea lions. Open daily from 9:00 a.m. to 4:30 p.m. Information: (305) 289-1121.

Smiles abound as a dolphin leaps from the water at the nonprofit Dolphin Research Center on Grassy Key. By permission of Dolphin Research Center, Grassy Key, Florida.

Crane Point Museum and Nature Center

Mile marker 50.5, gulfside

Learn about Keys wildlife at the natural history museum, then visit a butterfly garden, see the Keys' oldest home outside Key West and walk a bayfront boardwalk. Crane Point has approximately two miles of hiking trails and also houses the Marathon Wild Bird Center, a rescue and rehabilitation facility. Open 9:00 a.m. to 5:00 p.m. Monday to Saturday and Sunday from noon to 5:00 p.m. Information: (305) 743-9100.

Aquarium Encounters

Mile marker 53, gulfside

This interactive aquarium attraction, featuring a 200,000-gallon tank and an outdoor lagoon, opened along Marathon's Vaca Cut in 2014. Tour the aquarium and touch starfish and conch as part of the general admission cost, or splurge a bit to snorkel the lagoon and feed stingrays while standing in a waist-deep tank. The aquarium's top-billed experience is its Coral Reef Encounter, in which participants snorkel or dive among 50 fish species. They can also feed sharks and other marine predators through acrylic holes cut into the Plexiglas that separates the predator tank from the one they are in. Open daily from 9:00 a.m. to 5:00 p.m. Information: (305) 407-3262.

Sombrero Beach

Off mile marker 50, oceanside, at the end of Sombrero Beach Road

Perhaps the prettiest municipal beach in the Keys, this quarter-mile stretch of white sand benefits from being two miles away from the traffic and noise of the Overseas Highway. The city of Marathon also neatly maintains a linear grassy park along the outside edge of the sand. Federally threatened loggerhead turtles nest on Sombrero between April and October, so small portions of the sand are often closed for their protection. The beach is open daily from 7:00 a.m. until dusk. Parking is free.

Keys Fisheries Market and Marina

Mile marker 48, gulfside, at the end of 35th Street

Dine at picnic tables along the dock or purchase freshly caught stone crab, lobster, mahi-mahi, and much more at this working fishery's on-site retail market. Upstairs, Pincher's Perch bar holds a nightly toast to the sunset and, during the October to May stone crab season, offers outstanding specials.

Keys Fisheries also runs a wholesale operation, purveying the catch of local fishermen to restaurants and markets around the nation, among them Whole Foods and the iconic Joe's Stone Crab on Miami Beach. Open daily, 11:00 a.m. to 9:00 p.m. Information: (305) 743-4354.

Perky's Bat Tower
Mile marker 17, gulfside

Turn toward the bayside at the Sugarloaf Lodge, then drive a short distance to see this quirky site that is on the National Register of Historic Places. The 30-foot edifice was built in 1929 by developer Richter Clyde Perky, who sought to control mosquitoes by housing hungry bats. The problem is, no one told the bats, which flew away as soon as they were introduced to the tower. Stop by the tower whenever it is light enough to see. Admission is free.

Camping and Lodging

The 28 well-landscaped campsites at Curry Hammock State Park sit within yards of the Atlantic Ocean and a white sand beach. Each campsite has a picnic table, charcoal grill, water, and electric. RVs and tents are welcome on all sites. Tent campers should request a site with an adjoining sandy area. Book early if you plan to go in winter.

Bahia Honda State Park has three campgrounds with a combined 80 campsites. Twenty-three of those sites are on the water. All 80 sites come with a picnic table, grill, and water. Many sites also have electric.

Tent campers might want to use the Bayside Campground, where access is limited to smaller vehicles. Beware though, Bayside doesn't have showers. The Sandspur Campground is located within a hardwood hammock. The Buttonwood Campground has the largest sites at the park.

Campsites at both state parks can be booked online up to 11 months in advance through ReserveAmerica at www.reserveamerica.com, or by calling (800) 326-3521.

Use the same phone number and website to book one of the six gulfside cabin suites at Bahia Honda. Each unit has a wood dock with a picnic table and grill, as well as a kitchen.

The Marathon area has a diverse combination of mom and pop beach motels and higher-end resorts.

Seascape Motel sits at the end of a quiet residential street between mile markers 51 and 52. It offers 11 rooms and suites on a spacious 5-acre oceanfront property. Information: (305) 743-6212.

The 38 rooms and suites at Glunz Ocean Beach Hotel and Resort on Key Colony Beach were remodeled in 2013. The resort has its own tiki bar and is also a short, quiet walk from a handful of other restaurants, as well as a Par 3 municipal golf course. Information: (800) 321-7213.

If you're looking for a full-scale resort in the Middle Keys, try Tranquility Bay in central Marathon, (888) 965-6553, or Hawks Cay Resort on Duck Key, off mile marker 61. Information: (888) 395-5539.

The Lower Keys are home to an assortment of small motels and resorts that cater to outdoor-minded tourists.

Deer Run Bed and Breakfast on Long Beach Drive in southeastern Big Pine Key is a family-run operation that takes the environment seriously. Recyclable linens, compost toilets, and a vegan menu are just a few of the conservation measures taken by owners Jen DeMaria and Harry Appel. Their four rooms aren't cheap, but three of them are on a beach that is home to nesting turtles in the summer and Key deer throughout the year. Adults only. Information: (305) 872-2015.

More moderately priced is Old Wooden Bridge Guest Cottages and Marina, a fishing camp that has been open since 1942. Its 13 kitchenettes and one studio sit just yards away from the No Name Bridge, which is a popular fishing site. Information: (305) 872-2241.

Parmer's Resort on Little Torch Key sits along the Pine Channel, a half mile off U.S. 1. The spacious property has a mixture of standard-sized rooms, efficiencies, and suites, spread over bungalows of one to six units each. Large grassy areas and plenty of waterfront add to Parmer's old Keys charm. Information: (305) 872-2157.

11

Key West and Dry Tortugas National Park

The Southernmost City is known internationally as a place to visit for a continuous party in the hot tropical sun. But while Key West is indeed an excellent place to go for a bacchanalian romp, it also has no shortage of outdoor attractions.

Home to approximately 25,000 people, the island encompasses just 7.5 square miles at the end of the Overseas Highway and is generally divided into the distinct sections of Old Town and New Town. Old Town covers the western half of Key West and is the site of its central business district; including the famed Duval Street, Mallory Square, the Historic Seaport, and most of the Key West tourist attractions. With its concentration of wooden architectural gems, many of which have stood for much longer than 100 years, Old Town is easily distinguishable from the more ordinary looking New Town, even to a first time visitor. In fact, most of Old Town, including nearly 2,500 buildings, is designated on the National Register of Historic Places as the Key West Historic District.

Metropolitan Key West extends east of New Town onto neighboring Stock Island, where housing is more affordable for Key West's many low-wage workers. Stock Island is also now the hub of the commercial fishing industry for the Key West area, gentrification having pushed the industry out of the Historic Seaport.

Beyond Stock Island, Naval Air Station Key West on Boca Chica Key makes up the eastern fringe of the Key West vicinity. The Naval Air Station also occupies Sigsbee Park, an island a half mile north of Key West,

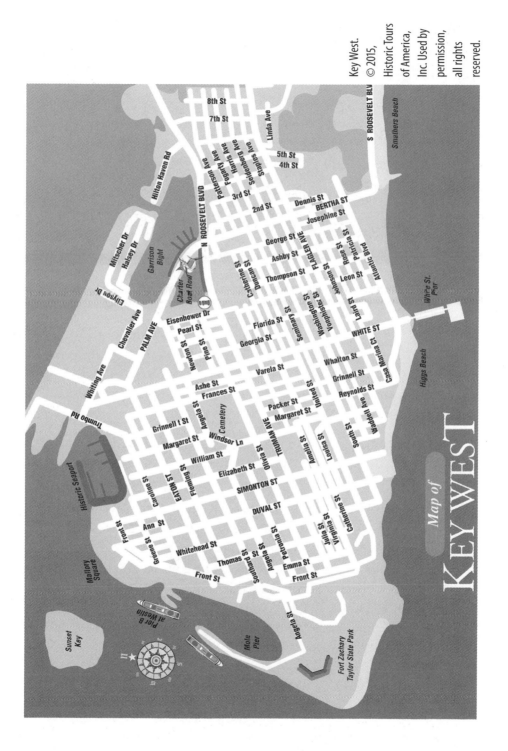

Map of
KEY WEST

A washed-up lobster trap sits along the isolated beach at Boca Grande Key in the Key West National Wildlife Refuge. Courtesy of the U.S. Fish and Wildlife Service.

nearby Fleming Key, also to Key West's north, and Trumbo Point, in the northeast corner of Old Town.

Small, densely populated and rich in history and culture, Key West is a town that feels like a city. Still, amid the distinctive inns and homes of Old Town, and beyond the shopping plazas and roadways of New Town, there is much for a nature lover to enjoy.

Gardens are a favorite in Key West, where plants grow fast in the warm, moist climate. You'll find gardens on guest house properties, hidden in residential neighborhoods, and displayed prominently at tourist attractions such as Audubon House, Key West Garden Club, and the Key West Botanical Garden.

Key West is also home to Fort Zachary Taylor Historic State Park, site of the island's most popular beach. On the south side of town, Smathers Beach and Higgs Beach also attract sun worshipers. The salt ponds in

southeast Key West draw kayakers to a wild side of the island's interior. Bicyclists, meanwhile, have their way in the Southernmost City, where limited parking, flat terrain, and the island's compact size make two-wheeling it the most convenient way to get around.

Still, as with all of the Florida Keys, it's the offshore environments that really draw nature tourists to Key West. Atlantic Ocean reefs several miles south of Key West, such as Dry Rocks, Sand Key, and the Sambos, are a magnet for both divers and fish. Just beyond the reefs, where the ocean begins to plunge, lies the *General Hoyt S. Vandenberg* carrier vessel, considered by many to be Key West's best diving locale.

West of the island, the Key West National Wildlife Refuge is a prime attraction. The 208,000-acre expanse contains patch reefs, shallow flats of seagrass, mangrove islands, and white sand beaches. It was established in 1908 to protect wading birds and is home to more than 250 bird species.

Beyond the refuge, approximately 70 miles off Key West, sits Dry Tortugas National Park. Its centerpiece is Fort Jefferson, which stands solitary and regal on Garden Key in the Florida Straits, one of seven islands within the 100-square-mile park. The park, as well as the surrounding ecological reserve that is managed by the Florida Keys National Marine Sanctuary, is also home to the most westerly reefs of the Florida system.

Even the most ardent outdoor-oriented tourists will also want to at least sample the Southernmost City's rich combination of nightlife and cultural life. Key West is known for its party scene, and with cause. Year-round, the bars and restaurants of Old Town beckon tourists to experience what locals call "The Duval Crawl." The party gets especially raucous each year during late October's Fantasy Fest, and on New Year's Eve, when the celebration draws national television coverage. Tamer is the nightly Sunset Celebration in Mallory Square, where jugglers, magicians, musicians, and other entertainers put on informal street performances.

The closely situated Mallory Square, Historic Seaport, and central Duval Street corridor are where the largest masses of Key West visitors spend their time. The area does have some genuinely interesting

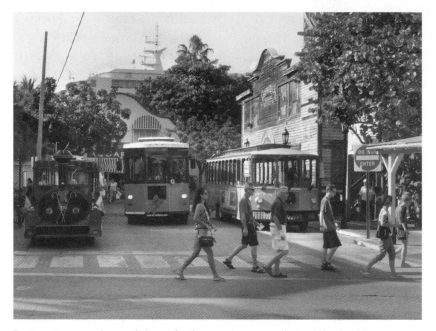

Tourist trains, cruise ships, and plenty of pedestrians are commonplace on Whitehead Street, near Mallory Square. Photo by author.

buildings, shops, bars, and attractions. But despite its attributes, parts of Old Town, and Duval Street especially, can often feel like a corporatized version of Key West—overrun with tourists, littered with cheesy T-shirt shops, and too focused on making the next buck to maintain a connection to its past.

Fortunately you needn't stray far from Duval to find the more authentic Key West, filled with historic homes, distinctive neighborhood bars, eclectic art galleries, and a diverse mix of both upscale and hole-in-the-wall eateries. Stroll onto practically any Old Town side street and you'll see reminders of what has drawn the likes of Ernest Hemingway, Harry Truman, and so many others to this American Caribbean island on the edge of nowhere.

While tourism is now Key West's mainstay, its history is far more hardscrabble. Founded in 1822, the city has made its fortunes through industries as diverse as cigar manufacturing, salt mining, sponging, fishing, and of course, liquor smuggling.

During its first few decades of existence, wreck salvaging—an industry in which townspeople, for an exorbitant price, rescued ships that were drowning on the reef—turned Key West into one of the richest cities in the United States. Lighthouses and improvements in shipping technology killed the wrecking industry during the second half of the nineteenth century. Nevertheless, Key West continued to prosper from turtle canning, fishing, military installations, and a cigar industry that was fueled by the labor of Cuban immigrants who were fleeing their island home amid wars with Cuba's colonial overlord, Spain. By 1889, seven years before Miami even incorporated, Key West was the largest city in Florida.

In 1912, the first train made its way down Henry Flagler's Overseas Railroad to Key West, connecting the island with the mainland some 130 miles away. Nevertheless, after a destructive hurricane in 1926 ended Florida's first land boom, Key West entered into a steep decline, preceding the Great Depression by several years. Meanwhile, overharvesting had curtailed the turtle and sponge industries, while the more centrally located Ybor City in Tampa had become the center of the Florida cigar industry.

By 1934, the population of Key West had nearly halved. But the town was rescued by the public works programs of the New Deal, and then by World War II, when the U.S. government greatly expanded naval facilities on the island.

The Navy continued to drive the Key West economy for another three decades. But the 1974 closure of the Key West Naval Station on the western edge of the island again signaled trouble. This time, the Southernmost City gave its full embrace to tourism. Today, the thousands of people milling through the attractions around Mallory Square are testament to the strategy's success.

In recent years high living costs have chipped away at Key West's long-standing diversity. But the island remains a melting pot. Old Town still has the old Bahama Village neighborhood, named for the island heritage of its original residents. The gay population in Key West is the highest per capita in Florida. Meanwhile, the tourism industry, Key West's reputation as a fun party town, and its long-standing history

Key West Cemetery

Sitting on 19 acres in the center of Old Town Key West, the Key West Cemetery is, quite literally, a stroll through the history of the Southernmost City.

Built in 1847, the cemetery contains 75,000 graves, approximately three times the city's living population. A couple dozen of those graves hold the remains of sailors who died on the USS *Maine* in 1898. The explosion of the *Maine* in Havana Harbor, three weeks after the ship had sailed from Key West, led to the Spanish-American War. A monument at the cemetery pays tribute to the *Maine* victims.

Dotting the graveyard's grounds are obelisks, crypts, and mausoleums, big and small, many marking the resting places of famous Key West denizens. Legendary bartender Joe Russell, namesake of the iconic Sloppy Joe's on Duval Street, was buried here in 1941. So, in 1896, was Florida's first millionaire, the mercantilist William Curry.

This being the Key West cemetery, it also has its share of quirky offerings. Check out the resting place of the 40-inch midget "General" Abe Sawyer, who asked to be buried in a full-sized tomb upon his passing in 1939. Look also for the grave of B. P. Roberts, who died at age 50 in 1979. "I told you I was sick," his grave marker reads.

The cemetery is open from 7:00 a.m. to 6:00 p.m. in the winter and from 7:00 a.m to 7:00 p.m. in the summer. The Historic Florida Keys Foundation offers walking tours twice a week. Call (305) 292-6718 for times.

The parting words of B. P. Roberts adorn one of many eccentric or noteworthy headstones at the Key West Cemetery. Photo by author.

as an artistic gathering point draw a combination of wanderers, eccentrics, and young workers from around the United States and the world.

Top Eco-destinations

Key West Botanical Garden

Featuring more than 4,000 individual plants, this eight-acre gem on College Road in Stock Island is as much forest as it is garden. In fact, if you come here expecting to see an ornamental garden, you might leave disappointed. There are no artistically trimmed hedges and no islands of colorful flowers surrounded by brick pavers. But if it's a genuine Keys natural experience you're looking for, the botanical garden is perhaps Key West's most authentic land-based attraction.

Promoted as the only frost-free botanical garden in the continental United States, the property features seven distinct loop routes that cover a combined distance of approximately a mile. They pass through a hardwood hammock, around two freshwater lakes, and past approximately 150 distinct plant species that are native to Key West, Cuba, and the western Caribbean.

The botanical garden got its start back in 1936 when Key West was a city on the brink. A powerful hurricane in 1926 had put an end to the Florida land boom, sending the Southernmost City into a steep economic decline. Eight years later, its population having dropped by almost half, the city commission declared Key West insolvent. Making matters worse, the Great Depression was raging.

The garden was one of numerous Works Progress Administration projects undertaken in Key West as part of Franklin Roosevelt's New Deal. It originally encompassed 55 acres, but was whittled down through the years. A World War II military hospital and nine holes of golf were some of the uses that took over portions of the garden.

The eight acres that are left, however, are still large enough to house 16 state-listed endangered plant species. Thirty-eight butterfly varieties are known to occupy the garden, and nearly 200 bird species were spotted on the property between 2004 and 2014. The garden is also home to the federally endangered Stock Island tree snail.

Stroll the walking loops, making sure to visit the pleasantly secluded Desbiens Pond. Bring water and a snack if you want to absorb the quiet of the garden after a day or two in hectic Key West.

Audio garden tours are available free of charge on your smart phone. Open daily from 10:00 a.m. to 4:00 p.m. Information: (305) 296-1504.

Key West Garden Club

With its mix of brick pathways, leafy courtyards, and lush foliage, the Key West Garden Club touts itself as among the most tranquil spots in the Southernmost City. Few who have rested on one of the club's shaded benches, soaking up the Atlantic breezes, would disagree.

Located at the eastern edge of White Street, just a few paces from Higgs Beach, the Garden Club occupies the remains of a Civil War–era fort called West Martello Tower. The fort was built between 1862 and 1867, part of a network of encampments meant to guard the east coast against foreign invasion. However, advancing technology soon rendered the garrison ineffectual and the U.S. military abandoned the site entirely after World War II. The Key West Garden Club moved into its ruins in the 1950s.

Today, the old brick columns of West Martello augment the diverse garden. Many visitors marvel at the towering strangler fig as well as the approximately 50 specimens in the orchidarium. Among the hundreds of distinct species at the garden club are exotic offerings such as the sweet almond tree and wild cotton. But the nearly 300 Garden Club members are most proud of their 31-foot lignum vitae tree. Meaning "tree of life" in Latin, the slow-growing lignum vitae is on Florida's endangered species list. Renowned for their extremely dense and hard wood, lignum vitaes enjoy lifespans measured in millennia.

The Key West Garden Club is worth a full stop but also offers a nice diversion in the midst of a morning or afternoon at Higgs Beach. While you're at the garden, be sure to visit the African refugee cemetery immediately to the east of the West Martello fort. Several pedestals, adorned with African art and topped with bronze plaques, commemorate the mass grave of 294 captives, who were rescued from a slaving vessel by

the Union Army in 1860 but died of disease before being repatriated to their home continent.

Key West Garden Club is open daily from 9:00 a.m. to 5:30 p.m. Entry is free, though a donation is suggested. Information: (305) 294-3210.

Fort Zachary Taylor Historic State Park

Key West's only state park is home to the locals' favorite beach and offers a window into the town's unusual history as a Union stronghold way below the Mason-Dixon line.

Today, landfill has made Fort Zach, as the locals call the garrison, contiguous with nearby downtown Key West. But when the installation was built between 1845 and 1866 it sat on a shoal 1,200 feet offshore.

The fort's biggest moment came during the Civil War when, despite the southern sympathies of most of the townsfolk, the Union Navy used it as a base to block hundreds of supply ships from reaching Confederate ports. Fort Taylor also played a significant role in the 1898 Spanish-American War.

Sunbathing and snorkeling are both popular activities at Fort Zachary Taylor Historic State Park. Photo by author.

The strategic value of the garrison dwindled in the ensuing decades, though it remained in use as a military training site through World War II. Fort Taylor was opened as a recreational site in 1985.

Visitors to the fort today can examine a selection of nine historic cannons, walk through the old barracks, and climb to the roof for a view of the fort grounds and the nearby Key West seaport. Guided tours are offered daily at noon.

For a more outdoorsy experience, throw on a swimsuit and head to the beach of the 56-acre park. A primary reason that Key Westers love to sun here is the quality of its swim area. Unlike many Keys shorelines, where the water remains shallow for a considerable distance, the swim area off Fort Zach drops over the head after 20 or so yards. The water is approximately 20 feet deep at the buoys that denote the swim area boundary.

It's not just people who enjoy the extra water depth. Marine life likes it too. Sea turtles, stingrays, and colorful reef fish such as sergeant majors, tang, parrot fish, and surgeon fish all make appearances in the park's swimming zone. For a better look, bring your snorkel gear and swim to either of the two rock outcroppings about 25 yards off the beach. If snorkeling is the primary goal of your Fort Zach visit, call ahead to ask park staff about underwater visibility conditions.

Because it's the largest green space on Key West, Fort Zach is a great birding locale. That's especially true during spring and fall migrations, when birds stop here to rest before and after crossing the Caribbean. The first documented sighting in the United States of a loggerhead kingbird, an olive-brown Caribbean migrant from the flycatcher family, occurred in the park in 2006. Walk into the hardwood hammock on the park's short Fort View Trail for the best birding.

Fort Zachary Taylor State Park is open daily from 8:00 a.m. until sunset. The fort closes at 5:00 p.m. Information: (305) 292-6713.

Florida Keys Eco-Discovery Center

The Florida Keys National Marine Sanctuary encompasses 3,840 square miles of ocean and bay and extends 220 miles, from the waters off

Key Largo all the way to beyond Dry Tortugas National Park. Within those boundaries lie the world's third-largest barrier reef, thousands of square miles of seagrass beds, and 1,600 mostly mangrove islands. Furthermore, 6,000 species of fish, marine mammals, plants, and invertebrates live within the sanctuary. In combination with the nearby national and state parks, as well as national wildlife refuges, the sanctuary protects all the waters of the Florida east coast from Key Biscayne to the Dry Tortugas to a depth of 300 feet.

An outstanding launching pad to learn not just about the sanctuary, but about the connectivity between the grassy marshes of the Everglades and vibrant reefs of the Keys, is the sanctuary's sole land-based attraction, the Eco-Discovery Center. Admission to the museum, which is located at the tip of Southard Street and immediately adjacent to Fort Zachary Taylor Historic State Park, is free.

The Florida Keys National Marine Sanctuary was established in 1990 to protect its waters from all sorts of travails. Popular commercial marine species, such as turtles, conch, and Goliath grouper, had been perilously overharvested. Oil companies were proposing to drill off the Keys. Vessel groundings, including three large ones within an 18-day period in late 1989, were damaging reefs and seagrass. Meanwhile, fueled by poor water quality and overexploitation, the sanctuary's most iconic habitat, its reefs, had also begun a decline that continues to this day. Indeed, concerns about coral harvesting, overfishing, and vessel groundings had led Congress to create a national marine sanctuary around the reefs of Key Largo in 1975 and another sanctuary around the Looe Key reef near Big Pine Key in 1981. Those two sanctuaries were incorporated into the Florida Keys National Marine Sanctuary on its founding.

Among the blanket prohibitions within the sanctuary are drilling and mining, collecting coral, and altering the sea floor. With the exception of designated channels, large shipping traffic is prohibited inside the reefs. Otherwise, the waters are managed through a marine zoning system that allows for different activities in various portions of the sanctuary. For example, both commercial and recreational fishing are allowed in most of the sanctuary. However, fishing is prohibited around

18 reefs to provide space for divers and snorkelers and to protect fish populations. Other sanctuary zoning districts protect bird rookeries and set aside areas for scientific research and monitoring.

Visitors to the Eco-Discovery Center can get a taste of those scientific efforts by stepping inside the model Aquarius Reef Base. The research station, which sits in 60 feet of water five miles off Key Largo, is the only permanent underwater ocean laboratory in the world.

Other highlights of the center include aquariums exhibiting hard and soft corals as well as reef fish, photos that show coral cover losses at Keys reefs over the past several decades, and a 20-minute high definition film that runs throughout the day. In addition, the Eco-Discovery Center features dioramas and touch screens that give primers on the habitats, both terrestrial and marine, of southern Florida and the Keys.

Open Tuesday to Saturday, 9:00 a.m. to 4:00 p.m. Information: (305) 809-4750.

Audubon House

Legendary ornithologist and artist John James Audubon never set foot inside this grand mid-nineteenth-century mansion located on the corner of Greene and Whitehead Streets, almost within shouting distance of Mallory Square. In fact, the home had not even been built in 1832 when Audubon made his lone sojourn to the Florida Keys, staying for six weeks to paint the 22 local species that were included in his classic 435-painting tome, *Birds of America*.

Still, the museum's collection of Audubon prints and its lush tropical garden make it a pleasant and informative excursion amidst the chaos of the surrounding central Key West tourist district.

Its name aside, Audubon House was in fact the home of John Geiger, a ship's captain who made his fortune in Key West's lucrative wrecking industry of the nineteenth century. Geiger built the three-story wooden home between 1846 and 1849 and his family occupied it for 110 years, until it was acquired, renovated, and turned into a museum between 1958 and 1960. A few of the home's contents are original, but

most of the house is appointed in stylish period pieces dating to the early nineteenth century.

Though tenuous, Audubon is believed to have had at least some connection to the eventual site of the Geiger house. He used a branch from a flowering tree on the property to serve as his model while he painted his white-crowned pigeon entry for *Birds of America*. The painting depicts two of the colorful birds perched on a limb of what has since come to be known in the United States as a Geiger tree.

For bird lovers, the highlight of a visit to Audubon House will likely be the 31 first-edition full size and small *Birds of America* prints that adorn its walls. The 22 small prints, which are displayed together in a top floor gallery, comprise the book's Florida Keys entries. Sadly, one of the species that Audubon was lucky enough to see, the blue-headed quail dove, is no longer found in the Keys. If you have a healthy bit of extra money, modern reproductions of Audubon's paintings are available for sale at the Audubon House Gallery at the museum's entrance.

The property's tropical garden, with its 450 orchids scattered among other native and exotic plants, is worth a visit in its own right. A Geiger tree stands at the front of the Audubon House, near Whitehead Street.

Audubon House is open daily from 9:30 a.m. to 5:00 p.m. Information: (305) 294-2116.

Dry Tortugas National Park

Located 2½ hours west of Key West via boat, Dry Tortugas National Park is easily the most far-flung outdoor attraction in South Florida. But whether you travel the 70 miles via ferry, seaplane, or private vessel, you'll know the effort has been worth it when Fort Jefferson appears on the horizon, its stout, brick walls framed majestically against the remote blue sea.

Though clearly the signature of this 100-square-mile national park, the Civil War–era fortress is only one of its attractions. The Dry Tortugas is also home to the southernmost edge of the 220-mile-long Florida

Keys reef tract, has seven small islands, and plays host to nesting bird colonies seen nowhere else in North America.

Nevertheless, it's Garden Key, site of Fort Jefferson, where all Dry Tortugas visitors not traveling by private boat or charter will start and end their visit. A 45-minute tour details the history of the fortress, which was built between 1846 and 1875 but never finished. The largest brick building in the Americas, it was located here, along the shipping lanes, in order to control routes to the Gulf of Mexico and to protect merchant ships headed to the Atlantic from the Mississippi River.

More famously, Fort Jefferson was used as a prison, mainly to incarcerate Union Army deserters. But it also housed four convicted conspirators in the assassination of Abraham Lincoln. The best known of those, Samuel Mudd, was the physician who treated assassin John Wilkes Booth's fractured leg in the hours after Booth shot Lincoln. While at Fort Jefferson, Mudd used his medical skills to stymie an 1867 yellow fever outbreak. President Andrew Johnson pardoned him two years later.

The U.S. Army abandoned the fort in 1874. In later years it was used as a quarantine hospital and a coaling station for warships. In 1935, Franklin Roosevelt designated Fort Jefferson as a national monument. The expanded Dry Tortugas National Park was inaugurated in 1992.

While at Garden Key, take the fort tour, then walk the sea wall and wander up to the fort's upper level to enjoy the amazing views. If you got to the Dry Tortugas via ferry, you'll have approximately five hours on the island. Most visitors eventually make their way to the island's beach to sun, swim, and snorkel.

Their southerly location aside, the reefs of the Dry Tortugas actually sit at the top of the Florida Keys system from a standpoint of the ocean's water flow. Because they are both upstream and far away from the pollutants that have played a role in degrading more accessible portions of the reef, and because they are remote enough to have also avoided many of the problems caused by direct visitation, the park's reefs are generally considered South Florida's most pristine. French angelfish, outfitted in a startling combination of yellow-speckled black with gray,

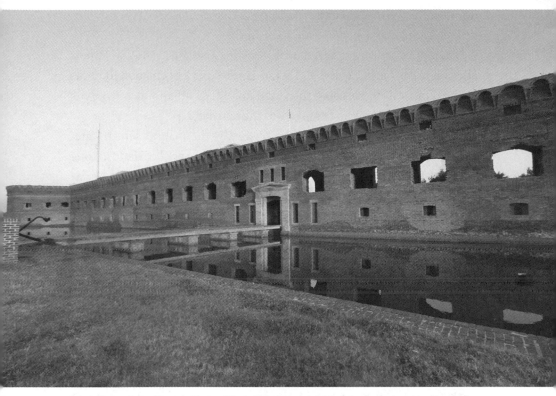

Fort Jefferson, in Dry Tortugas National Park, is the largest brick building in the Americas. By permission of Garl Harrold, www.garlscoastalkayaking.com.

threatened elkhorn corals, sea fans, and yellow damselfish are just a few of the coral and marine species that can often be seen while snorkeling or diving in the park. Also helping the Dry Tortugas fish stocks is the "no anchor" and "no fishing" zone that covers nearly half of the park.

The *Windjammer*, an iron-hulled shipping vessel that wrecked in 1907, is regarded as the best dive and snorkel site in the Dry Tortugas. Because it is located near Loggerhead Key, three miles west of the fort and visitor facilities on Garden Key, the best way to get there is via private vessel or charter. Still, you'll get an excellent taste of the marine life the Dry Tortugas has to offer merely by snorkeling off the Garden Key beach. If the water is calm, snorkel out to the remains of the coaling

dock on the south side of the island for a chance to see parrot fish, angelfish, snook, tarpon, and even reef sharks.

Though 99 percent covered by water, Dry Tortugas National Park is also a birders' haven. Some 300 avian species have been spotted on its islands, most of them using the small splotches of land as a stopping point during migrations to and from the Caribbean.

One highlight for Dry Tortugas birders is the magnificent frigatebirds, with their seven-foot wingspan, that soar over the islands. Long Key, less than a mile east of Fort Jefferson, is the only frigatebird nesting site in the United States.

An even greater birding attraction can be found on Bush Key, just yards from Garden Key, where sooty terns have established their lone nesting colony in the United States. Numbering 80,000 strong in a typical year, the white-breasted, black-winged birds descend on the park in the winter and spring. Bush Key is closed during nesting season, but the terns can be watched with the naked eye from Fort Jefferson. Bring binoculars for an even better view.

For most, transit to the Dry Tortugas will be via ferry or seaplane. The 2½-hour ferry ride is on the 110-foot *Yankee Freedom III*, a National Park Service concessionaire. While beautiful, the ride can sometimes be quite rough, especially during the windy winter and spring months. Be sure to take sea sickness medication as a precaution if you're not accustomed to being on the open water. For reservations and more information, go to the Dry Tortugas website at http://drytortugas.com/.

A premium price will keep you out of the waves and get you to Garden Key in 40 minutes via seaplane. Try to go at the beginning or end of the day for the privacy of being on the island when the *Yankee Freedom* passengers are not. Visit http://keywestseaplanecharters.com for more information.

The National Park Service also provides permits to private charter companies that offer diving, fishing, and wildlife excursions into the waters of the Dry Tortugas. To see the current list, visit http://www.nps.gov/drto/planyourvisit/upload/2014-15-DRTO-CUAs.pdf.

If you're not lucky enough to have your own ocean-faring boat, the best way to fully experience the Dry Tortugas is to camp there. The

Yankee Freedom allows campers to stay up to three nights prior to making the return trip. Campers get to enjoy Garden Key when few others are around, take in sunsets and sunrises and gaze at a night sky that is unimpeded by light pollution. The only downside is the population of rats that reside on the island.

If you do plan to stay for a night or two, consider bringing a kayak or stand-up paddleboard aboard the *Yankee Freedom*. From Garden Key, paddlers of moderate ability can circle the fort and continue around Bush and Long Keys for a close look at the bird rookeries. Make sure to observe the buoys that denote closed zones where nurse sharks and coral are protected. The paddle is approximately six miles long.

For an experience that is completely different than the one offered at Garden Key and Fort Jefferson, expert paddlers can make the three-mile crossing to Loggerhead Key. While lounging on Loggerhead's splendid isolated beach it's easy to imagine that you are on a deserted island, even though the 157-foot-high Dry Tortugas Lighthouse stands sentinel over the key. The currents are strong and winds can pick up suddenly, so before making the crossing be sure to file a route plan and to pay close attention to the weather forecast. Take a whistle, plenty of extra water, and, in case of trouble, a waterproof two-way radio with access to Channel 16.

For more information about Dry Tortugas National Park, visit http://www.nps.gov/drto/index.htm or call (305) 242-7700.

Bicycling Key West

Bicycling is king on this tightly packed island where traffic is heavy, one-way streets can be confusing, and parking a car is often a laborious chore. In fact, many Key West locals use bicycles as their main mode of transportation.

Tourists, too, may want to rent a bike to get around during their Key West sojourn. Fortunately, there's no shortage of places to do so. Bicycle rental shops proliferate in Old Town, at hotels, and on North Roosevelt Boulevard, which serves as the main entryway into the city.

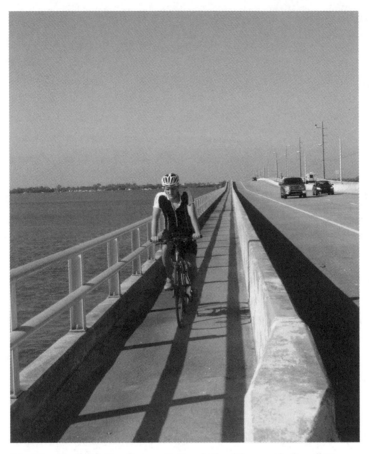

A cyclist on the Florida Keys Overseas Heritage Trail pedals across the Boca Chita Channel. Photo by author.

If you don't want to use a bike as your main transit mode while in Key West, renting one for a couple hours makes for a fun diversion. Cruise through the interesting Old Town neighborhoods east of Duval Street. After that, bicycle around the Truman Annex just southwest of Mallory Square, then take the short ride through Fort Zachary Taylor Historic State Park, where you can gaze on the shipping channel and the moat surrounding the fort. If you want more exercise, head southeast to Atlantic Boulevard to pedal along the Smathers Beach seawall.

More serious cyclists can also head out of town to ride the western section of the Overseas Heritage Trail, the 106.5-mile route from Key

West to Key Largo that has been in the works since 2000. One of the nicest sections of the trail is the approximately 15-mile span between Stock Island and Lower Sugarloaf Key. The pathway crosses six Henry Flagler railroad–era bridges and eight bridges in total. Even on land though, that portion of the trail offers many spectacular water views. Just as important, much of the path is nicely landscaped and well separated from the Overseas Highway, allowing for a relatively relaxing and peaceful ride.

Paddling Key West

With its heavily developed shorelines and compact size, Key West offers fewer pristine paddling opportunities than other portions of the Keys. On the other hand, paddling here does have its own unique urban flair.

The most popular paddling route within Key West proper traverses the city's Riviera Canal, from Cowpen Channel on the east side of the island to the Gulf of Mexico on its north side. The canal runs approximately two miles each way, transforming from wide and home-lined to much narrower and lined with a combination of mangroves and homes. On the gulfward half it passes through a city park as well as under a bridge that is so low that most kayakers will have to duck their heads. Boarders will be forced to drop to their knees, or even lower.

If you stick only to the Riviera Canal, however, you'll miss the salt ponds, which are the best part of the journey. These saltwater lakes were mined in the mid-nineteenth century, when Key West was a national leader in salt production. Today they offer a bit of nature within the confines of the island's 7.5 square miles, even though one side of the ponds does border the Key West International Airport.

Get to the salt ponds by paddling through one of two narrow mangrove tunnels that branch from the northern quarter of the Riviera Canal. Bring a paddle you can break in half if possible, since the going gets tight in the tunnels. Put in for the salt ponds paddle either at Cowpens Channel or at the canal launches within Little Hamaca Park and on 11th Street, just east of Flagler Drive in New Town.

Other launches in and near Key West include:

- Smathers Beach, off its eastern edge, on South Roosevelt Boulevard
- Stock Island public boat ramp, on the ocean side of U.S. 1, at mile marker 5.3
- South side of Boca Chica Channel, on the Gulf side of U.S. 1, at mile marker 5.5

Key West has no full-service kayak shops, but the town does have a plethora of options for kayak rentals. You'll find them easily, even if you leave the smart phone at home.

A second paddling option leaving from the island itself is the 12-mile circumnavigation. Depart from Smathers Beach, but be prepared for some tough currents as well as big boat traffic as you pass Fort Zachary Taylor and enter the shipping channel near the Mallory Square port.

Heading toward the backcountry of the Lower Keys, north and east of Key West, the paddling options become more plentiful. The southwest Boca Chica put-in is a gateway to Channel Key, two miles away, on the boundary of the Great White Heron National Wildlife Refuge. The island is intersected by two mangrove creeks, but the open water crossing to get there is tough on windy days. A nicer and often easier route to Channel Key takes you along the lee side of Key West Naval Air Station on Boca Chica, then past the small Monday and Bush Keys. To take that route, however, you'll want to put in on the northeast side of Boca Chica Channel, where the launch is at the bottom of a steep and uncomfortable parking area.

The best paddling from which Key West is the launching point may well be in the Key West National Wildlife Refuge. But with the nearest points of the 375-square-mile refuge located a half dozen miles offshore, by far the easiest way to get there is via motor boat. Check around for the various kayak touring concessions that take trips to the refuge.

Once within the Key West refuge you'll paddle through a shallow water world dotted with 13 islands, plus the circle of islands known as

the Marquesas. A few islands, including Boca Grande, have white sand beaches.

Established by President Theodore Roosevelt in 1908, the Key West National Wildlife Refuge is the oldest and biggest of the four Keys refuges. It's home to the largest colony of the beloved white-crowned pigeons in the Keys along with more than 250 other bird species. In addition, within the Keys, only the Dry Tortugas plays host to more turtle nests than the Key West refuge.

Be aware that all islands within the Key West National Wildlife Refuge are closed above the mean high tide line. In addition, there are seasonal closures extending 300 feet offshore to protect bird rookeries on some islands. For specifics, refer to the refuge's management plan, http://www.fws.gov/nationalkeydeer/pdfs/Backcountryplan.pdf.

Diving and Snorkeling Key West

Divers departing from Key West can choose among preservation areas along the main Florida Keys reef line, patch reefs in a national wildlife refuge, and what many believe is the most outstanding wreck dive in the entire island chain.

The dive shops that service Key West regularly take customers to between 10 and 20 sites within the southwesterly portion of the 220-mile-long Florida Keys Reef Tract.

The Florida Keys reefs play host to 260 fish species, as well as 65 stony coral species. Steer clear of the branching and bladed fire corals in the Keys, which can cause intense pain upon contact.

Yellowtail snapper, blue tang, Goliath grouper, and butterfly fish, with the distinctive black, circular splotch near their fins, are just a sampling of the fish one might see during a Key West dive or snorkel excursion. Mountain star and lobed star are among the seven species of coral along the Keys that are federally listed as threatened.

As in other parts of the world, corals throughout the Keys have struggled in recent decades. Coral cover in the 3,840-square-mile Florida Keys National Marine Sanctuary has declined by nearly half since

rigorous monitoring began in 1995, and the decline was already under way as long ago as the late 1970s. Pollution, direct impacts from people visiting the reefs, more extreme water temperatures, ocean acidification brought about by global warming, and the 1980s die-off of the reef grazing long-spined sea urchins have all taken their toll.

Still, the Keys remain one of the premier destinations in the world for divers and snorkelers. The Key Largo-based Coral Restoration Foundation has successfully engineered offshore coral farms, which they have begun to use to replenish Keys reefs. Furthermore, some of the local dive shops participate in the Florida Keys National Marine Sanctuary's Blue Star Program, which certifies operators that take special steps to conserve the coral reefs. Check the program's website at http://floridakeys.noaa.gov/onthewater/bluestar.html to see the current participants.

Topping the list of Key West dive attractions is the *Gen. Hoyt S. Vandenberg*, a 522-foot World War II transport vessel that some say is the best wreck dive in the world. Sunk as an artificial reef in 2009, the *Vandenberg* lies seven miles south of the Key West coastline in 140 feet of water. But because it is 100 feet tall, it doesn't take an expert to dive at least portions of the ship. Still, more experienced and advanced divers are best suited to take on this behemoth. The radar dishes and the bridge are among the most popular *Vandenberg* exploration sites.

While few would dispute that the *Vandenberg* is the best, it's far from the only wreck site off Key West. Another popular choice is Joe's Tug, where a 75-foot shrimp boat sits in 45 to 65 feet of water, six miles south of the coast. The boat, which sank in 1986, is surrounded by coral and has outstanding fish life.

In shallower water five miles west of Key West sits Alexander's Wreck. Also known as the USS *Amesbury*, this wreck is known as a good place to see Goliath grouper. Sitting in 25 feet of water, it is shallow enough for free diving or snorkeling and is an especially good option on days when visibility in the Atlantic is poor.

For those who prefer natural reefs, the Sand Key, Eastern Dry Rocks, and Rock Key reefs off Key West are Florida Keys National Marine Sanctuary Preservation Areas, where diving and snorkeling are

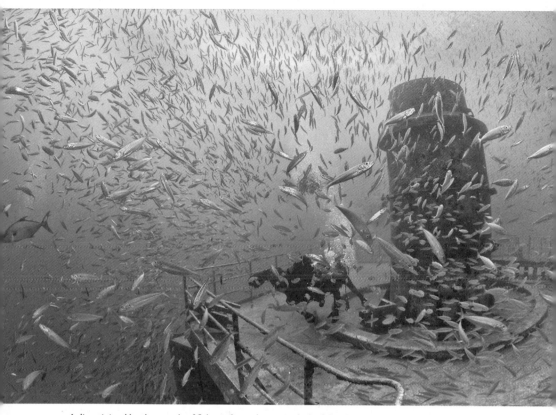

A diver, joined by thousands of fish, explores the upper deck of the *Gen. Hoyt S. Vandenberg* wreck. By permission of Don Kincaid, Key West, Florida.

enhanced because fishing and harvesting of marine species are prohibited. In addition, Western Sambo reef is similarly protected by the sanctuary as an ecological preserve. Most of the Key West–area reefs are ideally suited for snorkelers as well as divers, since they are mainly not more than 30 feet deep. Most exceptions are along the outside of the reefs, where the sea drops to between 35 and 50 feet.

Many regular Key West divers count Western Sambo among their favorite reefs, primarily due to its especially large abundance of fish life. A particularly interesting section of the reef is called the haystacks, named for the appearance of its mounds of coral.

If you're looking for someplace less crowded, the reefs around Key West that aren't designated as preserves are often a good choice.

Western Dry Rocks, about three miles west of Sand Key, ranges deeper than most of the nearby offerings and has some interesting crevices and caves that are suitable for advanced divers.

The patch reefs northwest of Key West, within the Key West National Wildlife Refuge, are nice spots on days that get rough in the Atlantic. A particularly popular patch reef is Cottrell Key, located nine miles northwest of the Southernmost City in water that gets no deeper than 15 feet.

Well-established Key West dive and snorkel shops include Captain's Corner, Dive Key West, Southpoint Divers, and Lost Reef Adventurers. Some dive shops and private charters will take small groups to far afield dive sites, including in the Dry Tortugas and the Marquesas Keys.

While the best diving experiences can only be had once you are certified, beginning divers can get out on the reef with an instructor by enrolling in a one-day Discover SCUBA course. Meanwhile, standard Open Water Certification courses last two to four days. Shop around for prices.

Snorkeling requires no training, although participants should be at least reasonably fit, especially on rougher days.

As in all of the Keys, summer, with its warm water and calmer days, is the most popular time to snorkel or dive off Key West. Beat the crowds by going in September or October, while the water remains warm.

Other Key West Attractions

Smathers Beach

South Roosevelt Boulevard

Stretching for approximately a mile near the island's southeast corner, Smathers is the largest beach in the Southernmost City. Play beach volleyball, picnic, bike, skate, or walk along the adjacent seawall, or just while away the day in the hot Key West sun. Restrooms are open 7:00 a.m. to 4:30 p.m. daily.

Southernmost Point

Southern tip of South Street

Imagine Cuba just 90 miles across the Straits of Florida while you pose for a keepsake photo next to the famed Southernmost Point buoy, erected by the city of Key West in 1983.

Key West Butterfly and Nature Conservatory

1316 Duval Street

This lush, 5,500-square-foot conservatory is a fantasyland for butterfly lovers. As soon as you step into the glassed enclosure you're literally surrounded by the beloved winged creatures as they frolic among tropical plants, waterfalls, and even a pair of pink flamingos.

Visitors will certainly notice the large, beautiful blue morphos from Costa Rica that are just about everywhere in the garden. But they're just one of approximately 50 butterfly species within the conservatory at any given time.

Only a handful of those species are native to the Keys, with most imported during their cocoon phase from Asia, Africa, Central America, and South America. The garden is populated with plants that provide nectar for butterflies but don't host butterfly eggs. Open 9:00 a.m. to 5:00 p.m. daily. Information: (305) 296-2988.

Captain Tony's

428 Greene Street

Even if you're not a drinker, no trip to Key West is complete without a visit to at least one of its classic watering holes. Among the most tradition-bound are Sloppy Joe's, Chart Room, Green Parrot, and Captain Tony's, named after its longtime owner Tony Tarracino, a fisherman, gambler, and father of 13 who served a term as Key West mayor.

In an earlier life, the 1851 building that has been Captain Tony's since 1958 housed Sloppy Joe's, and it was here that Ernest Hemingway did much of his drinking during his tenure as a Key West resident in the

Key West's First Legal Rum Distillery

There's been more rum swilled in Key West through the years than is even imaginable. But until recently this island city of smugglers and wreckers, fishermen and poets, drifters and dreamers never had a legal rum maker.

That changed in 2013 when Paul Menta, a chef and professional kiteboarder, opened up his boutique distillery at 105 Simonton Street, in a one-time saloon space that later served for several decades as a Coca-Cola bottling plant.

To give his dark rums a true taste of Key West, Menta soaks his barrels in seawater for two days then stores the mixtures in the salt-cured casks for at least six months. He also uses mostly Florida ingredients, including Redland-grown Key limes and cane from the often maligned sugar fields south of Lake Okeechobee, which wreak havoc on the troubled Everglades.

Still, conservationists will approve of the fact that Menta recycles his water. Meanwhile, rum aficionados will like the six-times distilling process.

Visit Key West First Legal Rum Distillery from 10:00 a.m. to 8:00 p.m. for a look at the production room and its two stills, for tastings, and to purchase bottles that range from the original 80 proof light rum to an unfiltered dark and another dark infused with vanilla beans. In addition, tours are offered Monday, Wednesday, Friday, and Saturday at 3:00 and 3:30 p.m. Call (305) 294-1441 for information.

1930s. Take a seat at a bar stool labeled with a celebrity who has drunk here, enjoy the racy headstone tribute to Captain Tony, and check out the tree in the middle of the bar, which reputedly was used for hangings during Key West's pirate days. (305) 294-1838.

Key West Lighthouse Museum

938 Whitehead Street

Climb the 88 steps to the lighthouse tower for a 360-degree panorama that is arguably the best view of Key West. The lighthouse was built in 1847 and upgraded to its present height of 86 feet in 1894. It was decommissioned in 1969. Take in the view of gulf and ocean, Historic Seaport and Southernmost Point; then visit the museum in the old keeper's quarters to see a collection of artifacts, as well as a model of the Keys' largest light, Sombrero, off Marathon. Open daily, 9:30 a.m. to 4:30 p.m. Information: (305) 294-0012.

Hemingway House

907 Whitehead Street

Ernest Hemingway spent the 1930s in Key West, boxing in his backyard, deep sea fishing with pals, and writing such works as *Green Hills of Africa* and *To Have and Have Not*. Learn more about the iconic standard-bearer of machismo at the ornate home where he lived with his second wife, Pauline. Don't miss Hemingway's writing studio and the in-ground swimming pool, which was the only such pool within 100 miles at the time of its construction. Thirty-minute guided tours are included with admission. Open daily, 9:00 a.m. to 5:00 p.m. Information: (305) 294-1136.

Harry S. Truman Little White House

111 Front Street

From 1946 to 1952, President Truman made 11 visits to Key West, spending 175 days of his presidency in what came to be called his Little White House. Logs kept during Truman's Key West sojourns note numerous visits from key military and civilian advisers.

Take the 50-minute tour for background on major issues Truman dealt with during his presidency, including civil rights and the Cold War, and to view furnishings that are original to Truman's time,

providing insight into the manner in which the nation's 33rd president lived. Open daily from 9:00 a.m. to 4:30 p.m. Information: (305) 294-9911.

Mel Fisher Maritime Heritage Museum

200 Greene Street

In 1622, a Spanish galleon called *Nuestra Señora de Atocha* succumbed to a hurricane in the Straits of Florida, sinking approximately halfway between Key West and the Dry Tortugas while en route from Spain to Havana. For the next 360 years the ship sat at the ocean bottom, its precise position unknown, until treasure hunter Mel Fisher discovered it in 1985 after a tireless 16-year search.

See some of the $450 million in gold, silver, emeralds, and other treasure that has been recovered as a result of that discovery at this museum near Mallory Square. The museum also offers twice daily tours of its conservation laboratory, where artifacts collected at sea are documented and preserved. Open weekdays from 8:30 a.m. to 5:00 p.m. and weekends from 9:30 a.m. to 5:00 p.m. Information: (305) 294-2633.

Key West Aquarium

1 Whitehead Street

This small open-air aquarium calls itself Key West's first tourist attraction. It's home to 150 to 200 mostly native marine species at any given time and is highlighted by its 50,000-gallon Atlantic Shore exhibit, where live mangroves sit along a pool inhabited by sharks, sea turtles, tropical fish, and gamefish.

Open since 1935, the facility definitely shows its age. Still, children will enjoy the conch and starfish touch tanks. Take the tours offered at 11:00 a.m., 1:00 p.m., 3:00 p.m., and 4:30 p.m. for a chance to feed nurse, sandbar, and bonnethead sharks. Open 10:00 a.m. to 6:00 p.m. daily. Information: (888) 544-5927.

Key West Turtle Cannery Museum

200 Margaret Street

Green turtles have had a place in Keys lore ever since Ponce de Leon named what are now the Dry Tortugas after the many turtles his men hunted there in 1513. However, they barely survived the commercial turtle hunting onslaught, which began in what would become Key West as far back as the late 1700s and didn't end until state regulations shut it down in 1971.

This small, free museum sits along the Historic Seaport in a replica of the cannery used by Thompson Industries, Key West's longtime dominant turtling company. Remnants of the old turtle pen, called a kraal, can be seen in the water behind the museum. Go there to learn about the five local sea turtle species, as well as the lessons of those turtling days. Open Wednesday to Saturday, noon to 4.00 p.m., from October through May. Information: (305) 294-0209.

Camping and Lodging

Boyd's Campground on Stock Island, five miles from Duval Street, offers the only campsites that are open to the public within the small Key West metro area.

Thirty of its 37 tent sites have freshwater and electric hook-ups. Sixteen of the sites are waterfront.

The tent sites share the crowded property with 150 RV sites. Amenities include a game room, a swimming pool, fishing docks, showers, and a marina. Information: (305) 294-1465.

Dry Tortugas National Park has eight regular campsites, as well as overflow sites, on magnificent Garden Key, in the shadow of Fort Jefferson. Each of the regular sites comes equipped with a picnic table and charcoal grill. The campground has toilets, but all campers must come supplied with whatever food, water, and other provisions they will need. Regular campsites are first-come, first-served. Those who end up in an overflow site must share grills and tables with regular site-holders.

Most campers will travel to the park on the *Yankee Freedom III* ferry boat, which limits stays to no more than three nights. Visit http://www. drytortugas.com/key-west-camping to learn more about the *Yankee Freedom*'s rules for campers and to book.

Key West offers a wide array of chain hotels, upscale beach resorts, and quaint guest houses. Room rates tend to be very high, particularly during winter and special events, such as late October's Fantasy Fest. So, if cost is a concern, consider going off-season. In addition, you're more likely to find moderate prices in New Town, a couple miles outside of the Old Town tourist and historic district.

Open since 1920, Casa Marina Resort was conceived by the industrialist Henry Flagler to house the passengers who arrived in Key West on his Overseas Railroad. Now part of the Waldorf Astoria brand, the resort retains its old-school grandeur while offering numerous amenities, including a private beach on the Atlantic. Information: (808) 303-5717.

The 261-room Southernmost Beach Resort Key West has plenty of variety at its four, not-quite-contiguous properties just east of the Southernmost Point. Two hotel buildings, one on the beach and the other a block off the water, house 242 of the rooms. The other 19 rooms are split between two converted homes with a circa-1900 Key West feel. The homes are next door to the beachfront hotel building. Information: (305) 296-6577.

Closer to the seaport and the heart of Duval Street, on Angela Street, The Gardens Hotel has 21 suites on two beautifully landscaped properties. The primary property, featuring 17 of the rooms spread over five lodge houses, is an acre-plus refuge that is at once connected to and separated from the clatter and action of surrounding central Old Town Key West. Information: (305) 294-2661.

Five blocks off Duval Street, on Fleming Street, Eden House offers more mid-range accommodations, at least by Key West standards. Open since 1924, the lodge has 38 rooms and suites in five buildings that surround a central courtyard and swimming pool. Wide second-story verandas add to the charm. Information: (305)296-6868.

Slightly less pricey still is one of Key West's newest hotels, the Silver Palms Inn on Truman Avenue. The hotel's 50 rooms are decorated in a

tropical motif and surround a courtyard swimming pool. Information: (305) 294-8700.

Finally, vacation rental homes are an alternative to traditional lodges in Key West. They are an especially affordable option if you are traveling in a large group. Find them on various vacation rental websites.

Acknowledgments

Many people throughout the southern Florida environmental community contributed their time and knowledge to this book. Thanks to everyone who provided assistance.

In particular, I thank Garl Harrold, Don Kincaid, Steve Gibbs, Eric Bass, and Josh Gore, who, along with several public agencies and private businesses, provided photographs for this book. An extra thanks to Dan Campbell, who made available his own photos while facilitating my access to other photographers' works.

I extend appreciation to Pete Frezza for his advice and suggestions, to Patti Konrad and Lynda Lewis for their generous help with editing, and I offer a big thank you to Clyde and Niki Butcher, who unselfishly donated their time and talent to prepare the foreword for this volume.

I am indebted to the Everglades Foundation, both for its work to conserve the southern Florida environment and for its material assistance to me as this project was beginning.

I am especially thankful to Dan Burkhardt, without whose encouragement and assistance I would never have undertaken this book.

Finally, thanks to my dad, Ken Silk, and my mom, Lynn Rhodes, for always being there.

Index

ROBERT SILK has written about and explored the waters and wilds of southern Florida for 15 years. He lives in Key Largo, where he can often view manatees from his kitchen window.